Watercolor Energies

Watercolor Energies

by Frank Webb A.W.S.

ECHO POINT BOOKS & MEDIA, LLC

Published by Echo Point Books & Media
Brattleboro, Vermont
www.EchoPointBooks.com

All rights reserved.
Neither this work nor any portions thereof may be reproduced, stored in a retrieval system, or transmitted in any capacity without written permission from the publisher.

Copyright © 2016 by Frank Webb

Watercolor Energies
ISBN: 978-1-62654-114-6 (paperback)

Cover design by Adrienne Núñez

Dedicated to Ed Whitney
for his intellectual and emotional commitment
to art and teaching

Acknowledgements

I am grateful to my daughter, Wendy Webb, for editorial assistance, and to North Light Editor, Fritz Henning. Helpful readings and suggestions were made by Angella Bradick, Rebecca Rinehart and Jayne Webb. I also thank the painters and collectors who made works available, and Barbara Nechis who suggested and encouraged the project. Most of all I thank my wife, Barbara Webb, who said to me one day in 1970, "Webb, why don't you concentrate on watercolor?"

Contents

Introduction 9

1
Convictions 13
Why paint? 14
Why watercolor? 15
Attitude 15
Education 16

2
Elements 19
Shape 19
Tone 20
Direction 23
Sizes 24
Line 24
Texture 24
Color 27

3
Materials 33
Studio 33
Brushes 35
Paint 36
Palettes 39
Paper 42
Impedimenta 42

4
Method 43
Beginning 43
Finish 45
Overview of aim 45
Preparing paper 45
Posture 49
Angle of paper 49
Approach 50
Editing 60
Sequence 61
Edges 62
Charging 64

5
Design 65
Visual language 65
Benefits 67
Freedom 68

6
Space 71
Landscape 71
Pictorial space 71
Flatness 72
Containment 76
Depth, three stages 78
Skate into space 78
Divide picture 78
Choose format 78
Reading direction 78
Facets 79

7
Execution 81
Demonstrations 82
Gallery 7a 101
Gallery 7b 121

8
Pattern 145
Translation 145
Finding a motif 147
Outdoor landscape 148
Pattern making 148
Hints 151

9
Esthetics 155
Camps 155
Deficiencies 156
Glories 156
Knowledge 156
Semi-abstract 156
Personal esthetic 157

10
Routine 159
Professional 159
Associations 159
Juried shows 160
Galleries 161
Solo shows 161
Sales 161
Commissions 162
Publicity 162
Audience 162
Photography 162
Standardized
 system 165
Free agents 169
Stationery 169
Collecting 170

Conclusion 171
Glossary 172
Bibliography 175

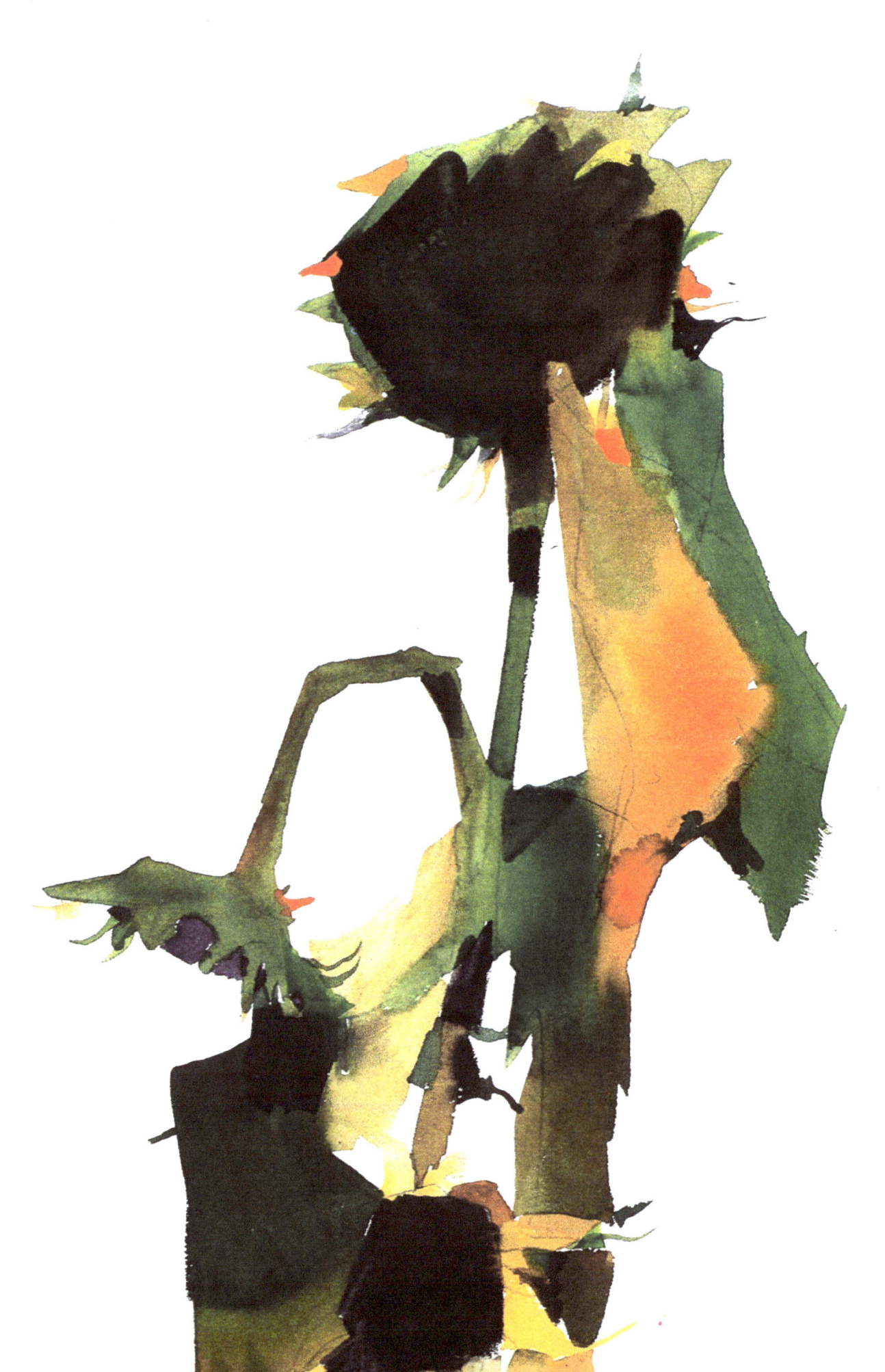

Introduction

WATERCOLOR: Simple washes of transparent, water soluble fluid paint on 100 percent rag paper—the closest symbol in the visual arts to the glory of light. Its beauty has not been overshadowed by recent discoveries of esoteric mediums; nor have 80 years of esthetic "isms" superseded it.

ENERGIES: Vigor or power in action or expression. Unlike matter which is a static substance, energy is a dynamic substance.

How far are you going in watercolor? Where do you stand in relation to the artist you started out to be? Are you a beginner—intermediate—master? Are you more interested in achievement than success? In making this assessment some people use the word *talent,* which implies, "This is what I have." I prefer the word *ability,* which suggests activity, "This is what I can make." We all wish to gain in understanding and ability. Another substitute word for talent is *habitus,* coined by the Scholastic school of philosophy of the Middle Ages. Habitus is a disposition in the heart of the workman toward the work to be made. Rules, method and publicity mean nothing if there is no habitus.

Growth in abilities takes place through perception, conception and execution. In simpler language: seeing, thinking and acting. Many books aim instruction toward the first and third—how to see and how to paint. My book deals with these, but concentrates on conception. Ability is the power to depict concepts, while genius is the power to generate concepts.

A concept is an integration. In this book I

Opposite page:
Sunflower Silhouette *22 x 15 inches*

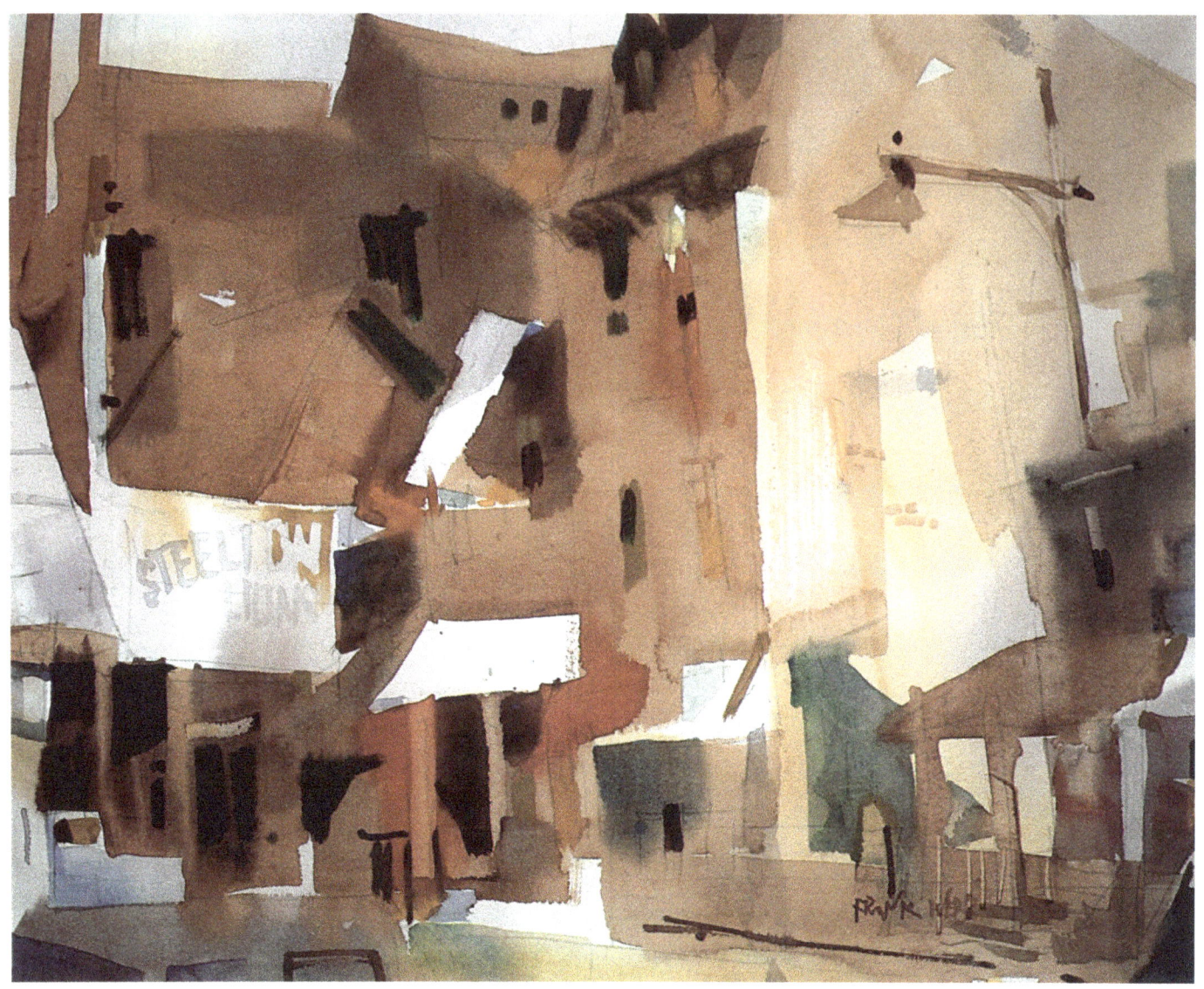

Steeltown *15 x 22 inches*

advance the integration of two opposing esthetics—naturalist and abstract—into semi-abstract.

Esthetically, there are many variations in the art of museums, galleries, classrooms, studios and books. Most painting categories can be subsumed under one of two classifications, naturalist and abstract. Although naturalism and realism are terms often used synonymously, it is helpful to draw a distinction between them. Naturalism, being based on sensory data and experience, is epitomized by the phrase "slice of life." *Naturalism is perceptual.* Realism recognizes the objective realm as existence (that which is) and essence (what it is). *Realism is conceptual.* These two representational modes can be lumped together as naturalist since they both begin with a study of the objective world.

In opposition to these is modern or abstract art, which does not begin with the object but with the subject (self). In philosophy, this concern for expressing man as thinker, actor and sentient being, is called existentialism. By combining the naturalist and abstract sources, I hope to create an integration of form and content in which the glories of each reside without the limitations of either. The semi-abstract is seldom discussed in books or in organized study programs. Semi-abstract tendencies can be detected in the works of many beginners as well as advanced artists. Perhaps you are a crypto-semi-abstractionist without even realizing it.

The challenge of this quest will not be met by casually copying nature or by mindless doodling. I cannot give you a how-to-do-it formula, though the semi-abstract esthetic affects all the chapters which follow. I discuss it again in chapter 10, where it is treated as the painter's personal search. I have little interest in giving you a linear progression of lessons, but rather present it throughout the book in the manner of instant awareness of the total field, in the same way we look at a mosiac. The two realms must be integrated through a long process of study. It is not merely the development of technique, but a combination of thinking, feeling and acting. You will mature as you paint, study and contemplate your own work and the work of others.

As you draw and paint, guideposts which point to progress are contradictory, and the road is strewn with obstacles and distractions. It is essential to bulldoze these obstacles or to find a way around them. Because painting is a solitary journey, it is crucial to sustain morale. It is toward this hope that I have addressed this book.

Nothing can come out of the artist that is not in the artist. All painting is autobiographical and is therefore a by-product of your personality, emotional capacity, sensitivity, discernment and esthetic power. Personal education and artistic growth are linked together. It is a tall order and a life-long job. No one has ever graduated, though many have quit.

I urge you forward, under your own power, to make your own discoveries with the qualities of the watercolor medium. I try to avoid esthetic smugness and am not proselytizing for a certain "ism." The workable range between naturalist and abstract is wide, and I have little interest in the two extremes. I am forging a language of criticism, defining the activity, and sharing technical information. It cannot be overemphasized that design is not limited to means, but serves also as ends. I cheer for you, expecting that your discoveries will fill your days and your papers with visual adventures.

The best effect of any book is that it excites the reader to self-activity.

. . . Carlyle

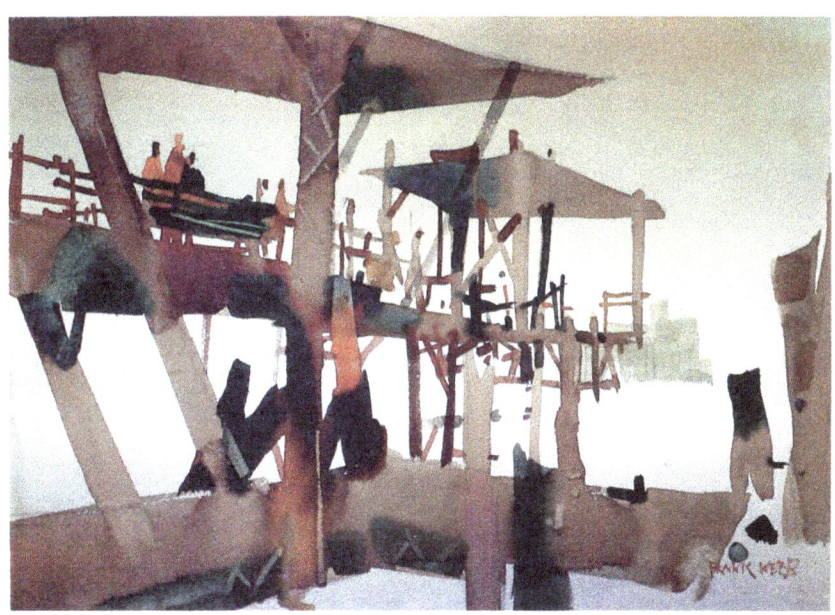

Calligraphic Crowd *15 x 22 inches*

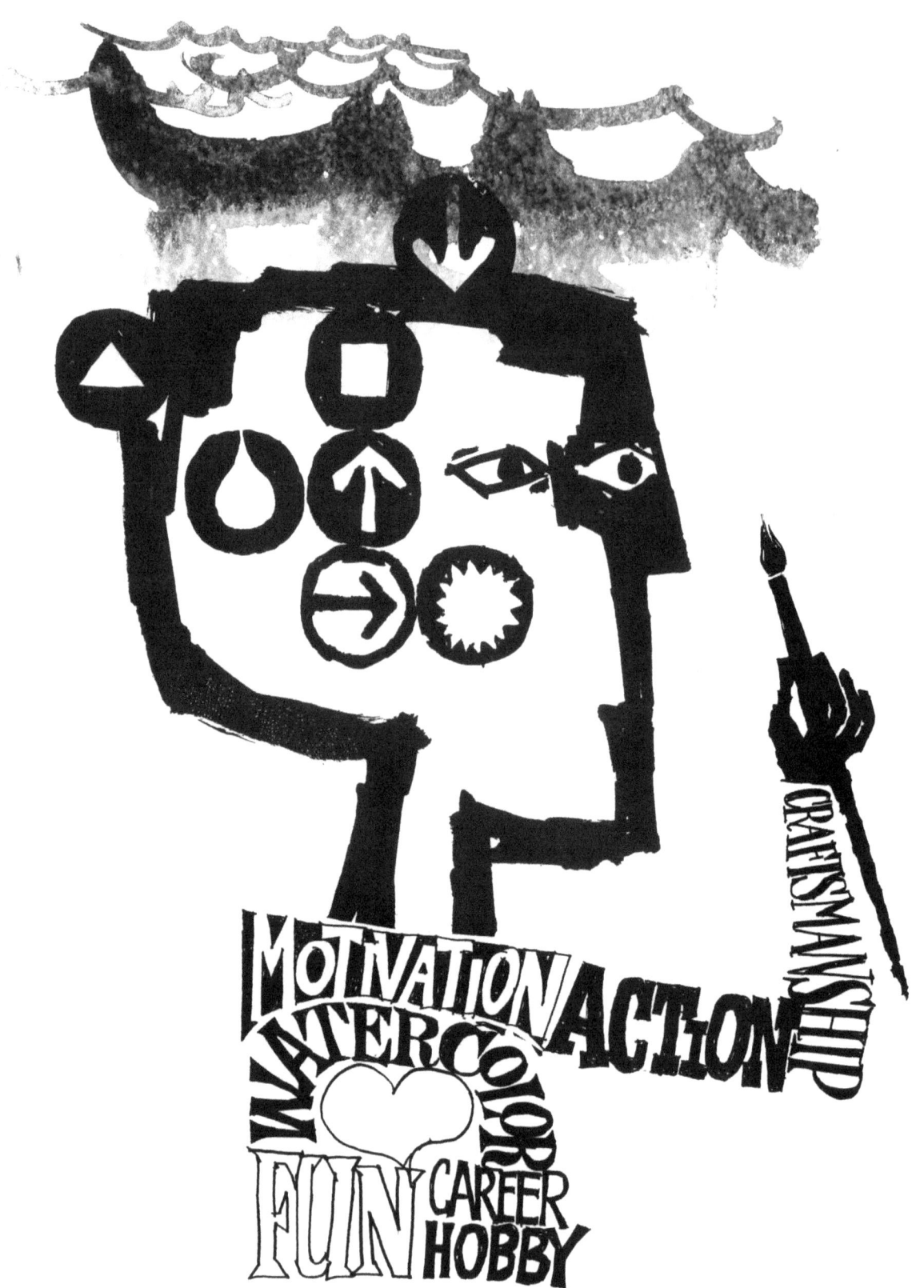

1 Convictions

A figure can be seen only against a background. A work of art organizes itself against the background of the artist's convictions. A conviction is the active process of convincing and persuading others. Art to be valid needs to be believed. It is a yea-saying of the artist's consciousness and is the fruit of desire. Art embodies and affirms the artist's values. The work of art says, "This is what life is like, or should be like." Roualt put it this way: "I am a believer and a conformist. Anyone can revolt; it is much more difficult to obey our inner promptings."

Convictions in life and art

Our knowledge is only partial: we see in part; understand in part. Inconsistencies plague us all of our days because we operate from mixed motives. The study of religion, art, philosophy and science enables us to chart a course through the maelstrom of life. Just as I have ultimate beliefs or convictions which give meaning and direction to my life, so also do I have convictions about my art and craft. These are evident in my works and in this text. Each artist brings convictions to the market place where comparisons are made. This exchange is a fair game; perhaps the most fair and free exchange among man-made enterprises. Each work is an implicit criticism of all others.

The following is a partial list of my convictions about painting which will surface in the following pages:

- motivation precedes action
- art is deliberately designed
- painting is a creative action
- art interprets experience
- the way of art is the way of trial and error
- the artist must respond to fresh impressions
- the artist's job is to communicate life
- fun and satisfaction are in the activity itself
- the quest for beauty requires craftsmanship
- failure is a stimulus

Why paint?

We paint to learn about ourselves, the world, and to discover of what painting consists.

The artist lives by wits. Few pursuits are so totally dependent on an individual's internal resources. Our culture is dominated by mechanical and electronic triumphs. Against these depersonalizing forces, each artist fights for a personal life. Each is a solitary worker, making works which are addressed to the public, and receiving the benefit of identity. No matter how small the artist's garden, it is a personal plot, relatively free from the boll weevils of outward politics and the crab grass of the computer. The door of the studio may not, however, be entirely safe from the wolf.

Financial rewards, contests and fame may serve as incentives, but they cannot substitute for inspiration. Artists have convictions about painting, about themselves, and about the world condition. They have preferences, intentions, and the will to make visual statements. The validity of the artist's activity redounds to the benefit of the community and to posterity, as evidenced by the meticulous care which is given to those works which have been rescued and preserved in museums. Works of art become permanent records of directly felt qualities.

There is much man-made ugliness resulting from the world's adoption of mass values. The artist looks out across this awkward and sometimes gross scene and captures content from the flux of experience. The work of art is a synthesis of thought, feeling and action. The work is offered for contemplation, free from materialistic demands and selfish motives. Whether received by many or few, it is a symbol of the wonder of life.

A mere defense of painting is not necessary, for the world sorely needs quality and beauty. Both artist and audience reap manifold benefits through appreciation. The artist is aware of the importance of qualities and relations, and knows that it is a privilege to be so involved.

As an artist you are free; free to make your own shapes and to make them darker or lighter, larger or smaller, cooler or warmer, smoother or coarser, brighter or duller in chroma; free to choose hues, directions, sizes, tones, materials and idioms. You can have anything you want; find it, pay for it, even sacrifice those things which are now less important.

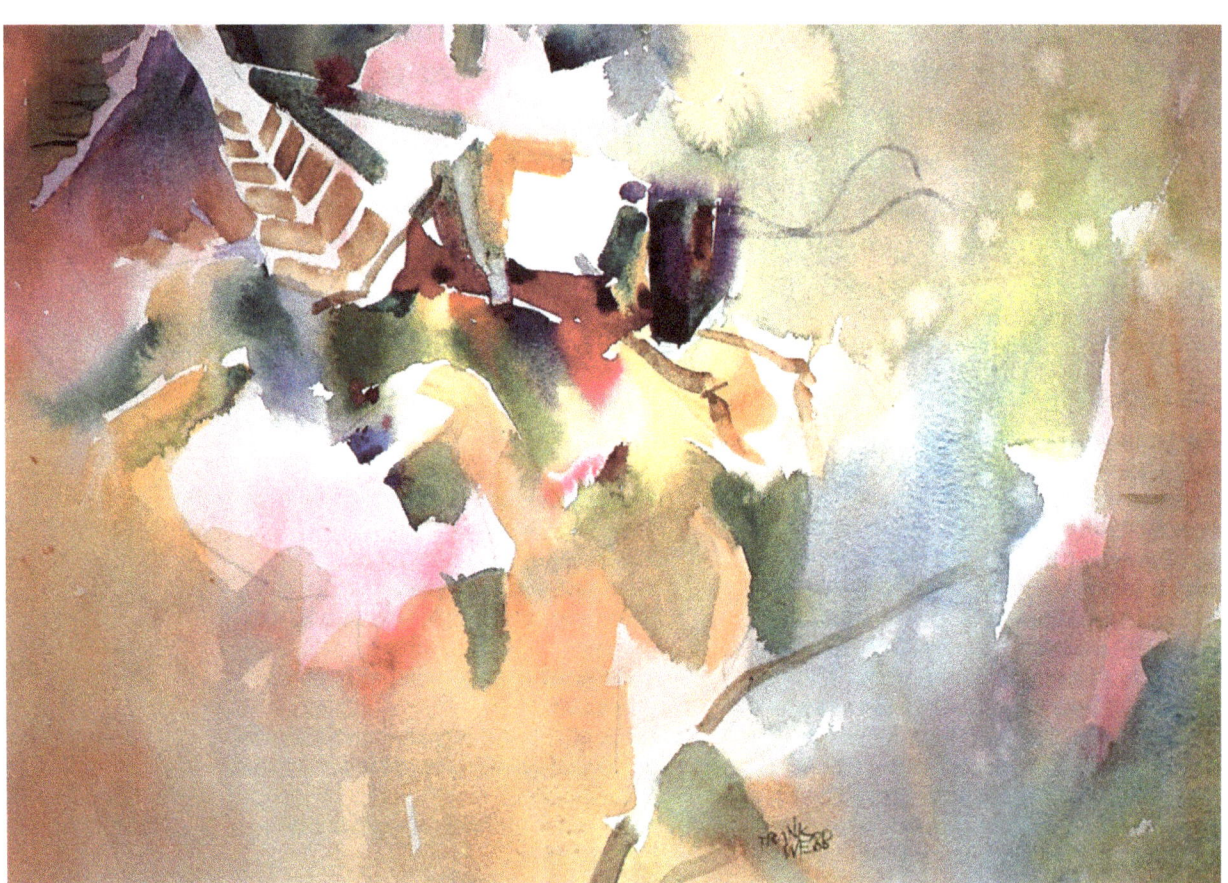

Meadow Musician *15 x 22 inches*

Why watercolor?

American painters have taken the watercolor medium to new frontiers of poetic expression. Watercolor landscape has perfectly embodied the people's love affair with the land. A partial list of American masters who have used aqueous media includes Charles Burchfield, Charles Demuth, Winslow Homer, John Marin, Maurice Prendergast, John S. Sargent and Andrew Wyeth.

Watercolor's reputation has been put down by those who favor the more muckety-muck media and by those artists who use watercolor only as preliminary studies. These attitudes foster the impression that watercolor is a trivial medium. Major works of watercolor are conspicuously absent from the permanent collections of many art museums. Collectors have been known to erroneously regard watercolor as being less permanent.

Some art teachers present a view of watercolor which limits its scope to a concern with methodology. While technique is important, (nothing which is inept or vague can be beautiful) it cannot supersede esthetic criteria. Superficial works are painted by superficial painters, and great works by great painters, whatever the medium.

The enthusiasm generated by watercolor painters has resulted in the formation of hundreds of watercolor societies. These societies constitute a limited community or fellowship for painters. Most exist primarily as exhibiting groups, but some also sponsor many related activities which create interest in the medium's beauties.

Beyond the esthetic merit of the painter's creative concept are the medium's inherent virtues:

(1) Luminosity. A characteristic obtained by the influence of the paper. The transparent paint layer allows the white of the paper to assert itself even in the dark passages. The positive glory of light is affirmed.

(2) Transparency. A feature often emphasized when glazes are partially superimposed on previous washes. Transparent marks made in sequence logically reveal their order in the painting layers. Optical effects of color and tone result in the synthesis of paint layers.

(3) Calligraphy. A direct and graphic use of line, present in much watercolor painting. A combination of wash-shapes with added calligraphy has a proud heritage which is epitomized in works found in many museums.

(4) Immediacy. A presentation of one mood without vacillation and halting indirection.

(5) Fusions. Gradation of tone which is easily made and is almost always beautiful. The resulting wet blendings give watercolor its own characteristic look.

(6) Simple paint structure. A feature which insures that the qualities of a watercolor will be evident two hundred years hence. The painted surface will undergo no chemical transformation. No method, or technique of application will adversely affect a painting's longevity.

(7) Intimacy. A quality of painting that reveals the artist's character, interest, condition and state of mind at the time of execution. Such a biographical forage gives the viewer a peek over the artist's shoulder. The accomplished artist's work has become a part of himself.

(8) Rhythms. An observation of gestures and tracks of the tools used in production. Appreciation of these rhythms is made not only by the eyes, but with body response in the kinesthetic sense. The viewer vicariously relives movements which are embodied in the work.

Knowledge of more than one medium adds to the watercolor painter's powers. Each medium has its own glories. Pastel is wonderful for a concentrated study of color because it has a beauty of surface paint quality and luminosity. The broad range of possible approaches in oil paint make it a rewarding study. Gouache, casein and acrylic can be used opaquely or semi-transparently. The required manipulations are the same in all media: to lighten or to darken tone; to alter hue or chroma; to treat edges. There is no one way to paint in any of these media. More important than medium selection is the making of a statement. What does the painting express? What are the painter's findings?

There is no one best medium. Selecting a major medium is a personal decision which is best made with authority by those who have worked long and hard in many. It is logical that the artist chooses a medium in relation to preferences, convictions and responses. Watercolor painters are apt to say as they depart from multi-media shows, "I liked the watercolors best."

Attitude

Are you ready to serve a long apprenticeship under yourself, to endure indifference, silent censorship and rejection? Are you a person of principles with the stamina to keep them? Or do you believe in the Cinderella

story, expecting to be discovered by an influential patron? It is pertinent to formulate such questions, for their real and imagined answers reveal the key to attitudes. Painters work because of, and in spite of disadvantages. Happiness is a secondary reward for the achievement of primary goals. The enjoyment is in the activity itself. In retrospect, you can see progress through your works rather than through the events of your life.

Your threefold job as producer, audience and critic is affected by your morale. What you think and feel is more important than what you see. The world does not need another painting as much as it needs your vision. Your goal is to achieve a state of heart and mind (morale) whereby a work of art comes as a natural by-product. The art-life is a search for qualities. There is no room in art for the "just good enough," let alone the inept.

To a large extent, attitude is fixed by wants, experience and temperament. If you are a romanticist, you will believe in personal value and inspiration. If you are a classicist, you will recognize absolutes which are operative and normative for you. If you are a naturalist, you will put confidence in statistics and in the "slice of life." If you are a materialist or an egoist, interested in fame and money rather than the work itself, you may realize these goals at the expense of esthetic knowledge.

Communication will be more effective if you see your role as host in your painting. Make provision for the edification and entertainment of your guests. Share the insights which you possess.

Art, as well as broadcasting, is addressed "to whom it may concern." Through communication, the artist seeks an audience. The commercial designer reaches thousands of people while fine artists need to reach only one buyer for a single work. At the outset of a career, the painter is up to the armpits in the swamp of indifference. Healthy attitudes must be upheld in order to endure the period of apprenticeship when esthetic power and technical skill are underdeveloped.

The following is a partial list of practical and healthy attitudes:

- Know how to begin a work
- Work for fun
- Work for the sake of learning
- Please yourself, for you can't please everyone
- Work without concern for acceptance or rejection
- Paint as though you have been called
- Make it better than good enough
- Draw and paint
- Exaggerate
- Appreciate your superiors, living and dead
- Make believe
- Develop a sense of inquiry and analysis
- Go whole hog, bite off more than you can chew
- Know when to stop
- Aim for achievement rather than success

Motivation is an internal affair. It is not the result of an outward gain of money or fame, although it is possible to receive these rewards as the fruits of work; thus, you can have your cake and eat it too.

Education

The painter's education is the study of appearances. It includes the acts of formulating and understanding ideas; the use of the tools and materials of the craft; and the development of a critical sense. The painter's study is an "on the job" learning in the realms of making and giving. Each art student begins at zero and walks the same path of trial and error that others have taken. The art student, unlike the scientist, cannot build on the work of others. A study of self is included, but often hidden in the painter's curriculum. Most important is the self-education of one's emotional life, which is often left to caprice.

In the beginning, the artist works in the idiom, or under the influence of other artists. Higher education begins when the student is able to express a unique point of view using a set of personal symbols which provide graphic identity. The student needs to receive technical information regarding materials, and must become acquainted with the tools of art. The chief tools are the language and principles of design. The early years should include a variety of teachers, books, philosophies, media museums, tons of paper and contact with nature. This is also the time to expand one's breadth of experience. Later, having numerous options, the advanced painter can select a specialized area for study.

There is no stereotype art student, but rather a complete spectrum. In addition to the young person just out of high school, there are large numbers of people who are finding time to paint after their children have

grown. Many of these studied art earlier in life and were sidetracked while raising families. Teaching or studying with them is fine stimulation, for they are fully commited as artists and as individuals.

The commercial artist who studies painting seriously must be able to double-track from expressing the ideas of others to self-expression. It is not simply a technical adjustment (loosening up) or the substitution of a frame for a "flap." The cost in time and energy for a commercial artist to express himself must be taken from a career that leaves little to spare. The artist who has made a living in the market place has knowledge and insight of realities unknown to those in ivory towers. Applied art requires dedication, ability and versatility. The commercial artist must produce on demand, immediately, from personally held resources. The residue of such a career, however, is only a collection of yesterday's newspapers and magazines. Such works can parade fine qualities, but the parade passes quickly. Works of fine art, on the other hand, last for centuries and have more than a documentary interest or utilitarian purpose. They are not limited to current events or the impulse of the market.

Many who teach art in public schools and colleges continue serious study of painting. One reason for their sustained enthusiasm is their dedication and desire to impart information to their own students. The adage about teaching being a continuous learning experience certainly holds true.

Art schools

We find no stereotype here. Some schools train for commercial art, with a consequent practical attitude toward communication and craft. Broadly speaking, these are called "design schools." Other schools are departments of universities and colleges, teaching fine art. Understandably, few schools provide more than a brief introduction to the various media. An ever increasing number of watercolor workshops are sponsored by individuals and societies around the country. Many of them offer a variety of guest instructors who provide any category of student with an opportunity to continue a personal program of education.

Art schools offer the following advantages:

Environment. No longer sustained by the guilds of the Middle Ages, the painter of today is often a solitary figure, out of touch and without patrons. A classroom provides a community where creative pot-boiling and cross-fertilization of ideas are fostered. It is salutary to remember, however, that no work of art was ever created by a committee or a community.

Time saved. A school and an instructor furnish the necessary technical information which would be difficult for the student to gather independently.

Goals defined. A school guides the student away from superficial goals. Without assistance, the student is less able to distinguish between the genuine and the specious.

Enthusiasms kindled and fanned. There are many bleached bones on the desert of esthetic effort. Discouragement is a natural consequence of the creative quest. The student must be shown that the way of art is the way of trial and error, filled with doubt and despair. The feeling of camaraderie that accompanies hob-nobbing with good fellow students puts esthetic backbone into the painter.

Teachers usually fall into two groups: (1) Those who teach technique and not art, making a reasonable argument that art cannot be taught. (2) Those who teach art but not technique, boasting that demonstration is not necessary, for it might stifle creative inquiry. Both of these teachers can be successful; art is more caught than taught.

Since no one has learned all that can be known of life and painting, the student and the painter should remain open to new impressions. Masters are painters who are in charge of currently held abilities; not finished persons. Next year they will be in charge of more ability and understanding than they currently possess for the study of art is a lifelong quest.

In school or out, on the job or later at home, the painter should design and follow an independent program of study. This is necessary to acquire good professional habits, the most important being faithful practice. Those who earn their living by working for others should not deny themselves the sweetest reward of being an artist—working for themselves.

Convictions are generative, which makes them more pertinent than questions, or answers. People can abide differences in technique, approach, execution, medium, or professional practice, but will go to war over convictions. Get convictions. Have the courage of those convictions.

Art is not duplication in a projection, but a new created image embodied in a medium, derived perhaps from life experience but not photographing it. . . . Louis Arnaud Reid

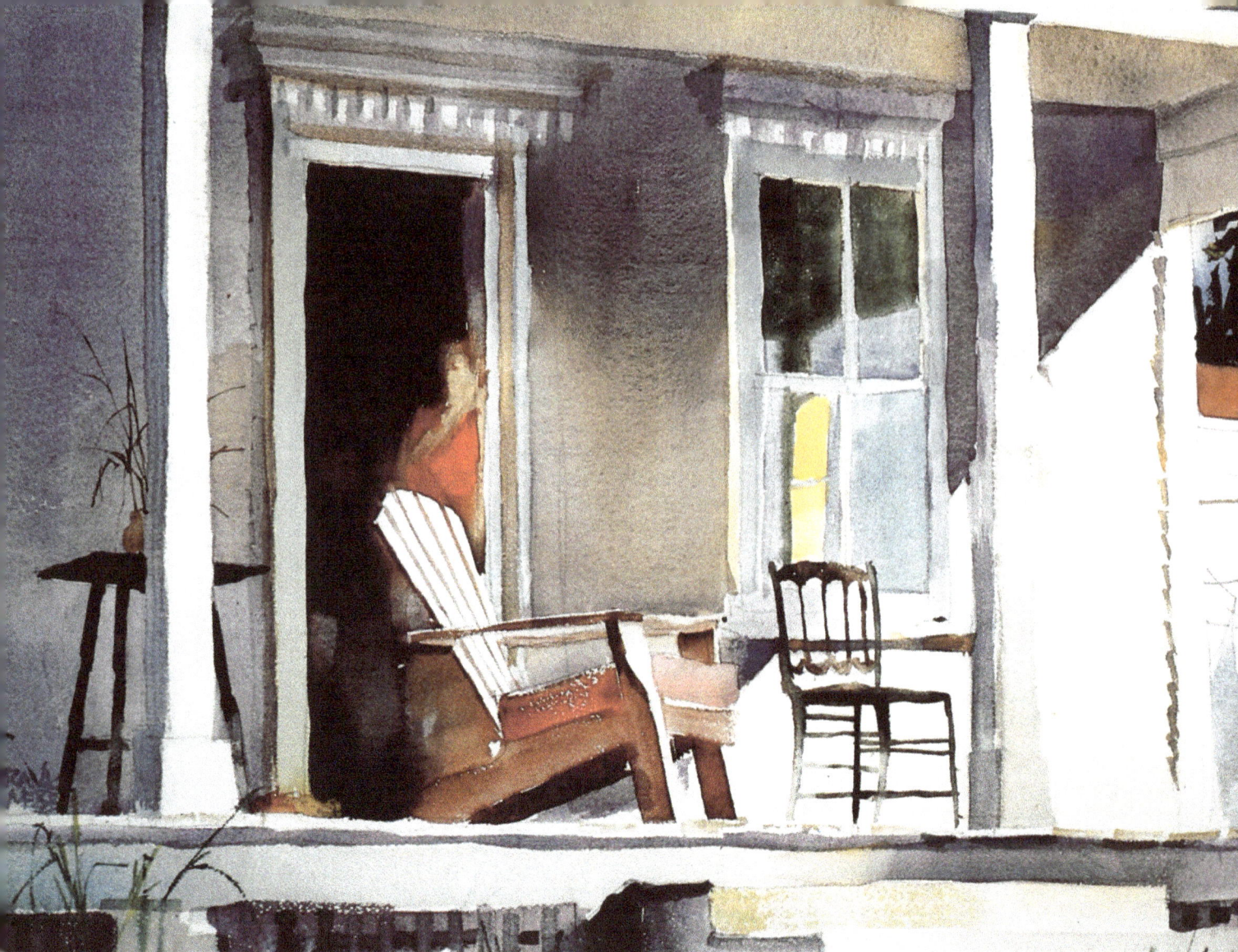

Porch of The Trailing Yew Inn *18 x 25 inches*

2
Elements

Pictures are not made of flowers, guitars, people, surf or turf, but with the irreducible elements of art: shapes, tones, directions, sizes, lines, textures and color. These nouns provide a vocabulary for a visual language.

Shape

Shape is the primary element in paintings. It is apprehended by the tactile and visual senses plus inner response. Shapes play a dual role. They are symbols of objects and they are paint marks. Shapes are better or worse according to the following criteria:

(1) A good shape is longer on one dimension. Avoid rounds, squares, equilateral triangles and all bisymmetrical shapes because they are static, boring, self-contained, and difficult to integrate.

(2) A good shape is (or contains) an oblique, which makes it more dynamic.

(3) A good shape possesses gradation of width.

(4) A good shape is interlocked with adjacent shapes, as in a jigsaw puzzle, wedging shape with shape, integrating the parts of the painting into the whole. Interlocked shapes suggest the parts relate to one another, such as the hand to the arm, the neck to the head.

(5) A good shape has variety in edge treatment. Such variety is achieved by creating soft, hard and rough brushed edges.

(6) Good shapes provide passage from one to another. Edges should be softened where areas of similar tone are juxtaposed.

(7) To design a good shape which corresponds with existing objects, it is desirable to use the most revealing silhouette in order to express the shape's character, bulk or function.

Shapes made by naturalists have little or no intended distortion, while abstractionists make shapes for the sake of shapes, without reference to an object. Semi-abstractionists fuse these two concepts to create a good shape which fulfills all the preceding requirements, while maintaining reference to the object. These shapes are distorted to express character and gesture, and to increase their plastic relationships.

Tone

Tones are intervals on the scale of light to dark (values). There are three kinds of tone:

(1) Local Tone—the tone of objects in the objective world; independent of illumination.

(2) Chiaroscuro—light and shade. Volumes in the objective world, such as cubes, spheres, cones and cylinders always obey the laws of consistent illumination. Tonal intervals express these volumes.

(3) Arbitrary tone—the designer's choice of tone used for pictorial purposes.

Patterns of tone

The simplest pattern is a single tone against a contrasting one. A more complex pattern requires the employment of one or more of the above uses of tone. Pattern making is a creative act, using chosen tones. Not tone as-it-is, from a motif, but tone as the artist wants it.

Intervals of tone

Any understanding of the actual differences among tones must take into account the distance and the direction between tones. Well separated intervals of tone provide the basic contrast which makes a painting readable. Color and texture can also provide readability, but are subsidiary to tone. Consider tonal patterns as abstractions. Tone is the primary means to communicate areas. If tones do not make shapes understandable, they will not be read.

Limits of tone

The great range of nature's light can be approximated by nine or ten tonal intervals of paint. Although nature's gamut of tone cannot be matched, its relationship can be suggested. Paint's limited range can be extended by gradation and alternation.

Light and shade

Shade is the apparent darkening of an object as it turns away from the light source. A cast shadow is seen on a surface which has had the illumination blocked by an intruding object. It is helpful to study the shapes of shadows cast by familiar objects. Cast shadow helps define the lay of the land or other surfaces which lack recognition. Minimize or eliminate dark cast shadows which punch holes in your paper, such as the offending shadow cast on the neck by the chin and jaw, or that blackish mustache cast by the nose onto the upper lip. Combine shade and shadow into one shape, when possible.

The complexity of some landscape subjects can be simplified by limiting the contrast between light and shade to a couple of tones. This reduced contrast prevents the object from being visually split, and helps maintain the total shape identity of the object within the pattern.

Notice that the tonal interval between the light and shade on a white object is a greater contrast than this interval on a darker object under the same illumination. Beware of allowing light and shade to overcome and replace design, drawing and color.

Problems of tone can be previewed, clarified and solved with a miniature sketch.

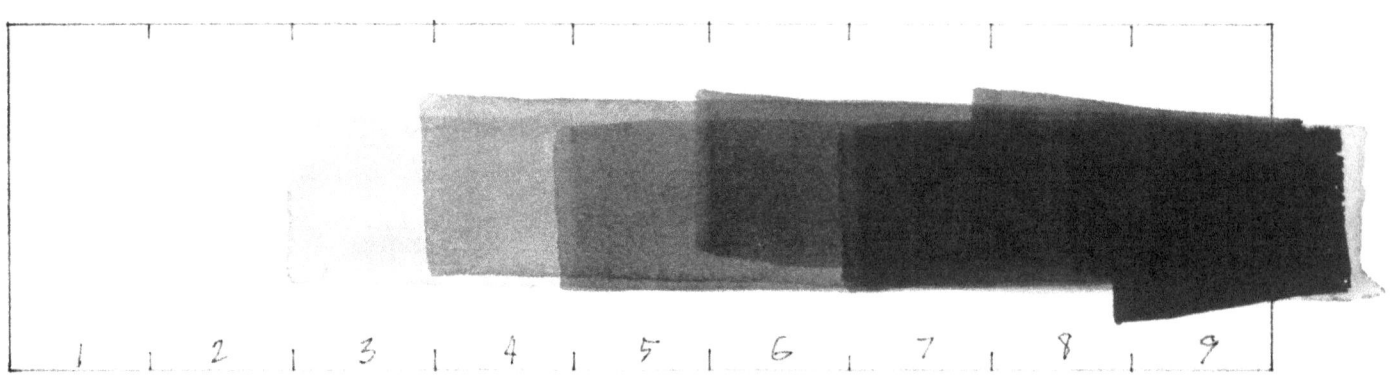

Museum of Art, Carnegie Institute, Pittsburgh
Gift of Mr. and Mrs. James H. Beal in honor of the Sarah M. Scaife Gallery, 1972

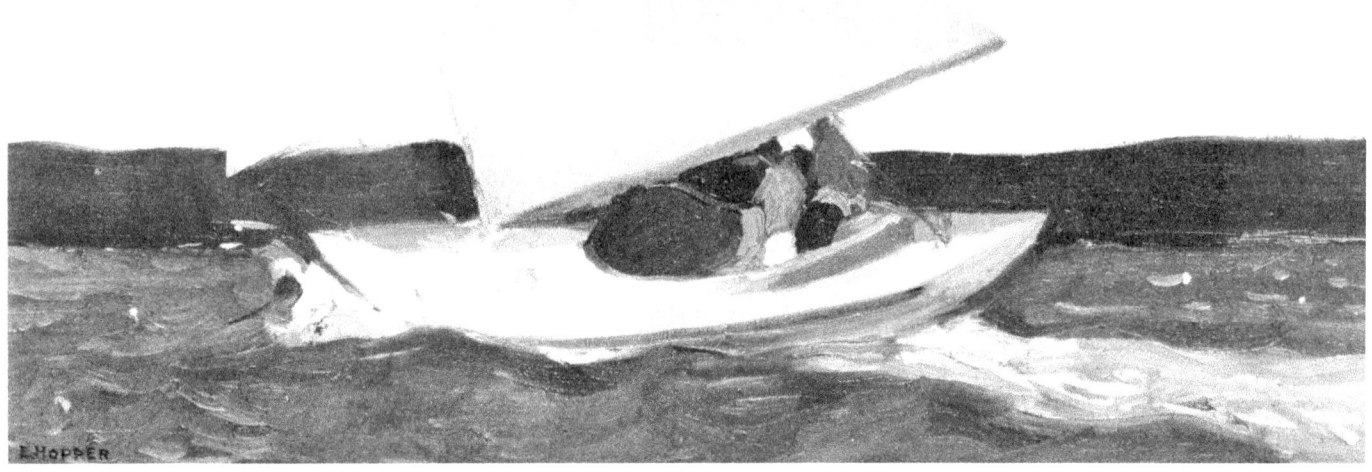

Sailing *by Edward Hopper, (1882-1967) Oil on canvas, 24 x 29 inches.* A fine two-dimensional pattern with chiaroscuro playing a secondary role. Large areas of almost flat tone are kept well-separated. Notice in the largest midtone area, the sky, that Hopper has gradually darkened the sky tone as it meets the shore. Generally, this happens only in fog. Contrast is thereby diminished at the edge of the horizon, saving needed contrasts for other, more important areas. Whites are instantly readable, well-placed, and have variations in size. Darks are nicely wedged and easily found. Look aloft and appreciate the little piece of dark which echoes the darks at the bottom. The angle of the boat hull is in a splendid relationship with the angle of the wake. Large, simple areas dramatize the small, vulnerable figures in the boat.

Dakota Sunflowers *15 x 22 inches*. These two photographic prints made from the same negative exemplify the limited range of tone. There is more tonal range in a single negative than one print can reveal. In this print the midtones merge into a common tone which remains much lighter than the darkest tones.

In this darker print the nuances among the midtones are more distinctive, but they merge with the darks. The same limitations apply to choice of key when planning a painting.

Armed with such a pattern, the artist is free to concentrate on the problems of color, texture, and edges during execution of the painting.

Key: high, middle and low

A high key pattern has the majority of tones at the light end of the scale, above middle tone. A low key has most of the tones below midtone. Choose your key deliberately to express the essence of a motif, or to establish mood. A high key suggests the outdoors' great illumination and luminosity. It also provides latitude for heightened coloration, for most high chroma color falls into this higher midtone range.

A low key can express a forest interior, darkness or a room interior. Choose key with a clear understanding of the limitations of tone in paint. Showing a wider range and nuances among the lighter tones will be done at the expense of the range in the darks, producing a low key painting in the manner of Rembrandt. The opposite is also true, for the range among the lights is reduced when diversity is sought among the darks. Turner's high key painting exemplifies this.

Most moderns embrace the Turner idea, which seeks true tonal relationships of shade and shadow, while diminishing the range among the higher midtones and the lights. Attempts to include both ends of the scale eliminate the midtone which is the carrier or body containing and making readable the darks and lights. The loss of midtone sacrifices color opportunities.

Organize tone

Areas of tone should differ in size, be obliquely positioned, and few in number. When areas are similar in tone, combine them to give breadth of effect and gesture. Try to keep patterns simple. When making preliminary pattern sketches, work with three tones: light, midtone and dark.

Tone in Watercolor

A chronic tonal problem for the watercolor painter is the medium's tendency to lighten as it dries. This characteristic applies to certain colors more than others. With experience, this change in tone is expected and compensated for by making the initial tone darker so that it will dry in the intended relationship. This same modified appraisal of tone is necessary when painting a second layer over a dried one. Paint applied to an area of wet paper will dry lighter than painted on a dry area, because the water on the surface of the paper dilutes the paint.

Direction

Unless paper is cut to a square, it has variation in length and width, and as a consequence possesses direction. Let the subject dictate the format of the picture. A vertical format is the logical choice for painting a standing figure, while a horizontal format is chosen for a beach scene.

There are only three directions which paint marks can take: vertical, horizontal and oblique. Strokes in the vertical direction suggest growth and dignity, offering maximum opposition to the horizontal. The horizontal expresses repose. The oblique direction is the great energizer of the pictorial scheme, showing movement into space. Obliques foster a sense of life through tension relationships.

Which direction expresses your motif? Choose and commit the big shapes in your painting to that direction.

When repeating the elements in a picture, place them in an oblique direction, not immediately under or across from one another. Because the eye looks for connections between repeated elements, there is an implied line between them. To produce interest and movement, give this line an oblique direction.

Oblique

Horizontal

Vertical

Sizes

To avoid boredom, produce a variety of sizes among the elements. Make some large, some middle sized, and some small, but make one obviously larger than the others. The size sequence should be irregular. This deliberate regulation of sizes among elements should not be limited to objects, but also applies to intervals (spaces) between objects.

Line

Line is the path of action. Our language is full of references to line; stand in line, hold that line, lines running around a vase, etc. Line is a graphic convention. The artist's line should be an inspired line. Inherent in line are the two chief graphic modes of visual art—movement and the contours of shape (boundaries). Line may scrawl awkwardly, it may leap, skip, fall, rise and pulsate. It may be thick, thin, long, short, soft, brittle, scribbly or astringent. While all these characteristics give it great latitude for expression, in the context of design, let us stress line's most obvious property—the contrast between straight and curved. Though paintings might not always feature line as line (calligraphy), each of the other six elements uses line as contour. Even the implied edge of a series of spots will be either straight or curved. A combination of curves or straight lines provides interest. Choose either straight or curved for dominance. Make one line longest in length.

Texture

The most obvious textures are rough and smooth. Texture can be copied from nature, or it can be fabricated for the sake of pictorial structure. (The texture of content vs. the texture of form.) Texture can fill a need where a tone or color is unavailable. Texture can clinch the "thereness" of a plane. Think of its function as wallpaper where the presence of the wall is emphasized. However, do not expect texture to substitute when a tonal pattern is deficient or missing.

Taxco, Mexico, 30 x 22 inches. Perhaps we see color first, but color must be built on a foundation of shape, tone, sizes, direction, line and texture or it will collapse.

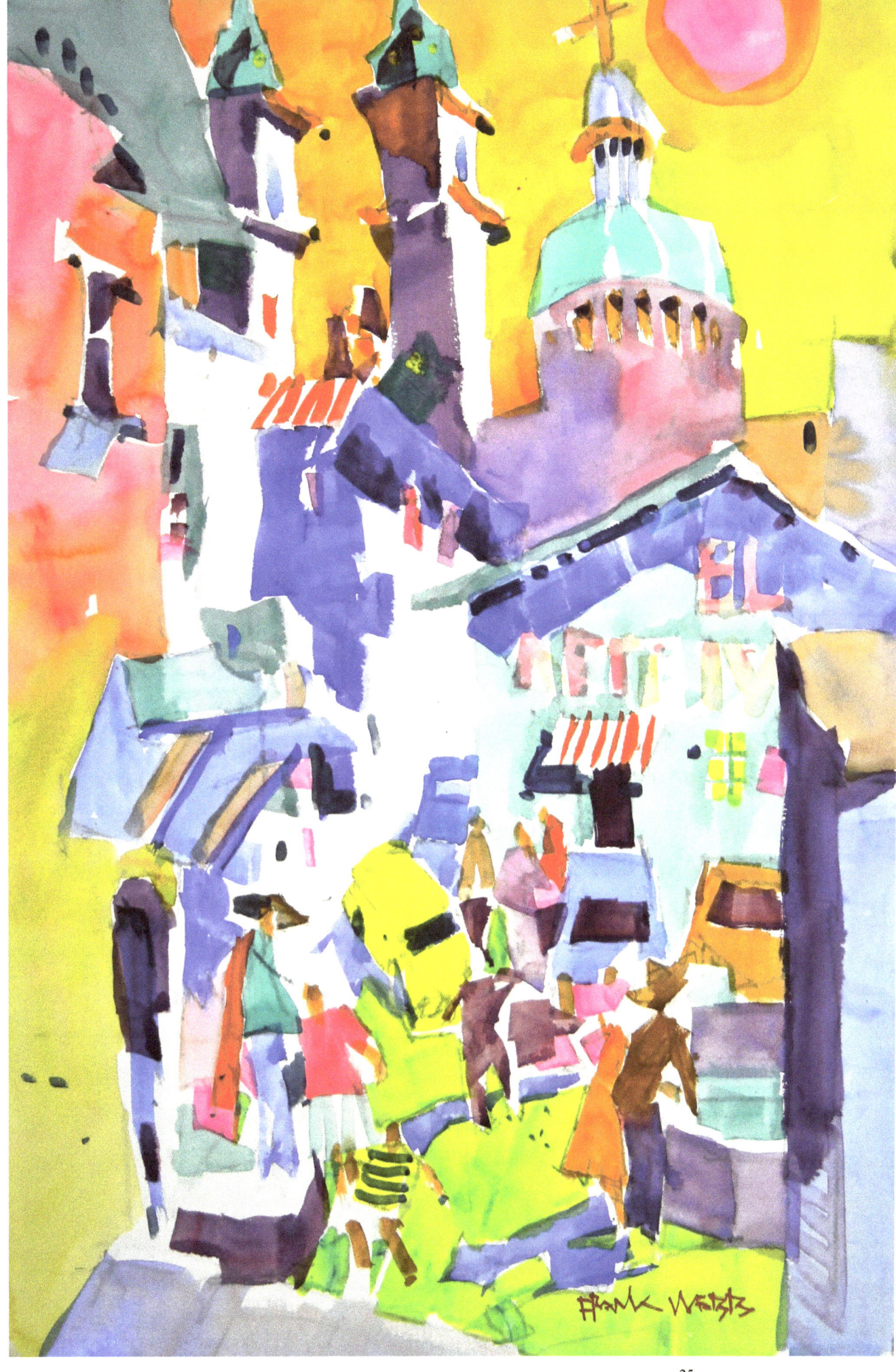

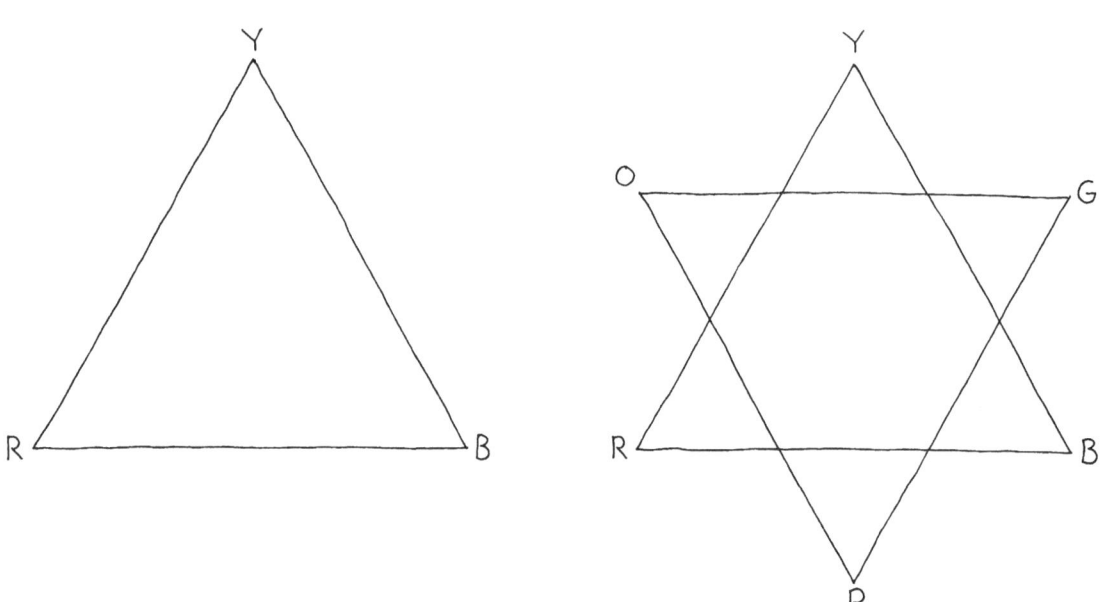

Above left: Familiar paint primaries. These have maximum contrast between them, i.e., they have nothing to do with each other.

Above right: The secondaries are added at the same radii because their chroma is equal to the primaries, though in theory they are mixtures. Thus we have six working brights with instant hue identity.

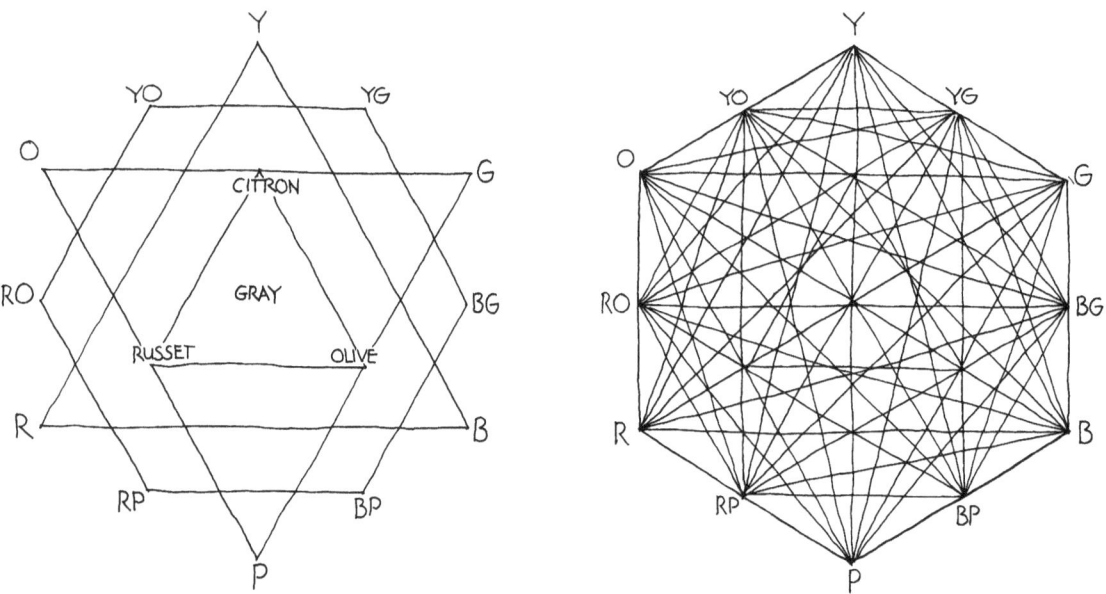

Above left: Six intermediates are added. They are nearly as high in chroma as the basic six, but have less hue identity, for all the intervals have become shortened. Closer in toward neutrality are the three tertiaries.

Above right: This overwhelming abundance of lines is more decorative than useful, though it gives a hint of the interconnections and influences which affect a hue moving toward any other.

Color

Some artists see color beautifully. Color is tied to perception and is the most personal of the art elements. A painter has, more or less, a feel for color. For that reason, its properties are the most difficult to communicate to students. The non-painter's notion of color is often limited to local color: the orange carrot, the red beet, etc. Naturalists who paint objective shapes using local color find it difficult to achieve a color dominance. Therefore, just as shape and tone can be created, so can color. It is not to be copied. Color is much more than a visual adjective to the noun "things" in paintings. Color creates a means and an end of expression, invoking immediate emotional response. Color is an effective structural element. Paint comes from tubes, facts from nature, but color comes from the artist.

The three properties of color are hue, tone and chroma. Each color has a hue (red, blue, etc.), a tone (light—dark), and a chroma (strong—weak). All three properties are mutually exclusive, although appraisal must be made for the desired degree of each in every application of color.

Color properties and relationships

One of the best ways to clarify color intentions is to visualize a chord, made of a few hues. Color wheel diagrams usually suggest the popular combinations, such as the complementary, the split complementary, triadic, and analagous schemes. Nevertheless, beyond the spectrum of primary and secondary hues are unlimited mixtures of low chroma colors. Your task is to adjust hue, tone and chroma where your non-painting friends are likely to see only hues.

Much of the scintillation and the glory of outdoor light can be suggested by the interaction of warm and cool passages of color. Esthetic interest is also established by mingling warm and cool. Since ordinary mixing of warm and cool results in neutralized or muddy color, a certain amount of finesse must be used in combining warm and cool.

Some of the ways are:
1. Patch beside patch, producing an optical mixture in place of an actual premix.
2. Gradation or fusion from one patch to another.
3. Warm over cool or vice versa.
4. Warm into wet cool and vice versa.

Loss and gain of color

Multi-color is no color. When many hues clamor for attention, they cancel each other. Color, like money, can easily be squandered. Wasting color in riotous moments of thoughtless abandon, spending it all over the paper, limits its effective power in strategic places. Since color is a loss and gain enterprise, the areas of high chroma usually require larger neighboring areas of lower chroma, where they resonate and glorify each other.

Regulating chroma

Chroma is the degree of intensity of a hue. Chroma may be regulated by: tinting or diluting, adding black or gray, or mixing with other hues. Color may be lowered in chroma by superimposing a transparent layer of a contrasting hue. It is often difficult in transparent watercolor to increase the chroma of previously applied passages. Therefore, make the initial washes higher in chroma (and lower in tone) than the intended effect, for the painted areas will lose in chroma and tone as they dry. The chroma of any painted passage can be lowered or raised through simultaneous contrast, by changing the surrounding passages. Low chroma neighbors increase the apparent chroma of a passage, while high ones will lower it. Simultaneous contrast also affects an area's tone and hue.

A painting with a dominant hue gains in unity and chroma. Paintings which parade multi-color, in one sense, have no color, since juxtaposed bright colors cancel each other, producing optical gray—a gray mixed by the eye rather than on the palette. While an optical gray is livelier than a ready-mixed one, and useful for many effects, its presence should be anticipated. It is often an uninvited guest visiting those who were seeking high chroma. Vary the chromas of any group of hues to create more interest. Visualize chromas as percentages: 0% is low chroma (gray), 50% is mid-chroma, and 100% is high chroma, straight from the tube. Generally, high chroma hues are used in or near the center of interest in small areas. Anyone can paint straight from the tube and anyone can paint in straight mud. It takes skill and knowledge to combine them successfully.

Regulating Hue

Give each painting a dominance of hue. If this dominance is lost during execution, aim for a dominance of warm or cool. The dominant hue should be repeated with variations of tone and chroma. The dominant hue can be varied through the use of different tube colors. If the dominant is a secondary hue, it can be mixed from different primary tube paints. These can be regarded as children from the same parents. Transparent watercolor paint, when diluted with water, remains in a direct hue relationship with the full chroma tube color. Opaque mediums using body white complicate hue/chroma relationship between the undertone and the top-tone.

Regulating tone of color

Each color can be produced in any tone from dark to light. The hue of a color is more quickly lost in the darker tones than in the tints. The addition of black is the most direct, though pedestrian, way to lower the tone of a color. Generally, when a tone is darkened or lightened, take a clue from nature and esthetics, and slightly shift the hue. The tone of a red is best lowered with sepia or burnt umber. Yellow must be darkened with great discrimination. Adding black produces green, while umbers tend to provide brown. Both result in unsatisfactory color. Valuable information is gained by setting up a still life of yellow objects and painting the effect of hue, tone and chroma. Find ways to make olive or other combinations for shades of yellow. Observation furnishes clues.

Students sometimes complain that there is something wrong with a color passage in a painting. The epithet "muddy" is frequently heard. Inspection often reveals that the problem lies with the tone and not the color. A false tone is noticed and is interpreted by the student as a false color.

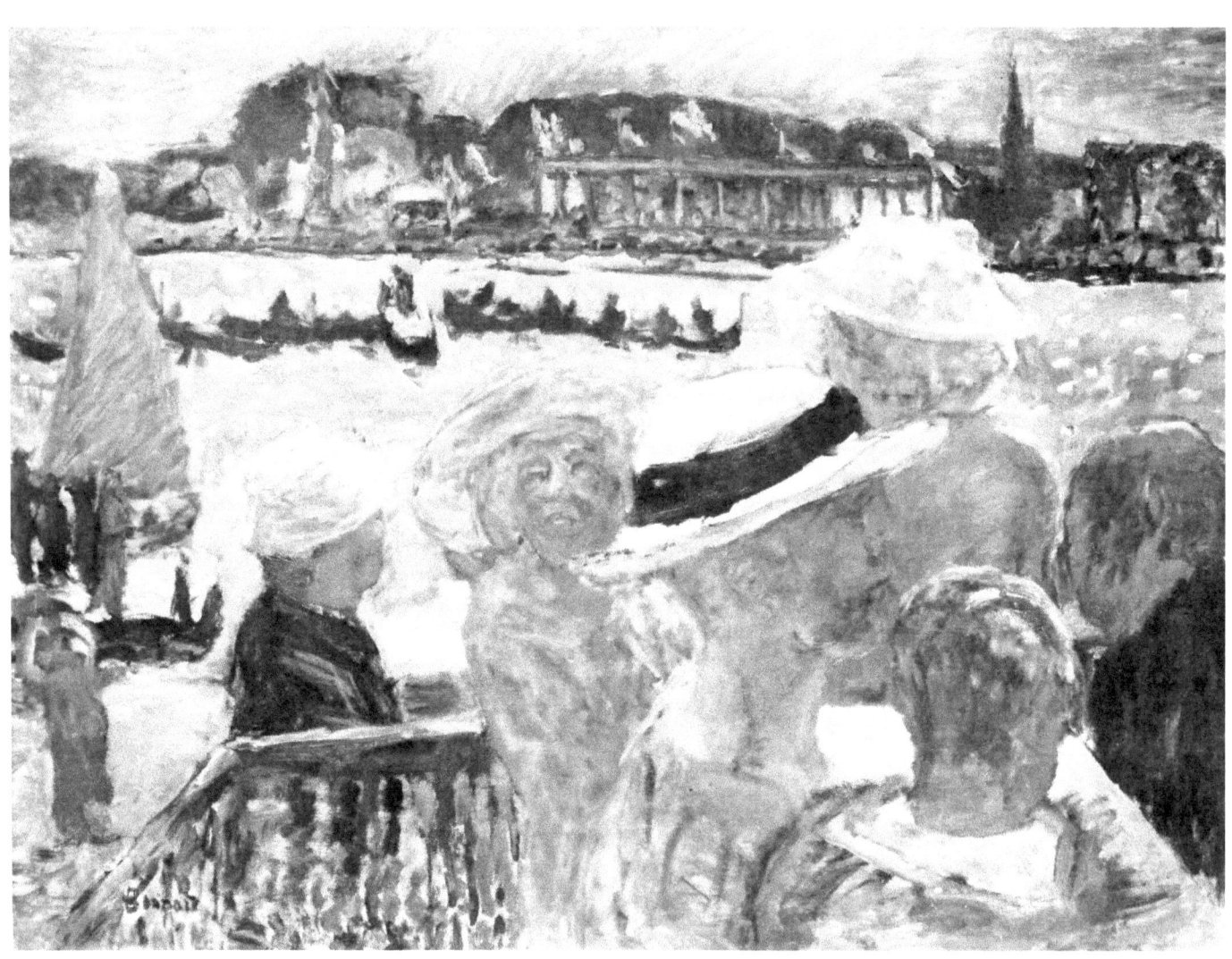

Museum of Art, Carnegie Institute, Pittsburgh
Presented through the generosity of Mrs. Alan M. Scaife, 1963.

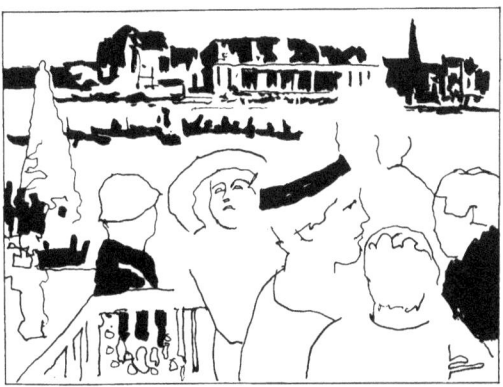

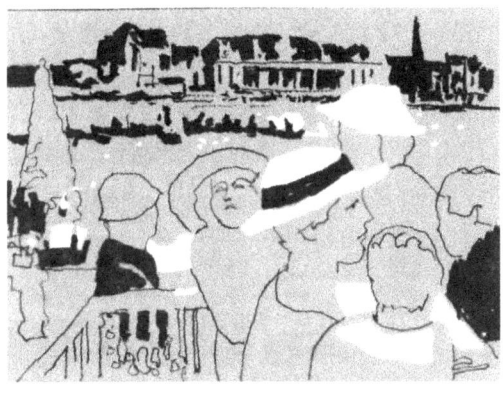

Regatta *by Pierre Bonnard (1867-1947) Oil on canvas, 28 3/4 x 39 1/2 inches.* Though the artist is a noted colorist, this monochrome reproduction proves that the wonderful color effect of the original has a solid tonal foundation. The whites are easily found, various in size, shift and alternate in position, and are directionally oblique, both singly and in the aggregate. The spotted darks across the bottom make an effective foil in relation to the continuous piece of dark across the top. Space is organized into the classic near, middle and far. Modeling and chiaroscuro have been suppressed. The foreground, middleground and sky have been merged into a common midtone, synthesizing flatness and depth. Among all these tones, the black and white hat emerges as the ultimate contrast.

Above and top: The whites as seen against midtone
Above and center: Darks are separated
Above: The simplified pattern in combination

Generally, palette mixtures should be made with the fewest possible agitations of the brush, as though making a tossed salad. Gently fold the colors together, making more of the combinations directly on the paper. Color is always livelier when not churned into mud on the palette. It cannot be appraised on the palette since it can be truly judged only in context with its neighbors on the paper.

Practice

As an alternative to painting with a full palette, I often work with limited combinations. A favorite set of primaries of transparent dye colors is: hansa yellow, alizarin crimson and Prussian blue. Dye paint, because it is clear, provides clean mixtures with little neutralization. These paints bleed freely on wet paper and therefore require control, a keen sense of timing, plus awareness of the amount of charge in the brush and dampness in the paper.

Most watercolor paint is pigmented; that is, made of tiny particles. Pigment paint such as the cadmiums, cobalt, ultramarine and the earth colors are less volatile when put into suspension in a loose wash. They tend toward neutralization when combined. Mixtures of dyes and pigment paint combine the best characteristics of each.

I often paint with a triad of the secondaries: orange, purple and green. This triad makes an interesting and less trite group of hues and chromas which serve as a basis for mixing tertiaries. Green and orange mix to provide citron; purple and orange provide russet; and olive results from the purple/green mixture. Beyond the tertiaries there is little likelihood of holding a spectrum concept or providing names. It is fascinating and rewarding to premix tertiaries and run the color gauntlet with fresh thinking. For this exercise, I exclude all other hues and neutrals, such as the earth colors, Payne's gray and black.

Workers in other mediums are often warned to avoid combining great contrasts of tone with great contrasts of hue, but I believe transparent watercolor extends to accommodate these two contrasts. This is due to gradations and economy of means.

In the presence of a natural motif, it is stimulating to deliberately change all perceived hues to their complements. Since a sketchbook pattern usually provides all the necessary data except color, it encourages the selection of arbitrary color.

I place color on my palette for quick and easy mixes of favorite combinations. I usually charge my brush with colors from two or three wells to provide a slight variation in

hue, chroma and tone. This method is preferable to the mid-palette puddle which transfers paint to the paper as though it were the living room wall.

Personal commentary on color

Naples yellow. Creates a pearly iridescence and gives a bit of substance to tints. It is also the only yellow which in mixture does not turn blue into green. Naturalist painters might find this useful for grading the blue sky into yellow as it approaches the horizon by eliminating the intermediate green. Applied opaquely, it is useful for placing small touches of warm lights into dark passages.

Payne's gray. Good for mixtures. It provides some wonderful dull purples when mixed with alizarin crimson, and low chroma greens when mixed with yellows. In limited warm color schemes it serves well as the coolest color.

Sepia. Lately I have substituted this color for burnt umber because it remains more transparent in mixtures. It is also useful for shading reds and yellows.

Alizarin crimson and phthalo green. Often used as a limited palette. These yield a series of low chroma purples. They also make the richest and most transparent dark available in paint chemistry. This dark can be cooler (more green) or warmer (more red). While anyone can achieve transparency in light tones, it is in the full-bodied midtones and darks that transparency is threatened. When viridian green is substituted for the phthalo green, it has less tinting strength but dries as an interesting sediment wash.

Ultramarine blue. A reddish blue which is the basic blue of the paint palette. It is very useful in mixtures with alizarin crimson for making purples. In modern paint production, ultramarine offers a wide range of blue hues.

Cobalt blue. The primary hue of the color wheel. It is opaque, heavy, expensive, good for mixtures and is somewhat greener than its neighbor, ultramarine.

Cerulean blue. Used full-strength, it is high in tone and bright in chroma. It is opaque, weak in tinting strength, and greener than cobalt. *Manganese blue* is approximately the same hue, but is more transparent.

Phthalo purple. A reaction from the Victorian mauve decades, it seems there is a taboo against purple. Many painters boast of its exclusion from their palettes. It is amusing to read of the art students, of bygone days striving to see purple shadows. Now purple is often denied a place on the palette. It is shunned because it is the color of royalty and passion. Like that other wonderful secondary, green, it is best made by mixture.

Prussian blue and phthalo blue. Both are transparent with a similar hue, and can be used in mixtures with any of the yellows to produce greens. In oil painting, Prussian blue has a very high tinting strength and insinuates itself into every tone on the palette, while in watercolor it loses its chroma as it dries. Tinting strength refers to the color's influence in tints and mixtures, and not merely to its appearance as it comes from the tube.

Ivory black. Good for mixtures with yellows to yield low chroma greens. It is also good for pale grays, and can lower the tone and chroma of most colors with a minimum change of hue. Black has been re-established since the academic impressionism days.

Yellow ochre. A fine earth color of mid-chroma yellow. In watercolor it can serve as a bright yellow until the more powerful cadmiums are hauled in. I think of it as a ready-made tertiary which can be mixed from green and orange (citron).

Indian red. A fine mid-chroma bluish red, which is somewhat opaque. It is useful for mixtures with blues where it produces rich maroons. When this earth color is used by itself, it loses chroma as it dries.

The cadmiums: yellow, orange and red. High chroma and correspondingly high priced. They tend toward opacity when used thickly.

Hansa yellow. A cool transparent lemon color. I use it in mixtures when the more opaque cadmiums might sully a mixture.

New gamboge. A transparent warm yellow. The original gamboge was made from camels' urine. Antiquarians might be amused to know that there once was a paint called "mummy," a fugitive, bituminous color found in ancient Egyptian crypts.

Sap, olive, Hooker's and emerald. These greens find no current slot on my palette.

Earth colors. Useful because they are already neutralized and inexpensive. I occasionally find it challenging to limit my palette to earth colors. When thinking of common earth colors, hold a concept of each color as it relates to the spectrum. Burnt sienna is dark mid-chroma orange, raw umber and raw sienna are mid-chroma yellows, while Indian red, Venetian red, and English red are mid-chroma reds.

In the interest of precise terminology, "shade" always designates a low tone while a high tone is called a "tint." It is a contradiction to talk about a light shade of a color, and it is redundant to speak of a light tint or a dark shade. When painting with these mid-chroma earth colors, new properties of old

familiar colors are encountered. In low chroma schemes, colors of ochre and Indian red will resonate with a new found richness. This is contradictory to their usual benign behavior in relationships with spectrum brights.

Vitalizing color

After establishing a simplified tonal pattern, I might use the following procedure to lay paint into a large area. The area is to be painted green. Rather than mixing a great puddle of green on the palette, I start a wash at one end with a brush full of Prussian blue and raw sienna. To extend the wash I clean the brush somewhat and then dip into black and yellow. Following across the area I charge the various paint strokes with yellow and Payne's gray, orange and phthalo green, ochre and phthalo blue, and so on. The large area has a consistent tone and a dominant hue (green), variations of hue and chroma, make for excitement. The edges of the color patches fuse together, avoiding unnecessary brushing.

Try new colors

Explore the properties of new colors in tints, shades and mixtures. A new color might find a welcome slot on your palette as an addition or as a replacement. It is advisable to omit unnecessary colors in any painting, but maintain as large a palette as required to produce a great variety of simple schemes.

To say to the painter, that nature is to be taken as she is, is to say to the player, that he may sit at the piano. That nature is always right, is an assertion, artistically, as untrue as it is one whose truth is universally taken for granted. Nature is very rarely right, to such an extent even, that it might almost be said that nature is usually wrong: That is to say, the condition of things that shall bring about the perfection of harmony worthy a picture is rare, and not common at all.

. . . Whistler

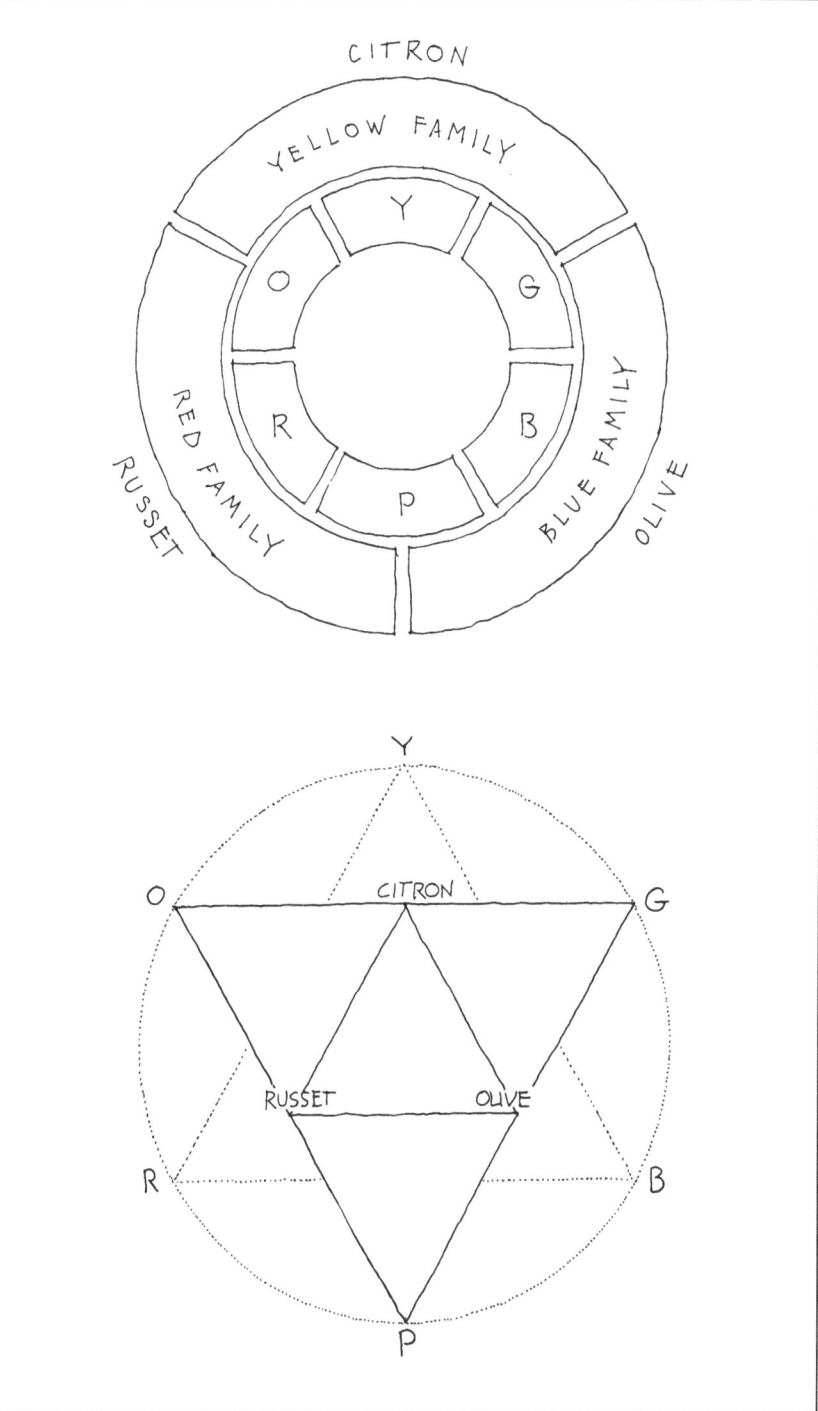

A tertiary concept helps in planning large, low chroma areas minus the use of browns or ready-made grays. It encourages more decisive thinking about color from a spectrum point of view. Citron is made with orange and green; it resembles ochre. Olive is mixed from purple and green—a bluish color bearing little resemblance to military olive drab. Russet is orange combined with purple. Citron, olive and russet are simply low chroma cousins of the primaries.

I think about color a great deal—the intervals between hues and the relationships among them. I am able to concentrate on color as I paint, because I have previously solved problems of design, pattern and tone via a pattern sketch. If required to solve all these at once, I am certain that color quality would suffer. The two most grievous symptoms would be indecisiveness and a stale surface resulting from overwork. Color comes not only through feeling, but by thinking and acting.

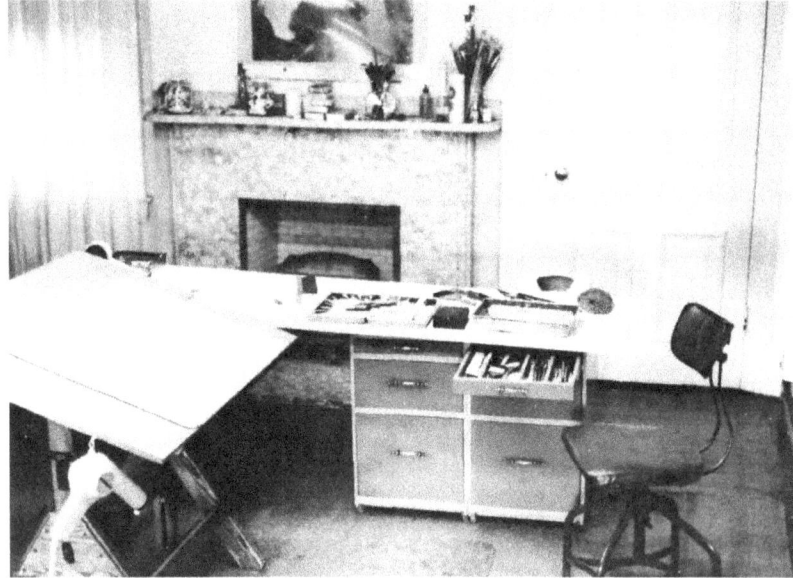

My studio. If right-handed, the tools, paint and water should be placed on the right side. It is surprising to see students sometimes working with a water pan placed on the opposite side of the painting hand. I never sit while painting at the table. I usually place terrycloth toweling over my board and taboret.

3
Materials

To deliberately impose esthetic qualities and relations on a surface, the artist uses instruments and materials. The artist's love for paint, paper and brushes adds another facet to those love affairs called works of art. As John Marin said, "Give the instruments a chance—their sounds are quite beautiful."

Studio space

Contrive a personal space in which to work. This provides a great incentive toward production. Also it is comforting to know that work-in-progress remains just as it was at the end of the previous painting session. The studio does not have to be an elaborate, sky-lit, Bohemian, atelier; nor is it necessary for such premises to serve as sites for conducted tours. A very important requirement in the painter-studio relationship is that the artist have privacy and immediate access to the needed tools, materials and resources.

I stand at a drafting table which has an adjustable top. The palette, brushes, water pan and other tools are to my right, at a suitable height for easy access. For many years, I have used fluorescent lighting with the brand name *CritiColor*. These lamp bulbs are specifically designed to provide full spectrum illumination to evaluate hue, chroma and tone. The fixtures are suspended from the ceiling to the left, right and behind at a sufficient distance to eliminate glare on wet paper. The lights are aimed toward the board so that all angles of reflection bounce away from the eyes.

A large studio mirror furnishes an inexpensive "model" on demand when figure work requires reference. It also serves as a testing device, revealing drawing faults. A small piece of ordinary glass, painted black on one side, serves as a "black mirror." It is useful for a study of light tonal areas in nature or in a drawing. In this mirror, midtones and darks combine into one black, while reflecting only simplified but subtle relationships of lowered light tones.

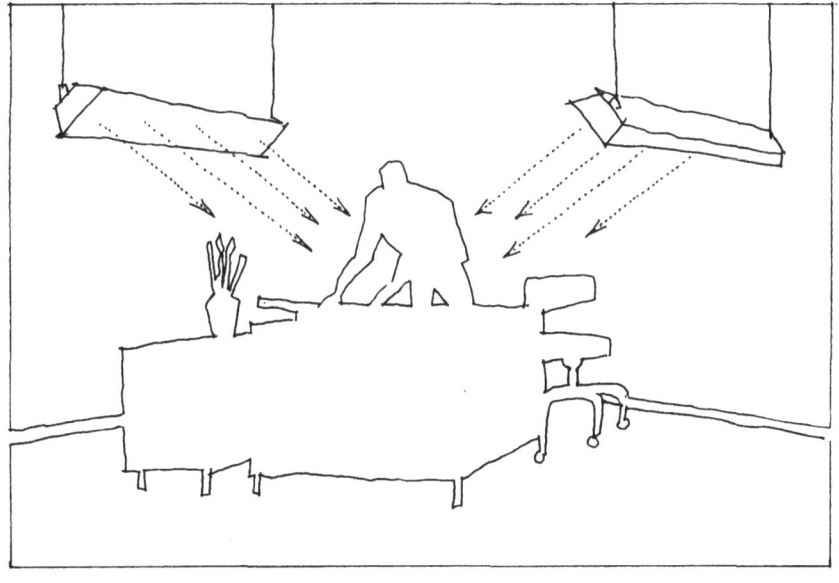

3-inch mottler camels' hair

2-inch mottler synthetic

1 1/2-inch flat synthetic

1-inch flat sable

1-inch aquarelle synthetic

3/4-inch flat sabeline

1/2-inch flat sabeline

No. 6 square lettering sable

No. 4 liner synthetic

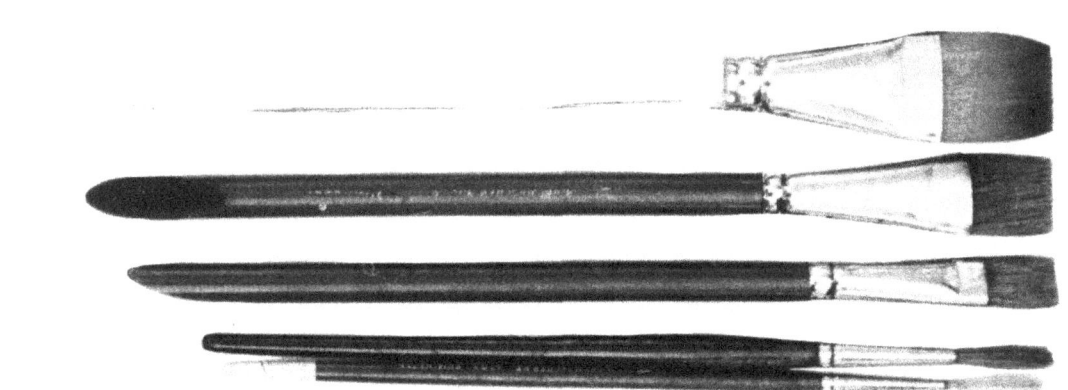

No. 36 round synthetic

No. 8 round sable

Make-it-yourself scriptliner, cut to reduce diameter of hair at ferrule of old pointed brush

No. 4 scriptliner sable

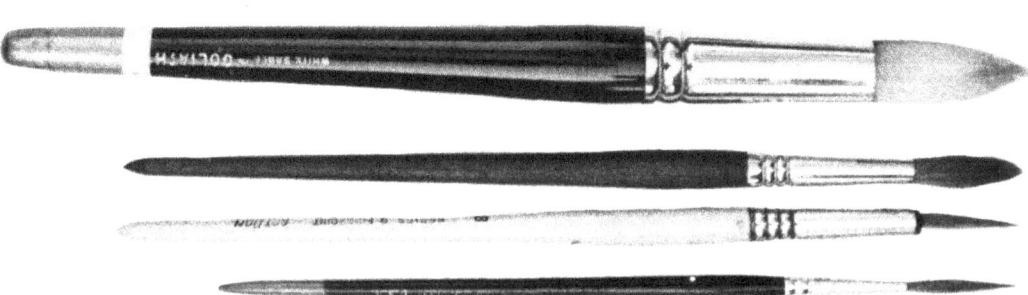

Materials

Do you love brush marks? Do you like the look, feel and smell of paint? Is 100% rag paper a joy to hold and behold? Are you captivated by the names of pigments and enjoy squeezing paint from tubes? Have they found you loitering in the aisles of the artist's materials stores? How could anyone love painting without loving paint?

Brushes

The watercolor student should very early gain an appreciation of two traditions. The first is Oriental brush calligraphy, using the pointed brush to express unlimited nuances of variety, gesture, speed, direction and charge. Oriental masters devote years to learning the strokes.

The other discipline of brushwork is showcard lettering. Though good lettering is scarce, there is usually some good work to be seen in fair to large-sized cities. It is characterized by wonderful abandon without the loss of individual letter characteristics. Inspect and appreciate the articulation and junctures of the strokes. In this age of photo-lettering and rub-down lettering, few art students seriously practice lettering. They do not gain the subtle knowledge of abstract shapes and intervals, which have unlimited variations and relationships in hundreds of fonts.

Almost every artist advises buying the best brushes. The new synthetic hair is a great advance for artists' brushes. Each hair comes to a fine point, whereas earlier synthetic brushes were chopped with blunt tips. I use flat chisel-edged brushes for most of my work. The largest of this type are called "mottlers." I use mottlers in widths of 2 and 3 inches. Unfortunately, the metal ferrules of some brands, despite brass or nickel coating, corrode after a period of use. Try to find brushes with ferrules of copper, brass, nickel or stainless steel. I also use flats of 1-1/2 inch and smaller ones which have round ferrules at their juncture with the handle and gradually flatten as they meet the hair. These ferrules are seamless and made of non-corrosive metal.

Flats or rounds with long hair are more suitable for work on dry paper because of their capacity to carry water. Because of surface tension, the brush with extra long hair often lacks sufficient resilience to deposit paint on dry paper. Brushes of shorter hair are ideal for application on wet paper, where there is no need for the brush to serve as a reservoir. Short haired "aquarelle" brushes are available in widths from 1-inch and smaller. Flat sable brushes are generally unavailable over 1-inch size, due to high cost. Large mottlers are made of camel's hair, squirrel, goat hair, ox hair, black sable, sableline or synthetic. There is a wide Oriental brush called a hake. Oriental pointed brushes are somewhat limp and floppy, but with experience they are responsive and capable of making very sensitive marks.

I own an assortment of small flats down to 1/4-inch size. Smaller yet is my No. 4 long hair square liner or striper. It has a pointed cousin called a scriptliner. These last two are sometimes called riggers—long haired brushes capable of making sensual lines without nervous shakes, and without reloading at every inch along the way. Because of these variables, I have a drawer full of brushes, with only slight differences of stiffness, length of hair, ability to chisel, etc.

hake brush

Paint

Paint is the correct name for the product which comes in tubes. Pigment is a term which applies to dry powders from which paint is made with the addition of a vehicle.

Grades of paint

Many manufacturers offer two grades of quality. Both grades specify "artists' color," though one brand labels its topgrade "finest quality." Little comparative information is offered by manufacturers or teachers concerning these two grades. Most professionals boast of using the finest grade. I concur. However, I noted the following in making comparisons. When using the cheaper grade, the bottom of the water pan showed a considerable amount of sediment after several hours of settling. Thus, this grade contained more inert or coarse particles. Though it had less tinting strength, the paint stayed in place on a wet paper with little bleeding, which resulted in greater control.

It also had a more consistent viscosity and solubility among all the colors. The tinting strength, though weaker, was also more consistent among the complete range of colors, an advantage for the beginner. A consistently heavier viscosity prevented colors from sliding out of their positions when the palette was upset or tilted during travel.

I seldom use the less expensive grade in current practice, but readily admit that in addition to economy, they have some positive properties and characteristics. Permanency is usually not a factor in comparisons of grades, as each is equally permanent. Paint grades, as other options, should be judged in accordance with desired criteria, such as, viscosity, consistency, tinting strength and solubility.

Brands of paint

Each brand has some individual colors and qualities which are lacking in others. As prices increase, fewer dealers will stock complete ranges, brands and grades of paint. The various brands and grades are completely compatible when mixed, since watercolor vehicles undergo no complex chemical transformations. Domestic paint manufacturers have resumed the European practice of occasionally using a proprietary name in lieu of generic nomenclature. I am not enthusiastic about buying "hufnagle blue" or "ajax red."

One brand formulates certain colors with a gooey consistency which creeps across a flat palette. This is only a minor problem for painters who do not travel, or for those who use a palette which traps paint in dippy wells, or those who squeeze fresh at each session.

One solution to the problem of creeping paint involves stiffening the paint with a blast of hot air from a hair drier. This results in a skin forming over the mound of paint which prevents or delays the charging of the brush. This side effect is more annoying than the original problem. For my traveling palette, I usually substitute a brand which does not creep and form a skin. My complaints are minimal, for I believe that artists' materials today are generally excellent.

New colors and brands are tried, after which most are put into a drawer where they wait for a second chance in a scheme with new companions. A few find a semi-permanent home on my palette, opening new doors in color perception.

Permanency

"Artists' color" is the term used on tubes of paint of professional quality. In addition to pigmented paint, artists' color includes dye colors such as alizarin crimson; phthalo blue, green and purple and hansa yellow. These dye (stain) colors are technically called "lakes." A lake is a pigment which has been made by fixing a dye upon an inert base.

Transparency and opacity

Each "artists' color" has a relative degree of transparency. Any of the lakes, such as phthalo blue or green, alizarin crimson, and hansa yellow are obviously quite transparent, as are the stain colors of Prussian blue and gamboge. Pigment colors which are somewhat transparent are viridian, Payne's gray, ivory black, Hooker's green and raw sienna. Most opaque are Naples yellow, Indian red, yellow ochre and cerulean blue. The others run the gamut from transparent to opaque.

Thickness of application has much to do with degree of transparency. A thin diluted application of an opaque paint will be more transparent than a thick layer of transparent paint. Transparency also varies in accordance with the degree of wetness of the paper at the time of application because paint is drawn into a wet paper, while it tends to remain on the surface of a dry one.

A friend paints watercolors using designer color (commercial artists' gouache). Normally these are used in a technique including the use of opaque body color white. A gouache painting can also be made with regular transparent watercolor paint with the addition of white to some or most of the tones. My friend, however, uses designer color without admixture of white. His paintings qualify as transparent watercolors, as their opacity is a relatively slight.

Permanency in paint terminology is relative. Individual colors vary in permanency. Some manufacturers make and identify "fugitive" (non-permanent) colors. Permanency applies to the longevity of paintings which are displayed with reasonable care. Reasonable care excludes exposure in a store window or ten days in an outdoor arts festival where the painting would undergo a bleaching effect of direct sunlight.

Much less permanent are the soluble dyes and inks sold in bottles and as markers. They are seductive in their clarity, bottled convenience and esoteric hues. They are also popular because they do not turn to mud, even when mixed as direct complements. Painters who use these products singly or in combinations with artists' colors, must do so with the understanding that these works have less chance of survival. Make your own test by painting strips of paper with artists' color, and others with liquid dye colors. Place them half-in, half-out of closed books which are then exposed on window sills over a period of time. You will obtain objective, comparative data.

An original work made from artists' color has a paint quality and a tactile presence which graces the paper. The subtle scintillation and radiance coming from within the paint is part of the charm of watercolor. John Marin said, "Give the paint a chance to show itself entirely as paint."

Transparency vs. opacity provides heated debate among watercolorists. Most groups carefully word their specifications when designing a prospectus for a show. Some shows allow aberrations such as collage, opaque and cloth supports, while others accept only "purist" paintings, i.e., transparent watercolor painting on paper, unvarnished and under glass. There are plenty of both kinds. Although I prefer the latter definition for my own works, when viewing the works of others I am more interested in quality than categories of medium, esthetics or technique.

Acrylic watercolor

Acrylic paint is used by many watercolor painters. Insolubility is the most noticeable difference as well as the greatest advantage of acrylics used as watercolor. Because they quickly dry insoluble, they can be painted over immediately with little loss of transparency or previous drawing. When buying acrylics, you get several times as much product for the same money. One wonders why watercolor paint comes in such stingy-sized tubes. Is gum arabic and glycerine more costly than linseed oil or acrylic emulsion? The answer in part is finer grinding.

Since there is a gain or loss in any enterprise, there are only two losses which I notice in acrylics. First, the immediate drying and resulting insolubility prevents or restricts the treatment of edges. This liability can be turned into an asset by modifying the painter's esthetic or technique. The second loss may be the hazard to brush life if the brush is allowed to dry before washing. A high-priced watercolor brush might dry in a few minutes into the likeness of a cap on a ball-point pen. For this reason, many painters use special brushes for work in the acrylics.

Despite exaggerated claims to the contrary, no single medium is better than any other. Each painter welcomes the desired qualities and tolerates the less desired behavior of any medium. Few people care what kind of paint you use or how you apply it. Knowledgeable people will seek to find the message conveyed, the image evoked, or the meaning revealed by your painting.

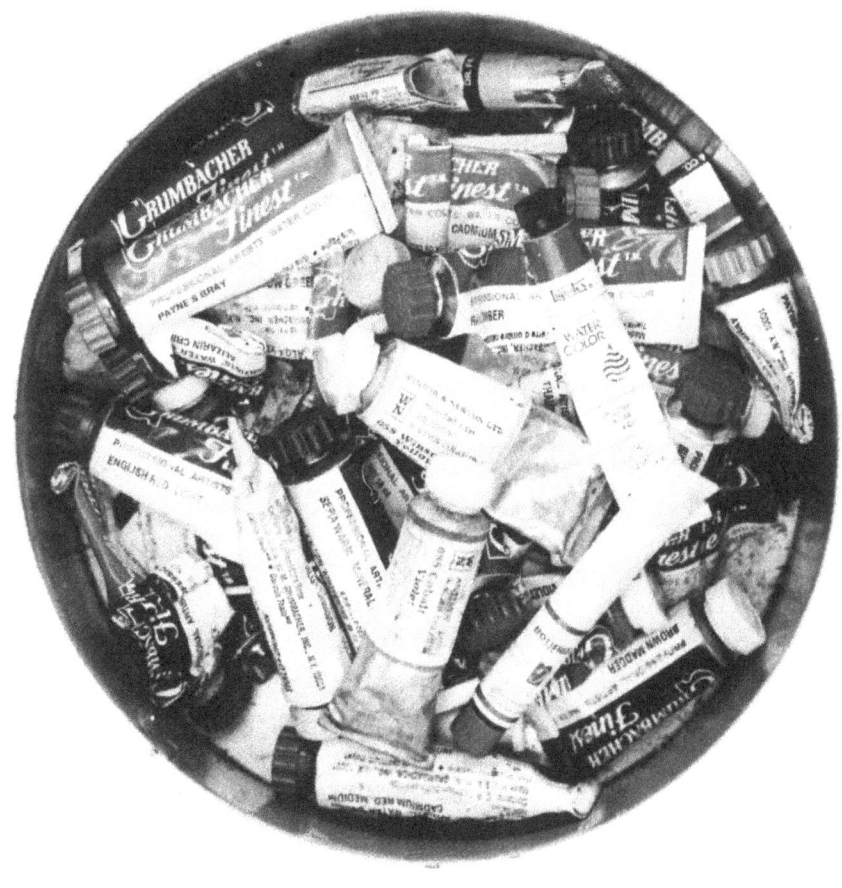

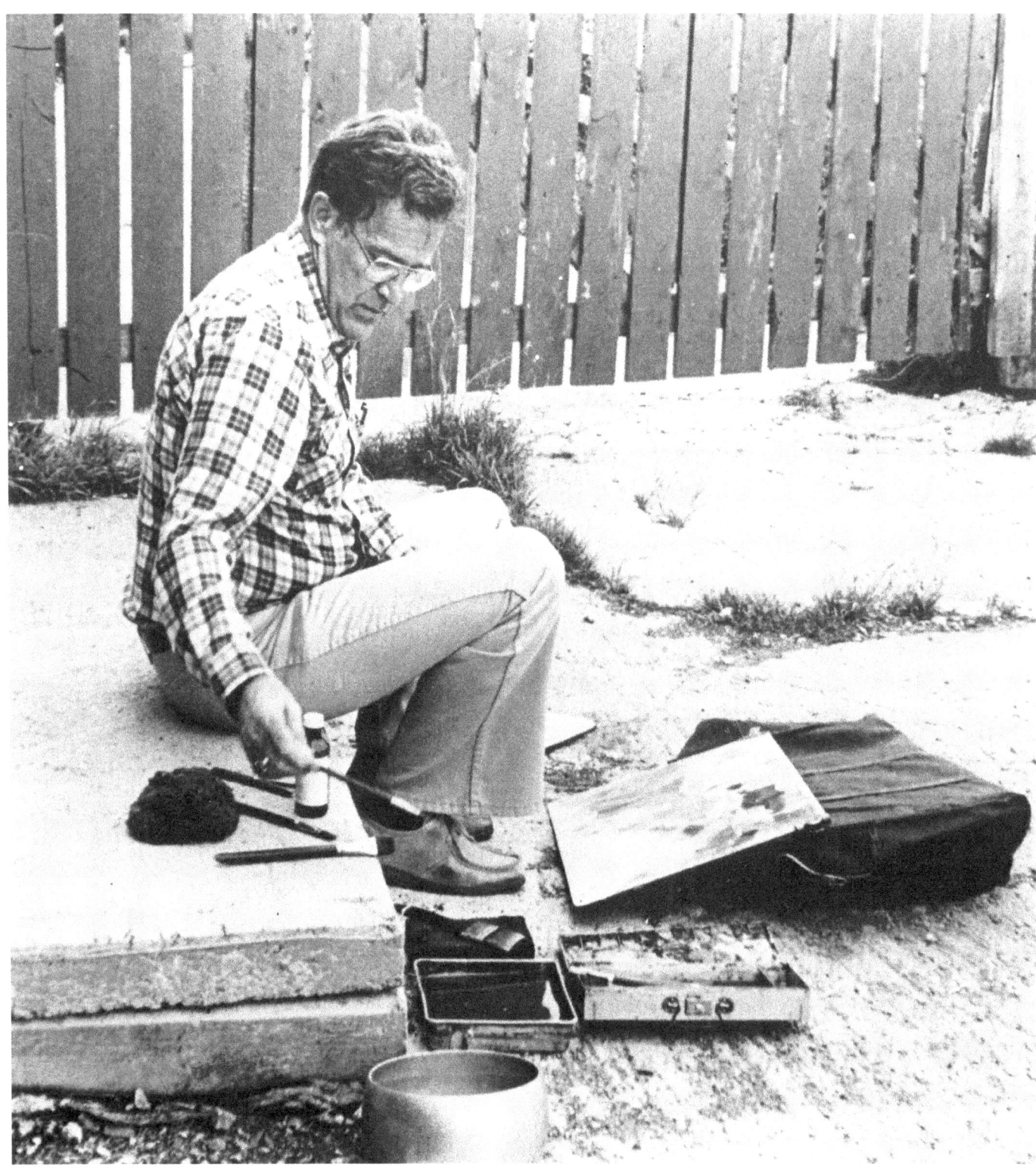

Working on location. This position allows arm's length gestures and enables you to see your work whole. Generally, I sit on a camp stool. The O'Hara paint box is compact as is the cake pan water container. I consolidate equipment for travel by packing brushes, sponges and pencils into a cake pan which has a metal sliding lid. While the small bottle of poison ivy lotion is optional, a spray can of insect repellent is a must.

Palettes

I squeeze paint into slots on a flat palette which can be closed, thereby keeping the color moist for an instant workout. A palette with a flat surface offers the following advantages: the brush can move directly into the paint with a lateral motion; small amounts of paint can be taken with great control; paint can be taken without water when I desire a thicker paste for working on a wet paper. (Remember that when working on a wet paper, the water is already in the paper, so it is not necessary to add water to the surface, lest you lose control.) The flat palette also encourages more mixing on the paper, which increases color minglings and freshness.

Palettes with dams or wells generally slow down brush charging, making the appraisal of the charge less certain, consequently influencing the painter to pre-mix puddles on the palette, and resulting in loss of some color interest.

I arrange my colors from hot to cold, clockwise around the palette. The neutrals and earth colors are kept in a group. Consistent location of color is more advantageous than any single idea of sequence. Awareness of the location of color enables me to find the color quickly, despite the similar appearance of some of the colors. The top tone of some colors is so similar they cannot be recognized until tinted with water (undertone).

My arrangement into habitual sequence is more important than selection of specific colors. I can paint using any painter's hues, but I am frustrated if required to use another's palette with a strange color sequence. The effect can be compared to a pianist finding the keyboard reversed. Tissues serve for quick cleaning of the palette. A fouled palette soon gets out of control and takes over, a usurper to the throne.

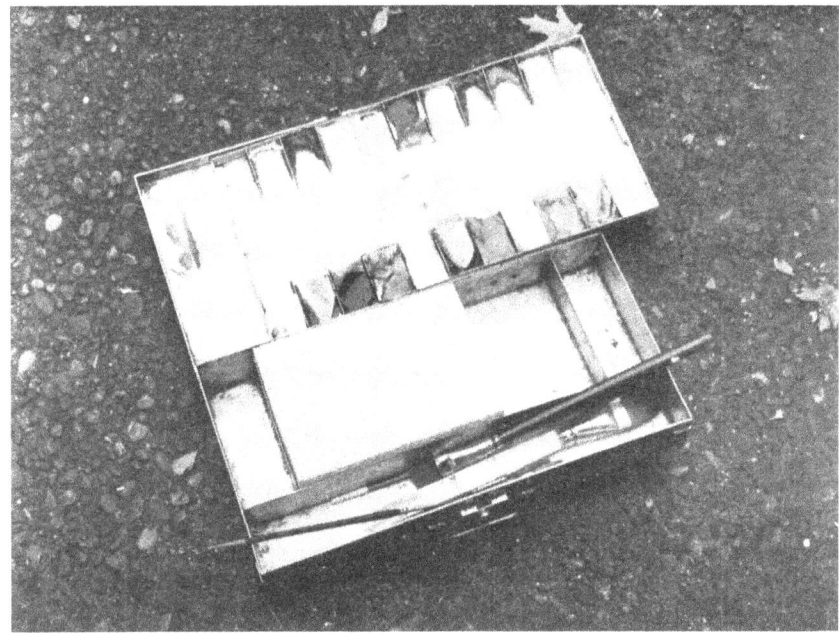

This O'Hara-style box carries brushes and other gear, along with a palette. The life of this white painted metal palette can be quadrupled if you give it several additional coats of white epoxy paint.

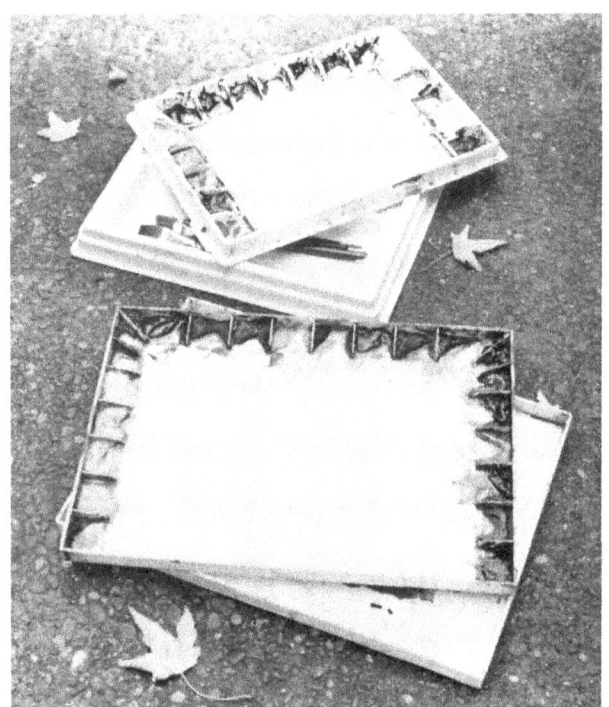

Two plastic palettes which I use in the studio. Both have lids which aid in keeping paint moist. The bottom palette has been modified by removal of the ridges (dams) of plastic which formerly fenced off the color slots. I have also glued additional separators into the corners to hold several more colors.

- Payne's Gray
- Phthalo Purple
- Thio Violet
- Ultramarine Blue
- Phthalo Crimson
- Cobalt Blue
- Prussian Blue
- Phthalo Green
- Cadmium Yellow Deep
- Cadmium Orange
- Hansa Lemon Yellow
- Viridian Green

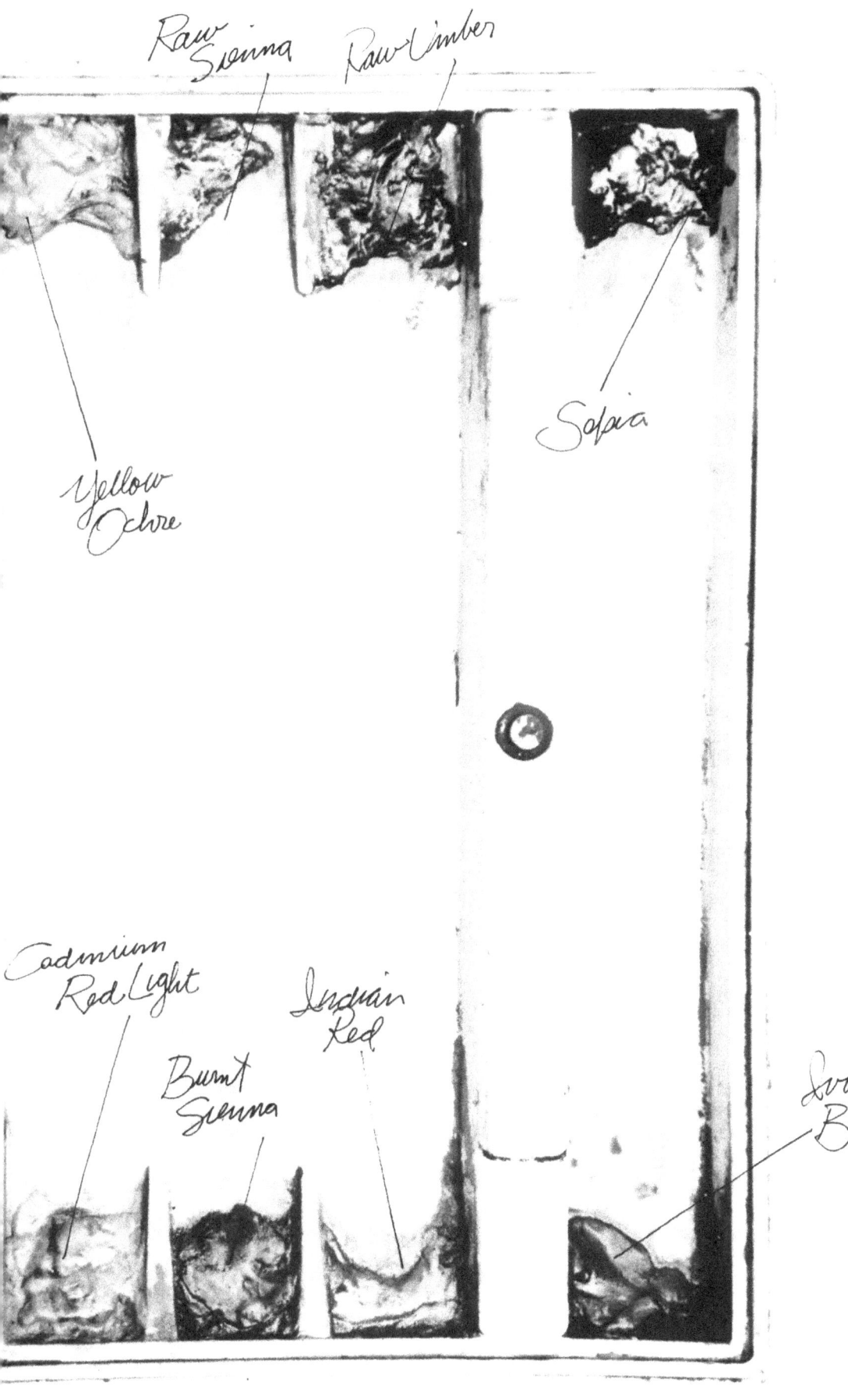

Reproduced 3/4 actual size, this is one of my favorite plastic palettes, which is inexpensive and meets my requirements for flatness. It hinges at center, just as it does in this centerfold, thus closing in the manner of a clam. This model is an off-white color, although I prefer pure white. Watch out for certain brands of paint which will creep when upset. Blast them with the hair dryer, or allow them to cure before traveling.

Paper

The ideal paper is handmade of 100% linen rag pulp. Linen rag is now scarce and handmade items are expensive. There are many fine handmade papers, including the European RWS and Fabriano. The production of handmade paper requires craftsmen who are willing to work at a very boring job; the kind of repeatable operation that a machine should do. A machine, however, cannot duplicate the wonderful irregularity of handmade paper. In machine-made paper, the fibers all lie in a single direction, giving the paper a monotonous surface grain.

My standard paper is 140 pound Arches cold pressed, imperial size 22 x 30 inches. It is mold-made, all rag paper. Mold-made is a compromise between machine-made and handmade papers. It has been produced for the past 80 years. Cylinder—mold or cylinder-vat machines produce mold-made paper with deckle on all four sides, approximating that of a handmade sheet. The machines operate at a slow speed and use a series of mechanical agitators which cause the fibers to interlock in a more casual, multi-directional formation. Liquid sizing is applied after the paper is formed. Individual stacking and drying of sheets also contributes to mold-made paper's similarity to the handmade product.

Certain domestic machine-made drawing papers are superior in some characteristics to other imported mold-made. There is often a disappointment in the use of machine-made watercolor paper, but our mills have made wonderful progress. More and more of the European handmade paper mills are closing.

I recommend experimenting with many brands and grades of paper. I have settled on one brand because of its predictable behavior. Purchase of paper by the ream (500 sheets) greatly reduces sheet cost. Most painters admit that a large supply encourages more painting.

Supporting paper

A hard-board such as 1/8-inch thick Masonite is ideal for the support of paper during painting because it remains free from warp and does not absorb water. An acrylic sheet such as plexiglass can substitute. I cut my board so that it is only 1/4-inch larger than my paper size. This helps prevent water run-backs from coming in at the edges, molesting half-dry washes, and allows metal clips to overlap and fasten the paper to the board at the four corners.

I round off the sharp corners of my board so that it is safer to pack and carry. I seldom use an easel for watercolor painting. In the studio or in the field, I prefer to support my board at a near horizontal angle. In the studio, I stand to paint at a table. In the field, I prefer to sit on a camp stool with the painting board on the ground, propped slightly.

Impedimenta

I possess and occasionally use salt, window screen, sticks, stamping and printing devices, eraser crumbs, soda straws, atomizers, resists, palette knives, rollers, templates, masking liquids, bleaches, collage papers, garden hose, etc. I seek opportunity to use texture as the icing on the cake; but texture can never substitute for tone and pattern in the creating of a design. Some aids which I employ with more regularity are: a hair drier which accelerates drying, erasers, razor blades, kitchen spatula, credit card, sponges, sketch tools and drafting tape. Drafting tape looks like masking tape, but is not quite so sticky when used for masking, and therefore less harmful to paper when being removed.

Whatsoever things are plastic to his hands, those he must remodel into shapes of his own, and the remodeling, however useless it may be, gives him more pleasure than the real thing.

...Will James

4
Method

Convictions of the artist and elements of art constitute the "what" in painting. Having the required materials, the next step is the selection of method. This is the "how" of painting; how the work is dished up. The artist conceives the motif not only in terms of convictions and elements, but also in terms of the glories and limitations of the chosen medium.

Beginning

You become a master of painting by learning how to begin. Do not hesitate to begin again and again and again. If the just right degree of dampness is not there, you will be in trouble. If the big area is not a fine color and shape, you must alter it or wipe out. Tear them up, or work on the flip side if the paper is still presentable.

Make beginnings during cold weather and hot, when excited or bored, when appreciated or not, standing or seated, rich or poor, old or young, married or single, whatever the circumstances. Begin in spite of, and because of, obstacles. Compete, not with others, but with yourself. Seek the character of the action. A good beginning is a design from the start. Works begun poorly cannot be carried far. A work cannot progress from tight to loose, but if begun loosely, may be tightened after it has progressed a certain distance.

There is no one right, technical way to begin. The prerequisite is an emotional involvement. You cannot move the hearts of others unless your heart is moved first. Nothing is created without passion. Objects can be assembled or constructed, but compositions can come only from those who are truly concerned. Make your paintings from love as well as skill.

On one paper, present one major idea. Other ideas require further papers and days. Take subject matter from the backyard and through design and esthetic impulse, give your picture life. Awaken your sense of research and analysis in the hidden structure of things. Entertain them, ponder, savor and marvel. Then you will be able to relate and

Photo by Allen Costoer, Pittstown, N.J.

My Sink *by David Bareford. 18 x 23 inches.* Manufacturers of bathrooms seldom use the word "sink," just as kitchen makers never use the word "stove." I locate this sink subject here rather than the gallery chapter because it has an affinity with watercolor production. Every studio requires a source of water. When you turn the next two pages you will see my bathtub. Bareford's sink is a replica of the sink in my 130-year-old house. The step-like contour at the left is arbitrarily repeated down the right side as a stepped tone. For naturalism's sake, light comes from the left, expressing itself by casting shadow from the spigot and an oblique in the bowl. Unpretentious subject matter like this invokes good humor.

imagine them into existence. Under the spell with the medium and materials comes the import of the work. The beginning is less dependent on the *how* than the *why*. The why is, again, the convictions and the emotional capacity of the artist. A picture is built not by those who can, but by those who will.

The beginning and endings of all human undertakings are untidy, the building of a house, the writing of a novel, the demolition of a bridge and eminently, the finish of a voyage.

. . . Galsworthy

Finish

The degree of finish often brings up the cliché joke about the painter needing to be two persons, one to paint the picture and the other to hit the first over the head when the picture is complete. This indicates that in the opinion of many a quantity of fine paintings are ruined by over-working. I believe that there are even more on the reject pile because they were not well begun. The ideal is to stop when the statement is complete. Know how to begin. Know when to stop.

Overview of the aim

Looking. A sensation. Seeing a piece of nature. Saying, "There is a barn." A present awareness. Eyesight reception. Chaos.

Percept. A perception. It exists. The real seeing is retained in memory. It provides a storehouse of visual data to mull over and ponder, which can later be integrated into concepts.

Concept. Relate to percepts, experience and intentions. Gaining an awareness of it in the totality of personal experience. It becomes axiomatic, and can be held as a scheme in the mind's eye as an integration of similar units.

Execution. A visual statement about experience. Experience is not what happened *to* us but what happened *in* us.

Public appearance. The work becomes separated from the artist by time and space. It enters into a life of its own, to stand or fall, depending upon interested viewers and one buyer.

Preparing paper

Many painters stretch paper. Although a popular and traditional method of paper preparation, I do not think it necessary to devote time to this elaborate procedure.

Dry paper

If your paper is at least 140 pound weight, it can be clipped immediately to the board. Remember to use a board which is close to paper size. Many painters sponge the surface of a dry paper and allow it to dry. This eliminates surface dirt and oily residue, and lessens the extremes of surface tension, making the paper sympathetic to wash running activities. If it is your desire to provide pencil guidelines, put them in after the paper has dried, so that they will not be "fixed" by the water. It is difficult to erase pencil lines which have been fixed to the surface by water. For large washes to appear wet and full-bodied, use sufficient water. Stinginess with water produces dry looking watercolors. Place paper on an inclined board to run a wash. Gravity acts on the wash to form a bead at the bottom. The intended area is covered by advancing this bead across the area and toward the bottom, while adding enough charge to maintain the bead. Do not lose the bead. When the bottom is reached, pick up the bead with a squeezed out brush. The direct and fresh beauty of washes run on dry paper is a result of minimum manipulation.

Wet paper

Saturate the paper front and back with a sponge. Or dunk it into a tub or a river and place it on the board. Then use a squeezed-out sponge to pick up most of the surface water so that you get the desired degree of surface wetness. Experience dictates the amount of water which should be in the brush, relative to the degree of wetness of the paper. Too much water causes a glut of uncontrolled paint. Charge the brush with more tube paint and less water. Paint large midtones first, allowing the whites to remain unpainted. As the paper becomes drier, darker tones and sharper edges can be painted. Delay clipping at corners until midway into execution, when the top corners begin to curl upward from the board. At this point, the paper has stopped swelling and has begun to shrink.

Wetting the surface only

This is practical only if you use a stretched paper, or a thick paper such as 140 pound and heavier. The use of spring clips at the corners provides a means to pull the paper outward, flattening bulges which occur when wet paper swells. Bulges are the inevitable consequence of a wet front and a dry back. Speedy painters are not concerned about bulges, because the painting is usually finished by the time the paper begins to absorb water.

Damp paper

My unique compromise between wet and dry paper. Saturate a paper front and back, put it on a board and place it on the ground or other strong support. Next, tightly roll a terry-cloth towel into a cylinder and roll the surface as if making a pie crust. Roll from the center outward using much pressure and both hands. This forces out excess water, not only from the surface, but also from within and under the paper. The resultant surface behavior is unlike that of others. Yet another variation of this results from re-wetting the surface only, and a pick-up with the damp sponge, or a wait until the shine is gone. Rolled wet paper lies quite flat, as though mounted. The damp paper procedure is practical when you wish to work wet on slow drying days.

Wetting of limited areas

It is a safe, logical method for piecemeal working. Caution: piecemeal working allows inconsistencies to creep into your work, thus losing unity. If a deliberate copy of nature was an aim of art, this procedure would be practical. However, in actual practice the truth of correspondence is gained only with the loss of the truth of coherence.

Re-wetting unfinished works
Top: A dried painting is submerged under an inch of cold water. Most people assume that paint will dissolve and float away from the surface, but that is untrue. Paint will be unaffected except when agitated or scrubbed.
Left: This shows the painting after some areas have been gently sponged. Some tones have been noticeably lightened in preparation for additional work to follow.

Posture

Put movement and rhythm into your strokes. Make gestures from the shoulders, waist, hips and knees. Do not get into the pat-pat habit. Strokes should vary in pressure, speed, length, radii and sizes. Pull, push, stab, flick, whisk, skip, touch and slither. (In painting classes, people can be seen hunched over a table with noses touching paper, holding the brush by the ferrule as though it were a pencil—*terrible*!). Paint large shapes from arm's length, giving gesture and power to them and enabling you to see the painting in total. If your strokes lack verve, try holding the brush by the extreme end. Make some gestures from the shoulder, others from the knees, the feet or, if seated, from the seat. Stand, if you can. Painting is not a cushy activity. Walk back and see your whole work, as Whistler did. The carrying power of the pattern can be evaluated in this way. Run back. See it simply. Make sure your brush strokes are readable. Good posture and generous gestures transmit a sense of life through your strokes.

Posture is influenced by two additional senses beyond the well-known five: *kinesthetic sense*—an awareness of what your bones and muscles are making in the way of gestures. With the concept of the letter "B" in your mind's eye, you can draw it with no hesitation. Your hand can write and make shapes without dependence on the eye; *sense of stasis*—orientation in relation to the vertical. Much of your response to spatial orientation is in relation to this sense. Vision is primarily a means of orientation.

Angle of the Paper

I produce most of my works on paper which is slightly tilted from the horizontal. I prop the top end of my board with a rock, log or my painting bag. Occasionally, it is instructive to work at a paper which is positioned on an easel in a near vertical plane. When working in this position, take gravity into account. There will be some tendency for the paint to collect in a bead and run down in drips. This is not as noticeable or distracting as you might think. The paint dries faster because those little puddles do not collect in the miniature dimples of the paper. Because the relative position of brush and paper is completely altered, gravity is no longer responsible for pulling paint from the brush. An advantage of this method is the possibility to walk back quickly to view the work. An easel might be a problem on windy days. Transporting, setting up and taking down an easel restricts the painter's mobility.

Photo by H. Poller

Workshop demonstration in Antigonish, Nova Scotia

Cos House *15 x 22 inches.*

Approach

Big tone approach

This can be done on wet or dry paper. The concept here is a big pattern. Choose three to seven large areas and do not go forth until these big tones are as well related as possible. These large tones should be wedged together and their intervals should be well separated into at least three broad areas. The danger of the big tone approach is that it can slip into an academic habit of following habitual schema with little variation.

Direct painting

Patch against patch on wet or dry. As Charles Hawthorne said, "Painting is putting one spot of color against another." It proceeds in an additive way. The danger here is that the large areas in such works might not be well related. Synonyms for this method are: Alla prima and premier coup. It is trying to put the last coat on first. Think of Frans Hals and John Singer Sargent.

Hard edge

An easy to understand, though challenging approach. The shapes or colors must carry the interest which is lacking in the variety of edges. Without soft edges, the parts tend to remain isolated. Intensification of the remaining qualities require a great deal of artistry to compensate for the missing interest. See the paintings of Stuart Davis. The recent interest in masking tape and opaque flat painting exemplifies hard edge. This paint stops the eye with its opaque "thereness," no light from within; not a logical approach for watercolor.

Flat approach

This approach relinquishes gradation of tone and color. Therefore, flat posterized pieces must be made into wonderful shapes. Intensified color substitutes for gradation in helping to replace missing drama and limited spatial effects. The adjective "decorative" is associated with flat painting. The glory of successful flat painting is the glory of great posters. Collectors have been hoarding these for esthetic as well as documentary reasons. Posters and flat paintings are noticed because they read well. They also are noticed because they are in contrast to the real world. They are abstracted, to a degree away from realism. Transparent watercolor, intrinsically produces gradation; therefore, the medium seldom is used to paint totally flat shapes. It can be done, in the manner of the English school of wash-running. Giotto was a master of flat painting.

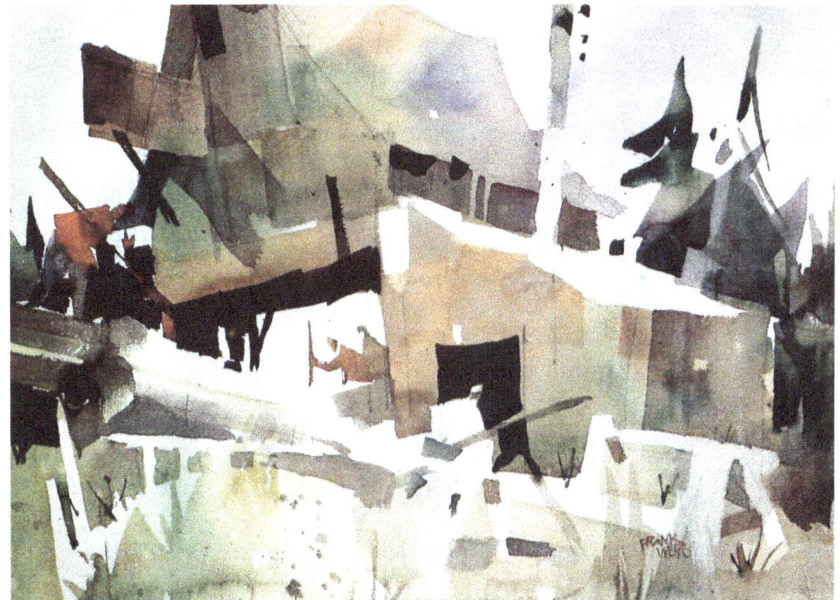

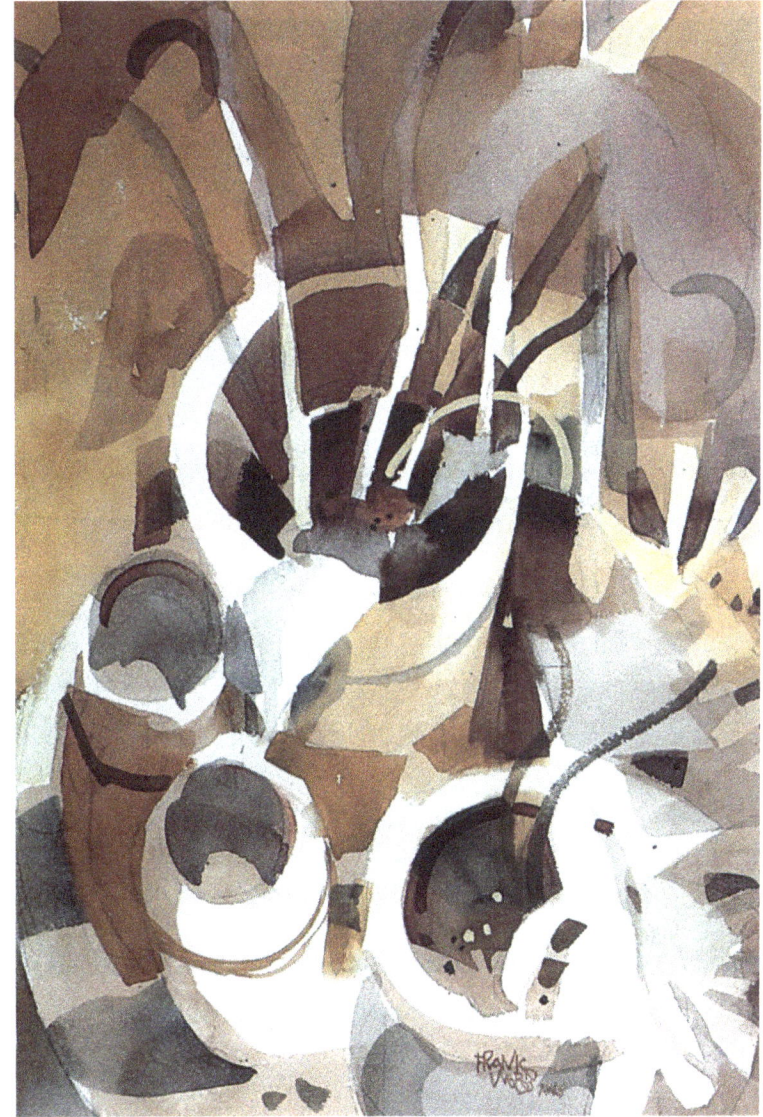

Above, and top: **Dover Sawmill** *15 x 22 inches.* Hard edge—a result of painting on dry paper.

Opposite page, below: Direct painting of Barbara Webb from life, using ordinary ballpoint pen and simple flat washes. A minimum statement aiming for character through silhouette and gesture.

Right: **Potluck** *22 x 15 inches.*
Flat shapes are employed. Openings of the pots are made circular rather than the usual oval, thus producing flatness because they are parallel to the picture plane.

Soft approach

Sometimes called "wet into wet." It is a logical way to achieve soft transitions in watercolor. Its beauty is its obvious exploitation of the medium's wetness. The fusions and gradations of tones and colors result in the freshest and most beautiful surface in all visual art. Technically, the danger is that the painter might be enraptured by such beauty and stop short of forging a complete pictorial statement. A bonus of this method is the variety which comes from a combination of edge qualities. The hard edge dramatizes the softnesses and vice versa. This approach can also be made more beautiful with a counterpoint of rich calligraphy. Woven in and among the tones of soft edges, calligraphy helps suggest edges not furnished by tone. Tones can be limited to partial statements in the manner of Raoul Dufy and Lyonel Feininger. Sometimes called "open color," a soft approach with calligraphy allows for passage and circulation, and ties areas of open tone to the surface. I usually advise students not to use line for edge if a tonal edge already exists, for this is redundant. If you must add such a contour line, place it "off-register," i.e., do not place it exactly at the edge of the tone.

Glazing

The best uses of overpainting or glazing results from a deliberate intention rather than a corrective one. Despite this, corrections can also be produced by glazing. One of the glories of glazing is the declaration of transparency. A superimposed wash creates a synthesis of color and tone where two tones are crossed. These crossed tones and colors are "optically presented," an effect which cannot be matched by one layer. Bitonality in watercolor produces polytonality.

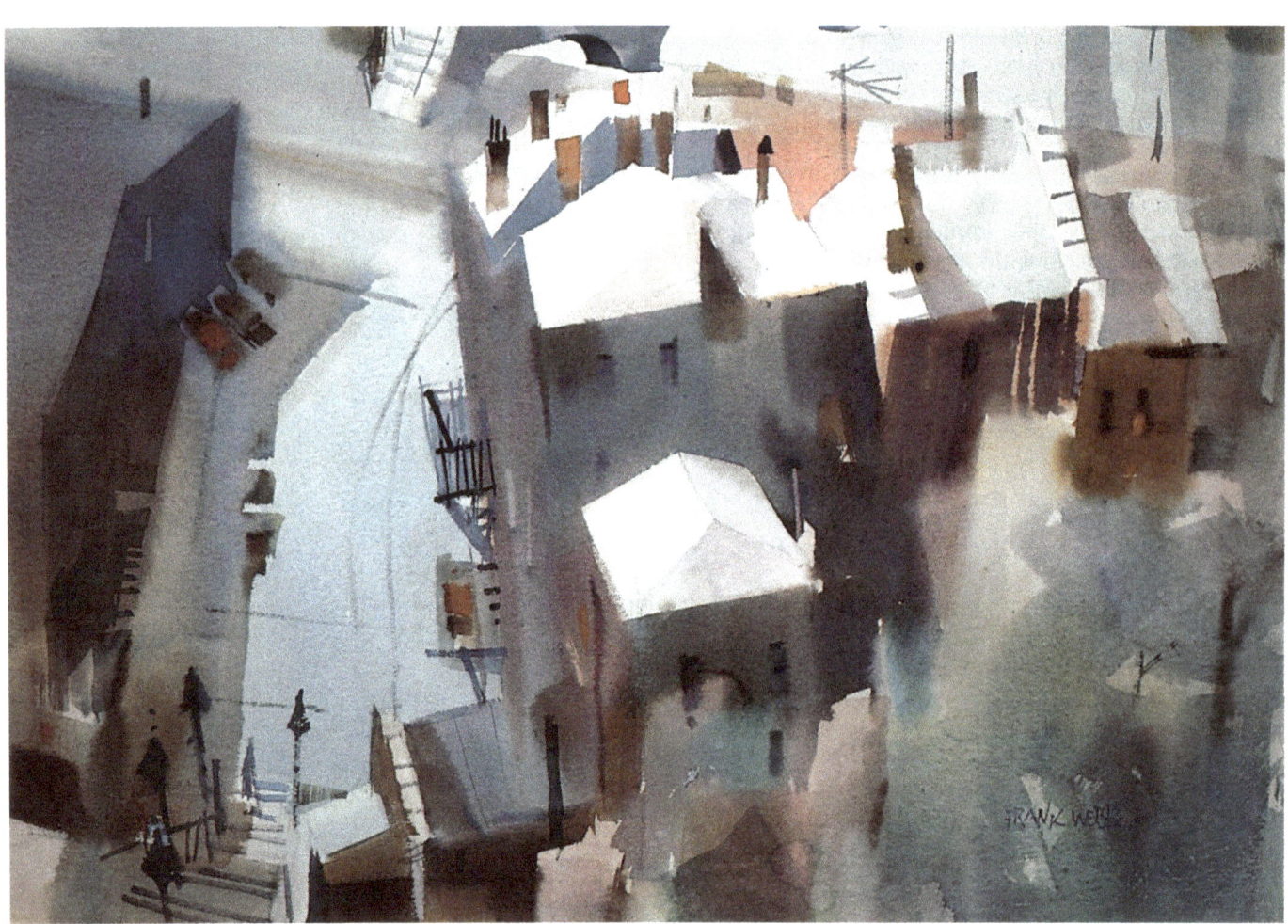

Galena From Stairtop *22 x 30 inches*

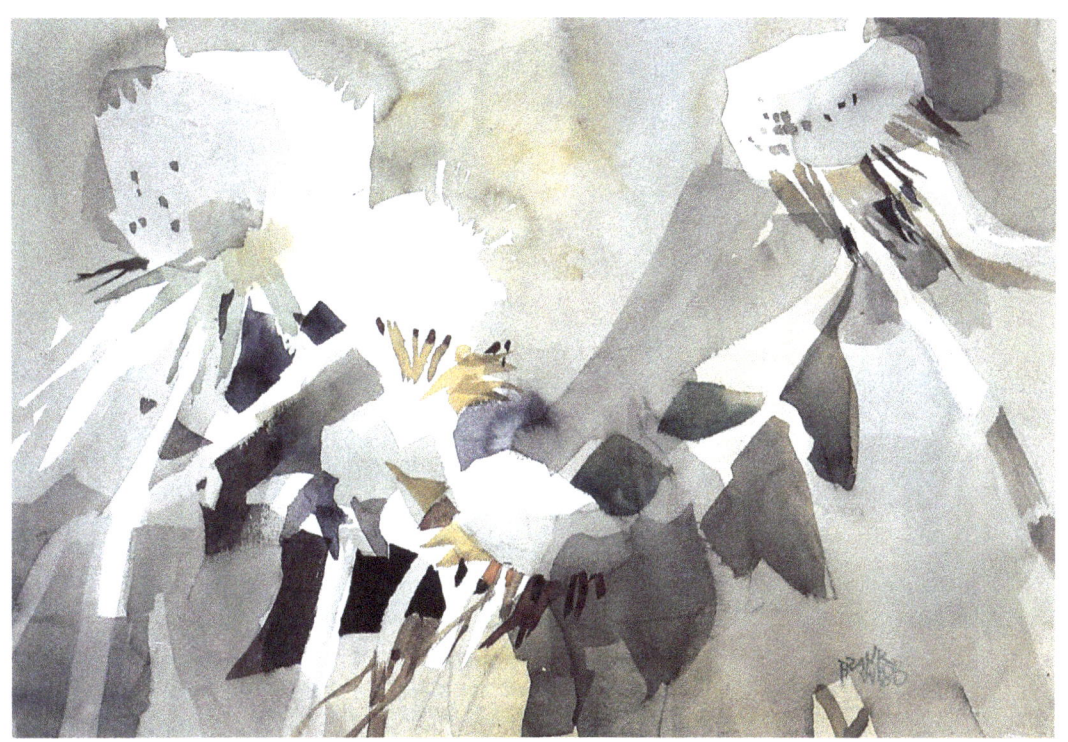

Above: **Stems and Seeds** *15 x 22 inches.*
This floral uses the glazing method.

Below: **Here's Lookin' at You, Kid** *15 x 22 inches.*
A soft approach logically expresses the essence of flowers.

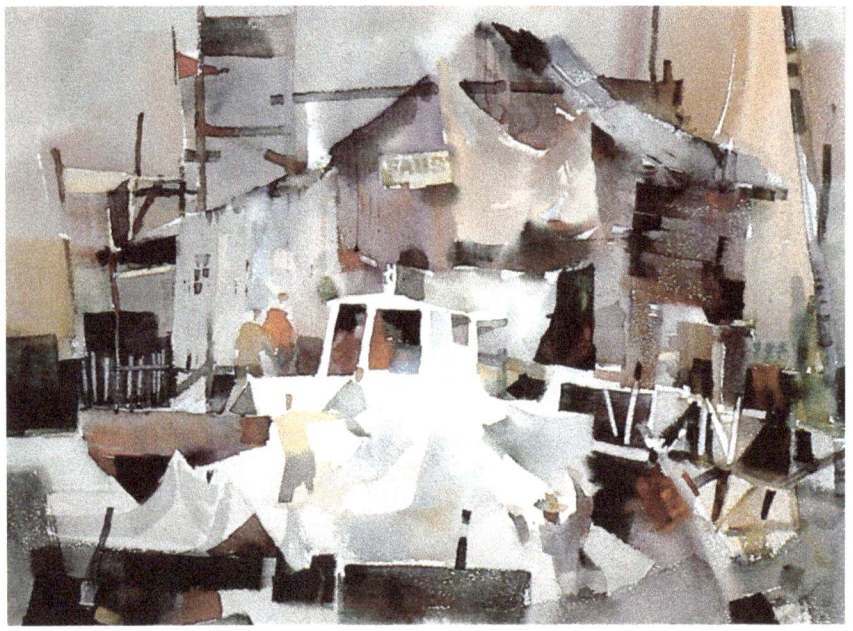

River Marina *22 x 30 inches.*
If a subject is as busy as a marina, it is logical to use a busy approach, i.e., incidents all over the paper. This is not to encourage chaos, for even here you can find the whites and darks within the midtone. I have included tarpaulins which provide the opportunity to extend the white and play some people shapes against it.

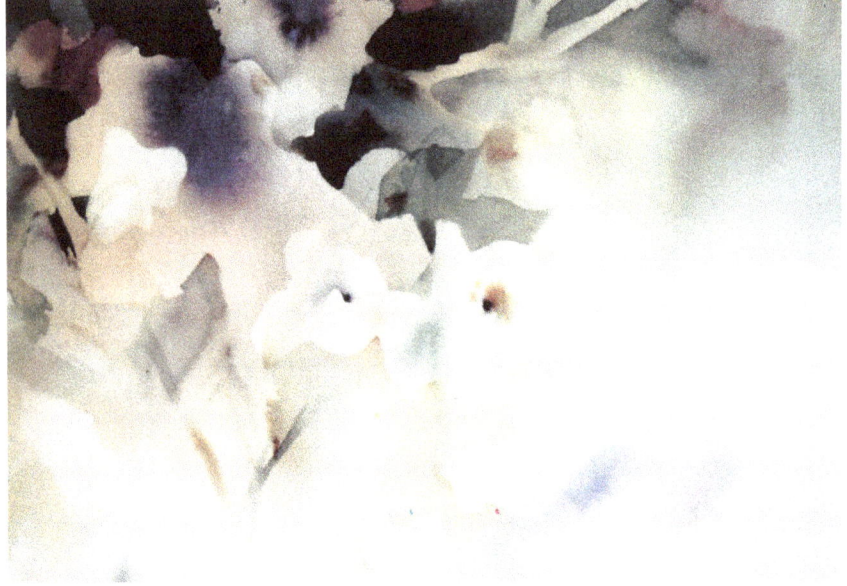

Flowers, Seen and Unseen *15 x 22 inches.*
Soft imprimatura was applied abstractly, with no particular reference to final intention. All edges of the imprimitura were correctly softened by the pre-wet paper, and all tones are lighter than midtone except for the few mushy areas of thicker dark paint placed at top left. After the paper dried, glazes discreetly established hard edges, though many of these edges are instantly flooded away with clear water. A soft effect has resulted with just enough hard edge to make the soft ones more interesting.

Busy approach

The all-over pattern. The entire field of the picture is checkered with contrasts. It is at once decorative in the manner of an activated plane. A mosaic comes to mind, recalling the works of Maurice Prendergast. Pointillism superficially bears a resemblance with its little touches. However, impressionist works are not examples of formal spacial effects, but are results of naturalist aims. The busy approach produces simultaneity of the field, minimizing the visual in favor of the tactile. To the extent that the busy approach is visual, it emphasizes the two-dimensional. When compared with other works, this mosaic gives off energy which, in comparison, makes other works seem uneventful. The danger in this busy approach is unresolved relationships of large areas. When relationships of the parts to the whole are secondary or non-existent, the result is not a work of art, despite the degree of skill or craft which it might parade. We see totally and we appreciate totally in that total seeing. If someone compliments you on a part of your painting, be aware that you have been insulted.

Imprimatura

This approach uses a thin layer of stain color underpainting. It can be simply an all-over color tone, or it can be soft edged shapes. The imprimatura can relate directly, partially or may not relate at all to the shapes, tones, directions, sizes, lines, textures and colors which will follow. Even when planning to coincide exactly with the overpainting, the imprimatura should generally have soft edges, allowing for final considerations and readjustment of edges and drawing during overpainting.

The imprimatura should be no darker than midtone.

Advantages of imprimatura:
1. Variation in the whites.
2. Optical tone and color.
3. Promotes abstract qualities. (Optical color is the synthesis made by the eye which sees one color under the other. It is unlike any single layer.)
4. Soft under and hard over make a rich counterpoint.

Scrub-out as a corrective

Scrubbed out passages are best accomplished with a genuine sponge. Areas may be scrubbed in a general area, that is, with soft, irregular edges. Edges can be reestablished later during repainting. Limited small, hard edged areas can be masked around with tape, then sponged. Masks can also be made from simple bond paper cut-outs. It is important to use a clean sponge with plenty of clean water, changing the water as needed and washing the sponge after each wipe. Another method involves dunking the entire work into a tub, brushing or sponging the offensive area while the paper is submerged in the cool bath. Scrubbed out areas usually retain residual tone. These will be less obvious when repainted.

Scrub-out for optical effect of tone and color.

I often scrub-out old paintings and paint totally new subjects on the lightened tones. It helps to invert the paper so that the old subject is upside down. The possibility of a ghostly image (*pentimento*) adds interest. In this discussion, I am not including the scrub-out of fresh passages. That kind of scrubbing is an important corrective or editing procedure, but because such fresh tones may be removed entirely, they need not be discussed here. Areas of partially dry paint are always unpredictable. Wait for them to dry. Better, decide immediately they are unsuitable, and gently scrub them away while wet. When editing with the scrub-out method, allow the area to dry before overpainting. If scrubbing out large passages or entire papers, do not give the paper such a beating that the public sees the evidence. After a too vigorous scrub, the sizing is gone from the paper. In this condition, a paper behaves like a blotter. The mutilated surface no longer receives paint sympathetically and limits further operations.

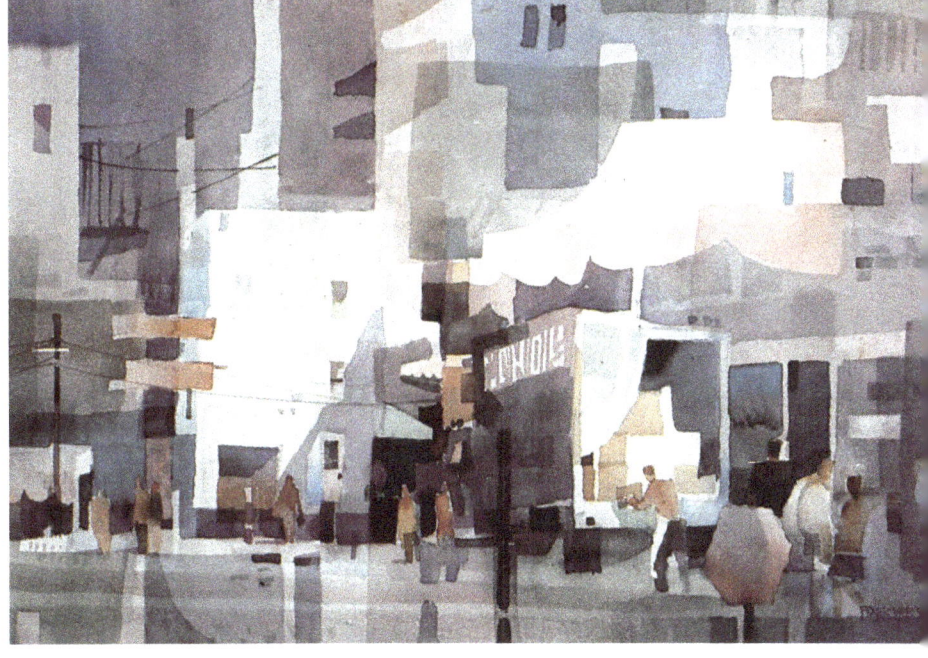

Oyster House *15 x 22 inches*. Private collection. This reproduction cannot reveal the increased optical interest of color resulting from glazing, but its tonal effects are apparent. The painting initially failed. It was allowed to dry and then partially scrubbed with a sponge and plenty of clear water. Transparent glazes were imposed with little or no effort to duplicate earlier edges and shapes. On the contrary, these glazed shapes were staggered and shifted. Earlier tone and color still plays a role, but in a more complex harmony which is somewhat closer to abstract. Thus this job is not a "merely" realistic picture.

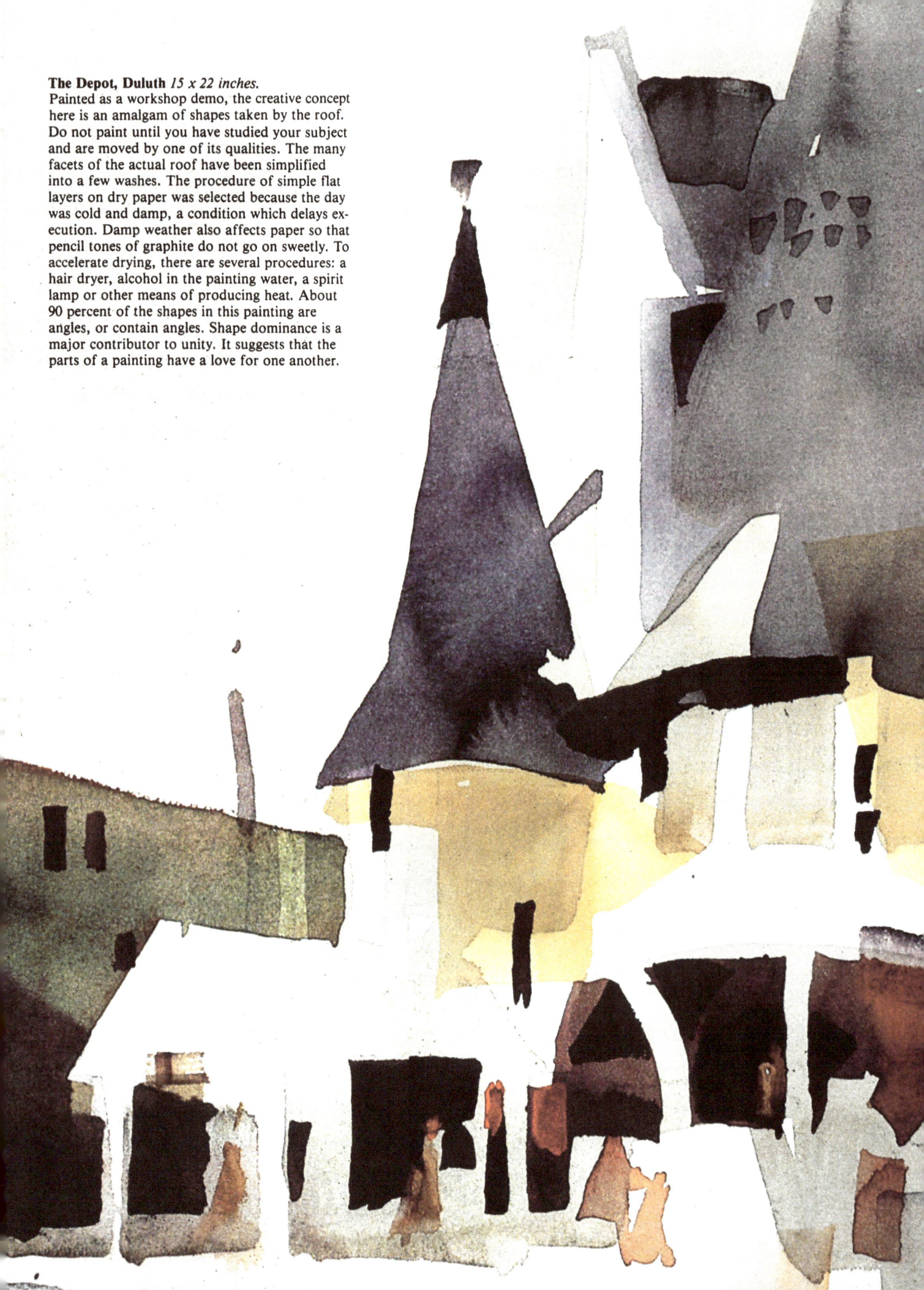

The Depot, Duluth *15 x 22 inches.*
Painted as a workshop demo, the creative concept here is an amalgam of shapes taken by the roof. Do not paint until you have studied your subject and are moved by one of its qualities. The many facets of the actual roof have been simplified into a few washes. The procedure of simple flat layers on dry paper was selected because the day was cold and damp, a condition which delays execution. Damp weather also affects paper so that pencil tones of graphite do not go on sweetly. To accelerate drying, there are several procedures: a hair dryer, alcohol in the painting water, a spirit lamp or other means of producing heat. About 90 percent of the shapes in this painting are angles, or contain angles. Shape dominance is a major contributor to unity. It suggests that the parts of a painting have a love for one another.

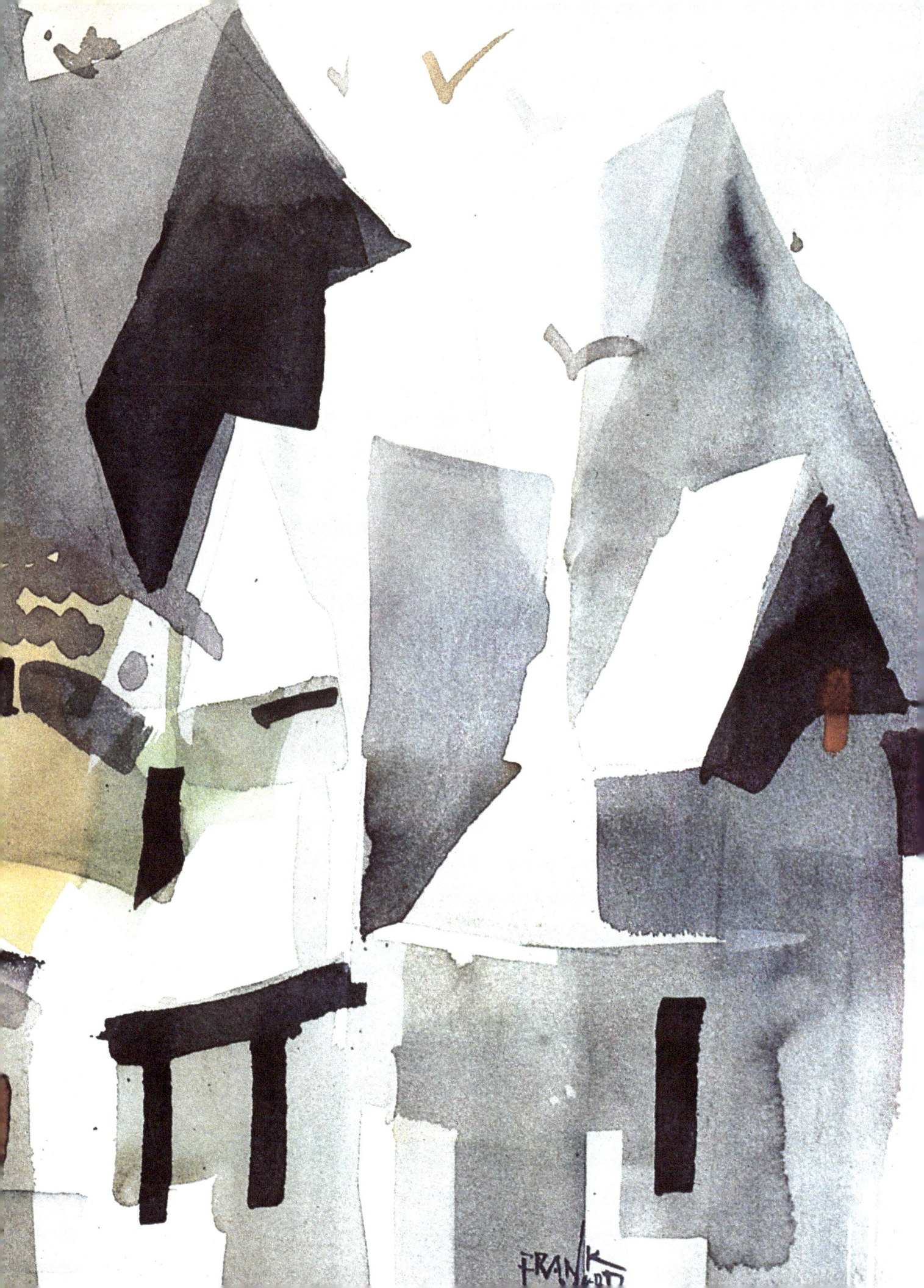

Calligraphic approach

Effects of brush line calligraphy are exemplified in the works of Charles Burchfield, a result of his close contact with nature. An example of abstract calligraphy is the iconography of Franz Kline. Calligraphy is closely related to the busy approach, but the marks of calligraphy are directly made marks, giving evidence of the tool used.

Direct marks have a beauty of their own. Good handwriting and lettering are the epitome of calligraphic beauty. The artist is not alive in you if you have not been thrilled by such marks. In lettering, a distinction is made between built-up letters and those directly drawn. Built-ups are outlined, then filled in. If all of the shapes in a painting are built-up shapes, they will be less forceful, lacking emotional content. Flat brushes, round brushes, pens, quills, ink-sticks or other tools are all capable of making characteristic direct marks. The width of a flat brush makes a definite sized mark, width varies by the direction taken by the tool and the angle at which it is held. The marks of the broad pen (chisel-edge) are similar to the effects of the flat brush.

We must find out what the brush wants to do, what the specific shapes the brush can produce. Letter forms offer a wonderful learning experience. However, most of us are *too busy*. Only a few of us are even aware that an Oriental master spends a lifetime on this quest.

An esthetic comparison can be made between paintings which attempt to paint "things" as things, and works which use calligraphic symbols and signs to "say" things. The former is addressed to the eyes, while the latter is addressed to the mind as well. Calligraphic mark-making requires a will, a pattern and knowledge. The end of knowledge is action. You cannot act until you know.

Contemporary photo-realist painters attempt to remove all evidence of brushwork. Disdain of handwriting, a *sine qua non* of Renaissance painters, reappeared during the 19th century, and has been again resuscitated for purposes of surpassing photographic slickness. Photo realism is the antithesis of brush calligraphy.

Calligraphic scribal writing is a good exercise for the painting student. Appreciation, followed by knowledge and practice, will add beauty to the marks in your painting. For example, see the foreground in Edgar Whitney's painting on page 104.

Four reasons to employ calligraphy:
1. Define contour.
2. Bridge across, or tie areas together.
3. Enliven inexpressive areas.
4. Maintain the essential flatness of the picture plane.

Nature speaks in symbols and in signs.
 ...Whittier

Brush drill using newspaper classified ads for guidelines. The top row of circles is made of functional strokes, i.e., the flat brush is held at a constant angle of about 30 degrees during the two curved strokes. The second row of circles is made with a brush which is twirled while the curved strokes are made. This is called a controlled stroke.

Opposite page and above:
Alphabets *by Arnold Bank.*
One of our most distinguished calligraphers creates many fonts, each an individual work of art. His works are exhibited internationally in prestigious museums. A half-century of Bauhaus influence may have suppressed calligraphy, but its appreciation and study have resumed and the demand for it is brisk.

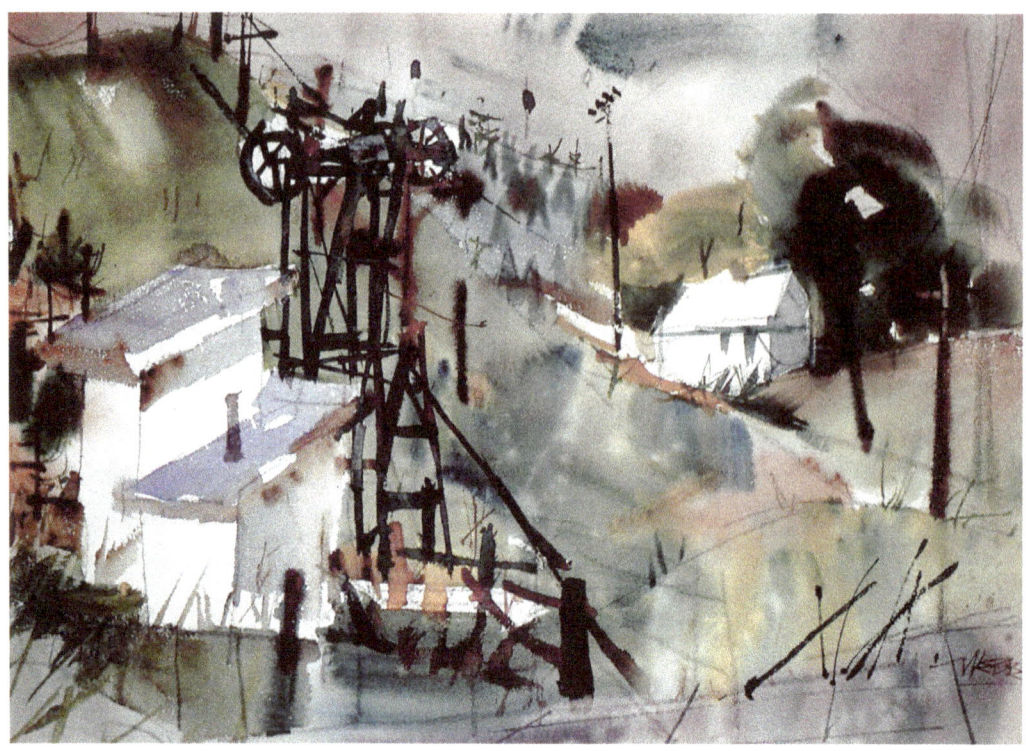

Summer Ski Lift *15 x 22 inches.*
Calligraphic lace not only decorates this surface, but expresses the essence of machinery. Painted with a round (pointed) brush.

Casting a shadow across areas of a painting to preview effects of darker toned glazes.

Editing

If a painting has failed to become a work of art, it may be edited the same day or 20 years later. Bring unresolved areas into conformity by scrubbing false tones. Glazing other areas into darker tones will prove fruitful. To preview these and other color and tonal changes, cut pieces of color and tone from old magazines with a single-edged razor blade, and place on the painting. When the desired effect is achieved, lift each and modify the painting beneath.

Another way to preview tonal changes is to place the painting in sunlight. When it is not available, use a single spotlight. A shadow can then be cast over areas which are selected for darkening. Paper cutouts, your hand, or any object can be used to project the required shape. Under sunlight, the size of the cast shadow remains constant despite distance, although the edge will soften as distance increases. Under artificial light, the size of the cast shadow may be regulated by varying the object's distance from the painting. This same procedure can be used to preview the addition of light on your painting. On a large paper which shades the entire painting, make a cut-out shape through which light will pass onto the painting.

Sequence of procedures

Most watercolor painters work from light tones toward the dark when most of the color interest and tone modulations are featured in the light and midtones. Many landscape subjects are best shown within this range. This sequence is exemplified in the works of the English school, where successive glazes are painted. The sequence of light to dark is most practical for painting wet on wet where the large midtones are painted first while the paper is wet, and the darks later when the paper is partially dry. When the painting's interest is to be featured in the darks, it is logical to work from dark to light on a dry paper. Small rivers of white untouched paper can be left between areas of dark, to be filled in later. Working from dark to light has a danger, for it is difficult to get variety in the midtones. By the time the painter reaches the whites, they may be false and unrelated. A good general approach is to start with the large midtones, saving the whites, and placing some of the darks which might profit from soft edges. This simultaneous apprehension of the entire picture field is a practical and modern way to advance the painting all over, at one time. It insures unity.

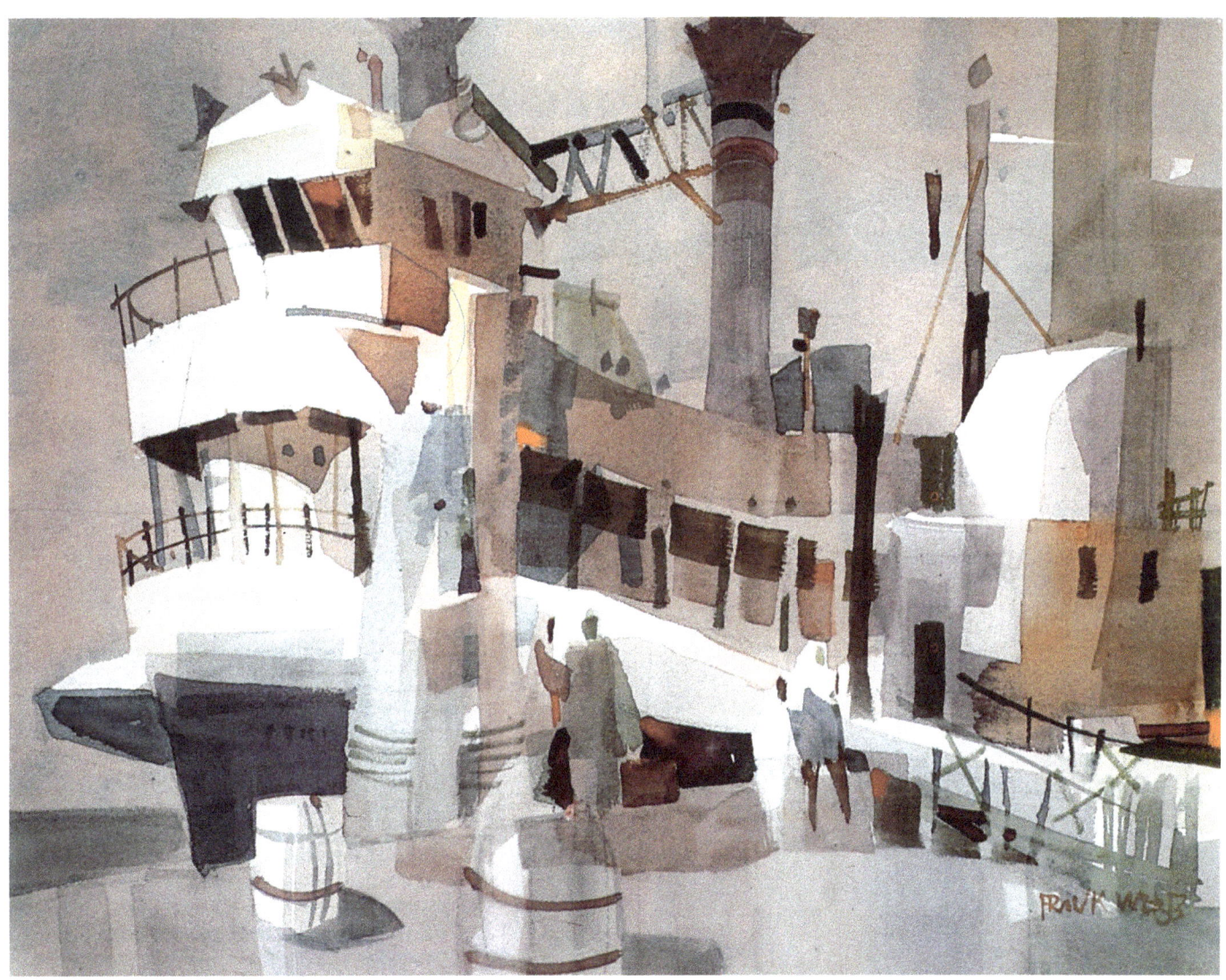

Annapolis Excursion *15 x 22 inches*

Penfield Farm *15 x 22 inches.*
Edge details from this work are exhibited below and on the opposite page

Soft edge detail of tree

Edges

The three kinds of edges which can be given painted shapes are hard, soft and rough brushed. There are naturalist and abstract reasons to treat edges.

Soft edges are useful to express softness in nature, as in surf, clouds, foliage, fur and grass. Soften edges for the following design reasons:

1. Soften edges between similar tones to dramatize hard edges elsewhere.
2. Soften the edge of a curved surface as it turns away from the frontal plane, much the same as the turn of a cheek, or the crest of a hill.
3. Where two shapes cross, soften the edge of the more distant shape to push it behind the hard edge of the nearer one.
4. Soften some edges arbitrarily to contrive variety among other kinds of edges.
5. Soften edges to supply passage and atmosphere. Even the mindless camera varies edges when the lens adjustment is set to limit the depth of field.

Hard edges usually indicate things "in focus." Sharpness can be moderated by combination with softness when it is too insistent. It can be deemphasized where desired, without resort to softening, by decreasing tonal or color contrast of adjacent areas. Make a slight gradation on either side of the dividing edge, grading one toward the other, to reduce contrast at their juncture. Thus the hard edge is retained while "edginess" is abated.

Rough edges express texture in such things as forest, rocks and tree bark. They also create esthetic variety and interest in paintings. Rough edges must be painted on a dry, or nearly dry paper. Roughness can be suggested by scraping an edge of a dry passage with a single-edged razor blade. Beware of losing the wet look through the use of too many dry passages and rough edges.

Give shapes the appropriate edge to express the subject. For instance, water should look wet. Using roughness to express the glitter of light or foam on water contradicts the essential wetness of water. Rough edges are significant as a partial statement for areas of rough texture. If a forest shape is given a rough edge, the entire tone is interpreted as a forest, with the viewer supplying the millions of leaves via the imagination. In short, what the edge does, the whole shape does. This significance applies not only to edges of things, but also to edges of shade and shadow on things.

Rough edges are painted in three ways:
1. A dry brush, which is the most familiar.
2. A fast moving brush, which desposits paint roughly because its resilient hair does not have sufficient time to make contact with the valleys of the paper.
3. A brush held flat, with the hair parallel to paper, thereby depositing paint on the tops of the miniscule mounds of paper.

Of the three methods of rough brushing, only the dry brush gives the dry look.

To get variety in edges, make a soft, wet start, with soft edges. Any amount of hard edges can be added later. Although it is very difficult to begin with hard edges and attempt to soften them after they have dried, there is a method of softening a hard edge while the wash is fresh and wet. A brush wet with clear water (but not flooded) is used to treat the edge, forming a small gradation on the edge of the wet shape.

Movement in a painting is established, in part, by edge treatment. Hard edges stop the eye, while soft edges set up circulation. For the sake of esthetic interest, deliberately impose all three qualities of edge in a painting. Make one edge quality dominant around each shape and one dominant throughout the entire painting.

Hard edge detail of barn roof

Rough edge detail of tree

Charging the brush

Each loading of the brush requires consideration of the following:

Tone	Size of stroke
Hue	Speed of stroke
Chroma	Viscosity of paint
Amount of paint	Direction
Shape	Texture
Line	Paint's affinity with paper

Finally, consider the paint stroke's relationship to previous and subsequent strokes.

The brush can be charged and then regulated by flicking the brush while holding it at arm's length; a habit which may be domestically or socially unacceptable. Instead, the brush can be pulled between two fingers to remove a partial amount of charge. My method is to touch the brush on a damp cellulose sponge. A brush is usually rinsed between chargings. There is also a method of loading when the charge is kept, but modified after one or several strokes. Load the brush, partially cover the area, then without a rinse, add a bit of water and another color, slightly modifying the initial charge. This encourages gradation of hue, tone and chroma, and establishes color dominance. With the paint actually mixed on the paper, color is more exciting than a pre-mix from the palette. A charged brush should always touch the paper gently. Allow gravity and hydraulics to do the job of spreading paint. These effects will surpass any manipulations made by the painter.

All good and genuine draftsmen draw according to the picture inscribed in their minds, and not according to nature.
. . . Baudelaire

5
Design

The mind's eye must find boundaries for handling data. A line establishes a boundary. Emotion has limits, and a lifetime has an end. Pictures have limits, as do the walls on which they hang. Within the boundaries of a two-dimensional paper, design is the deliberate man-made relationships among the elements and intervals. Surprises heighten anticipation along the way. The work of art is an intentional re-creation in accordance with convictions.

Design is not just a pleasing arrangement, nor is it simply an ornament applied to the surfaces of things which are ready-made. Design is not merely rules, although many an artist refers to them as such. Design principles are operative in life as actualities. Design grows (organically) out of action and gesture. Design is necessary to bring your subject into art existence and action. It is a fiat of the imagination. Design principles are presented here as verbs because they act.

Visual language

The phenomenal world must be translated into the language of paint, which has its own idiom and syntax. The designer uses this language to make visual statements. Although it is very limited in vocabulary, the language has unlimited syntax. There are only seven

NOUNS:
 shapes lines
 tones textures
 directions colors
 sizes

Every single graphic mark, or combinations of marks, is one or more of these seven nouns.

Verbs bring life and action to nouns. In the linguistics of visual art, there are only eight
VERBS:
 unify alternate
 contrast gradate
 dominate harmonize
 repeat balance

Nouns and verbs combine to give meaning to art works. Without knowledge of visual linguistics, visual noise can be produced, but who could decipher its meaning?

Definitions

Unify (v.). To make into a unit. To consolidate by causing each of the nouns to dominate. Contrast must be present to create interest, but a dominance must resolve any equalities. There is no place for equalities among the parts of a painting: a good painting is full of wonderful inequalities. Unity is the single most important esthetic quality in art. When unity has been gained, nothing can be added or taken away; the work is indivisible. The German word, *gestalt*, expresses this unity, a unified physical, psychological or symbolic configuration which has properties that are more than the sum of the parts. The parts are irreducible. When a work is unified, it is distinctive from any other work in the world, past, present and future. It is a total unit, complete, able to stand without appeal to any outside source. It is consistent in its degree of realism or abstraction.

Contrast (v.) To set in opposition in order to show or emphasize differences when compared. Contrast intensifies, energizes and otherwise creates interest. Interest is as necessary to art as it is to life. Interest in politics is created by opposing parties and ideas. It is the antidote to boredom. No one takes brush in hand to deliberately produce a boring painting. For instance, contrast can be established between the various tones on a paper. Without that contrast, the picture will be invisible. Any mark made on a paper provides a contrast of tone. When making a second mark, many more contrasts are set up among the other nouns, i.e., size, direction, texture, line, shape and color. Easily made contrasts just as easily lead to chaos, the opposite of boredom, which must be limited in a given scheme. Contrast is regulated with the next VERB.

Dominate (v.) Rule by superior force. To occupy the superior position. The designer should contrive a dominance of contrast which results in unity. Think of the muscles of the human body. When an instruction is sent from the brain for the arm to move, certain arm muscles contract, while others relax. If all the muscles contract or relax at the same time, the arm will be immobilized. Action toward purpose can result only from dominance of one entity and the subordination of others. Without a dominance there can be no unity. Dominance eliminates regularities and leads to the pleasing arrangement of irregularities.

Repeat (v.) To state again. Repetitions are echoes, parallels, and similarities necessary for the integration of elements. Just as nouns are repeated with slightly different adjectives to avoid regularity and boredom, it is necessary to vary the thematic repeats (theme and variations). Examples of monotonous, perfect, visual repeats include the piano keyboard, the picket fence and machine-made products. Perfect repetition is the aim of mechanical industry. To achieve irregularities, vary repeats in size, direction, tone, color, texture, line and shape. Repetitions require critical evaluation and adjustment. This regulation is, in part, made with understanding of the next VERB.

Alternate (v.) To occur in successive turns. Happening or following in turns, succeeding each other continuously. These occurrences should be irregular. Alternation among tones, such as black (B) and white (W), can be shown typographically thus: BWBWBWBWBWBW, a perfectly mechanical reciprocity. A more interesting alternation is suggested by: BWBWWWWWBWWB. And even more interest is added with unequal sized intervals: BBWB...BW..... WWWWBW. Beyond these limited examples are possibilities ad infinitum, which come during creative production. Any NOUN sequence can be alternated.

Balance (v.) To bring into, or maintain a state of equilibrium. Balance supplies a means to weigh visual forces. The usual graphic diagram of a balancing beam over a fulcrum is familiar, but is limited to two-dimensional forces. A more demanding and sophisticated appraisal of weight requires balance of volumes in the third-dimensional space. Perfect balance of identical or equal elements which might differ only in size is easily made, but a sense of life and action comes from balancing unequal or equivalent elements. Equivalents are equal in effect, if not in substance. For instance, movement across a plane can be balanced with a tone, color, texture or any other visual contrast.

Harmonize (v.) To bring into agreement. For instance, circles and ovals are in harmony because they are shapes having little contrast. Colors are harmonious when they are near neighbors on the color wheel. All-over harmony lacks interest. A contrast must be introduced. Note: the quality of harmony cannot replace unity. Unity must be the result of introducing contrast, with a subsequent resolution via dominance.

Gradate (v.) To pass imperceptibly from one degree of tone, hue, size, chroma, direction, shape or line to another. Life is full of gradation, e.g., young to old, night to day, small to large, ignorance to knowledge. Gradation indicates a sense of time to the spatial arts. It is a decrease or an increase of contrasts between two NOUNS, providing incident without fanfare, and preventing large areas from becoming inexpressive or dead.

Benefits of design

Calendars, clocks, budgets, buses and businesses designate regular intervals in the world of time. Spatial relationships also require regulation. People cannot live with too much regulation, nor can they live in chaos. Balance is needed in life just as design is required in visual art. Design uses parallels, repetitions, rhythms and all other means through which bonds are fashioned among parts. Designers paint ideas and relationships, not things.

Whenever a comparison can be made, there is the possibility of better or worse. The principles and the language of design equip the artist to make critical evaluations during the act of painting, and after completion.

Art comes from artists, not a system of rules. The artist makes judgements by deduction and induction. It is important to remember that the principles used by the artist are servants. Rules serve the artist, the artist does not serve rules. Rules of themselves will not create a work of art.

If design is one side of a coin, the other side is spontaneity. Art requires both. One artist begins from chaos and works toward order, while another starts with order and allows chance to appear during the act of painting. It is necessary to combine the two opposites, freedom and restraint, without the loss of either.

Though design is tied to deliberate intentions, the artist cannot completely predict the meaning before the work is made. The meaning is discovered, entertained and realized during the act and the completion of the work. The work is specifically true to itself; but this does not suspend standards of artistic truth any more than the irresponsibilities of some artists can be justified by the cant phrase, "individual freedom." All knowledge of all influences, standards and histories which have found their way into awareness come to culmination in making esthetic judgements.

In my own work and in the appreciation of others' works, I have a preference for logical structure. I enjoy being able to discern the principles and quasi-absolutes which underlie any enterprise. I would rather *will* than *react*. I argue in favor of intentions, causes and values. I reject reactionary and passive philosophies along with mysticism, materialism, skepticism, irrationalism and routine dissent.

Freedom in design

I favor intentions because I wish to be free to produce on demand. As a professional, I take charge of the esthetic situation on my paper, admit the need for, and welcome fresh impressions. Beyond paper much happens in life without my contribution, so when I act, it is in cooperation with or by approval of others. I must wait in line at the bank and post office, and pay taxes for complicated systems of external power. However, in painting, I do not require exemption from external influence to be free. Freedom comes from taking charge, and exercising my esthetic options. Color is my color, shape, my shape. In fact, the total relationships of all the elements, subject matter and technique are entirely mine. That is the fun of art. When a group of people make a decision, they form a committee, take a vote and find a consensus.

The seven NOUNS and eight VERBS total only 15 words. At face value, they seem to provide an impoverished language. Nevertheless, combinations and possibilities are limited only by the imagination. The alphabet of the written language spawns unlimited freedom in verbal expression. The alphabet of visual language extends unlimited freedom in creating images.

Early Greeks wanted to know *what there is* (metaphysics). Later philosophy included a category of epistemology. This is the study of *how we know what there is*. The epistemology of visual art is design. Design furnishes a norm which enables us to know and to state how and why we know. This makes us critics, before, during and after the heat of creation.

A painting is a thing which requires as much cunning, rascality and viciousness as the perpetration of a crime.

 ...Degas

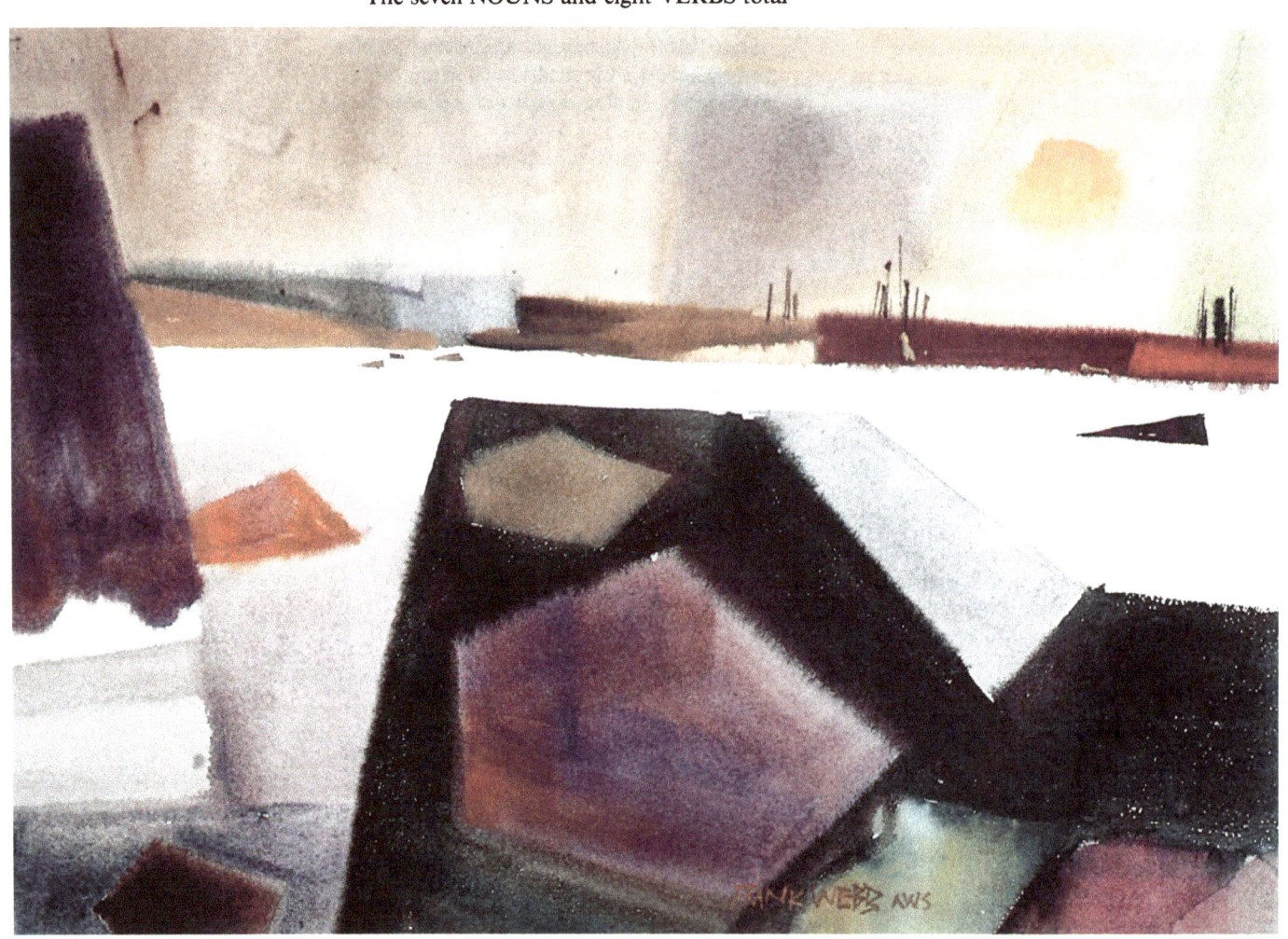

Maine Rocks *15 x 22 inches.*

Left:
Turtle Creek *22 x 30 inches.*

Below:
Watching Market Square
22 x 30 inches

Interior With Women *by Edouard Vuillard, (1868-1940) oil on canvas, 22 1/2 x 24 inches.*

This monochrome reproduction clearly reveals a clarity of statement resulting from tonal organization. Larger areas of midtone provide a chassis which carries smaller areas of dark and light. The spots of larger white with smaller darks are shifting and alternating in size and location. The center of interest is created by the tonal contrast, human interest and an eye-catching lacey device of the dark chair which interlocks pieces of white. The plane of the floor has been tipped downward while the table shape has probably been tipped upward and twisted counterclockwise toward the viewer. Organization of sizes in this painting is less impressive, as the six large areas are equally sized.

6
Space

This is the space age. It seems appropriate that artists are exploring the virtual space of visual art, while scientists are sending probes into outer space. A painter aims to reconcile the two-dimensional with the three-dimensional in such a way that the latter is seen in the former without losing the sense of the paper's flatness. It is not the kind of space into which a bird would fly, but another kind of space—an autonomous realm of perception and judgement.

Landscape painting, the esthetic contribution of the 19th century, coincided with other inventions in the physical realm, expressly photography, that democratizer of picture making. As science triumphed, the amplitude of man and religious faith declined. Patrons, heroes, heroines and grand themes disappeared from art. A partial compensation for the loss of content came by way of an intensified interest in concept, design and color.

Pictorial space

A picture is a make-believe space, a quasi-realm, where things are as they ought to be. This mimic world must be given its own equilibrium. Pictorial space has no connection with actual space of nature: nature is not in the picture making business. While nature goes on and on, a picture is flat and stops at the borders. A little piece of nature does not have the completeness required by a painting. The primary aim of a two-dimensional art work is to originate a virtual space.

One may experience disillusionment when walking out into the merely realistic street from a movie, after having participated in the conditional and imaginative space created by the film. Created virtual space is the primary illusion of the graphic arts and is the very basis of make-believe. The way you conceive and design space is the single most distinguishing characteristic of your work. The study of space deserves the adjective "experimental," a word often invoked by artists when merely switching tools, substituting colors or trying a new approach.

Orientation

Space is organized in accordance with our bodies. The bottom of the picture is the near and the top of the picture is the far. Because this is our relationship to the actual world, we read pictures with this same orientation. The horizon is always just across from the eyes, while the feet are usually below. Space begins at the feet and moves upward and out toward the horizon. It is a personal space. Areas to the left and right are often neighbors' spaces, requiring permission to gain access. Shapes may be freely run off the top and bottom of pictures without a sense of loss. This is possible because the eye vertically scans the areas where most interest is directed. Containment is threatened if pieces run off left and right. Up and down is yours; left and right are your neighbors'.

Two-dimensional space

Shapes drawn on paper produce tensions between themselves and the edges of the paper. These forces are not as much seen as felt by the artist. The manipulation of these emotion-tensions is called shifting. Each shift changes the relationships of the entire surface, including the intervals.

Three-dimensional pictorial space

Pictorial space is comprehended as push-pull. Every movement into depth should be neutralized by a movement forward. These movements or forces operate in spite of realistic spatial orientations, such as converging lines and diminishing sizes. Spatial forces of volumes around an imaginary axis can be likened to a planetary system. Spatial concepts emerge from our bodies by occupying space, by being there.

Positive and negative space

Spaces between things (negative shapes) are as important as the things themselves (positive shapes). Since negative shapes are also painted areas, their shapes require an equal amount of attention, perhaps more than positive shapes, because we are usually less aware of spatial intervals.

Perspective

Convergence to a vanishing point on the horizon is based on the observation from a single station point. Perspective represents but does not create space. Even the most rigid adherence to laws of perspective does not necessarily provide full visual verisimilitude. This is because a particular size and perspective of artwork requires a specific distance and station point at which it should be viewed. The same applies to photographs. I do not advocate ignorance or rebellion in the ranks of perspective, but recommend full acquaintance.

Only the painter who is knowledgeable in the use of perspective can skillfully avoid some of its limitations. The artist, rather than an unyielding system, should regulate spatial effects. One powerful spatial sensation can result from overlapping shapes. Another effective spatial sensation is the development of planar activity and the resolution of tensions among oblique movements. Pictorial space is to be created; not copied.

Flatness and depth

It is easy to conceive a flat design, and it is likewise not difficult to render solid objects. A more demanding quest is the combination of these two kinds of seeing. The painter should attempt to see flat and deep at the same time. Seeing flat, exclusively, limits artistic effects to superficial decorative levels. Seeing bulky and deep only, denies the essential flatness in painting because it produces the so-called funnel effect. Following are ways to maintain a degree of flatness, thereby avoiding naive and unresolved space.

Push-pull

In the illustration at left, tone is not used for local tone or to express solidity of objects in light and shade. Tone is used as a powerful spatial effect by darkening and pushing back the space around things. It is addressed to the mind, rather than the eye. Its effect is decorative, unifying and flat.

Irondequoit Marina *15 x 22 inches*

Set-up movement into space and a return.

Think of the path of a thrown boomerang. A spiral-like movement in, and a return. The movement can be planar, voluminous, overlapping, or a combination.

Daylight Debarkation *15 x 22 inches*

Paint overlapping flat washes

A staggered or "out-of-register" position of second washes over earlier washes maintains the focal plane of the paper due to equivocal spatial sensations. Note: The paper is not the focal plane, which is somewhat further in than the surface of the paper. The focal plane is the point of equilibrium from which movements into depth occur and return.

West Wilmerding *15 x 22 inches*

Use calligraphy

Line declares the paper surface, due, in part, to writing habits. There is a graphic "thereness" of a line on paper. Line is abstract. It is, to a degree, away from nature. Therefore, it signifies a conceptual space in lieu of an actual space.

Luminosity, Light and Line *15 x 22 inches*

Reverse the diminishing sizes of recognizable objects.

Objects in actual space, appear smaller in size when behind similar ones. Flatness can be preserved by restricting or reversing diminution of size. This must be accomplished without inconsistency in the degree of abstraction or distortion among parts of the whole work.

Preliminary Wash Drawing *18 x 25 inches*

Mauve Sunflowers *22 x 30 inches*

Motif #1 *15 x 22 inches*

Transpose the usual position of small—large pieces

Large sizes are expected at the bottom of a picture. Putting small pieces at the bottom (near), and large at the top (far), contradicts the usual spatial sensation. To preserve flatness in a naturalist work, when the sizes of objects cannot be manipulated, introduce small brush strokes in the foreground, while making larger touches in the top, far areas.

Tilt foreground down

This furnishes numerous opportunities:
1. More interest can be created in the increased foreground area.
2. Convergence of perspective lines can be suppressed.
3. Sizes of near objects can be reduced to control volumes which might otherwise burst forward toward the viewer.
4. Diminishing sizes into depth can be presented with less extreme reductions.

Reverse color temperature

The advancing of warm color and the receding of cool color can be reversed to contradict naturalist space.

Use a distant station point

This effect can be compared to looking through a telescope. Naturalist perspective is employed, but the vanishing points are removed so far that convergence appears to be absent. The photo at left used a standard lens which approximates eyesight. The bottom photo used a telescopic lens and was made from a greater distance. It flattens space.

Establish connections

Openings in contours and passages between similar tones are employed generally to provide circulation. But they also keep shapes from going back into depth. Connected shapes "hold hands," keeping each other within limited space.

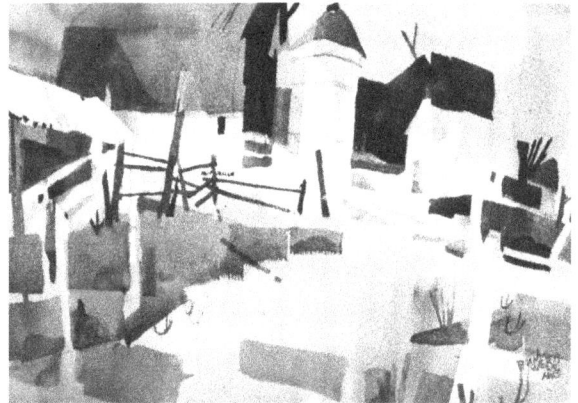

Silver Glen Farm *15 x 22 inches*

Make brush strokes in one direction

This de-emphasizes bulk. Noncommittal strokes remain on the surface, detached from deep space. This is specifically apparent in vertical strokes, which depart from the naturalist habit of expressing corporality by stroking along or across the form. Mosaic-like brush marks or pointillism also declares the flat surface.

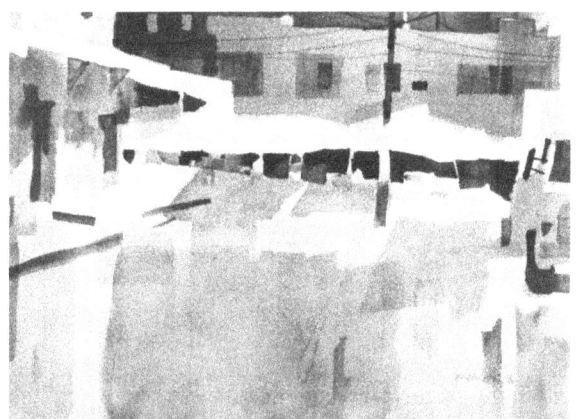

Produce Market *15 x 22 inches*

Eliminate or limit chiaroscuro

Suppression of light and shade emphasizes flatness. As a compromise, retain chiaroscuro but maintain flatness by restricting shade to a single tone on spherical and cylindrical objects.

Market Square *22 x 30 inches*

Add verticals and horizontals

The integrity of the picture plane can be maintained by employment of horizontal and vertical straights, which parallel the four borders of the paper. These lines echo, integrate and soften the edge of the painting.

Bypass deep vistas

Find motifs of limited depth. Poussin was one of the first landscape masters to introduce architecture into paintings, setting up verticals for the articulation of space. Facades, walls, florals and still lifes are favorite motifs for artists because of their limited depth. Many of the finest paintings indicate no more than 18 inches of depth.

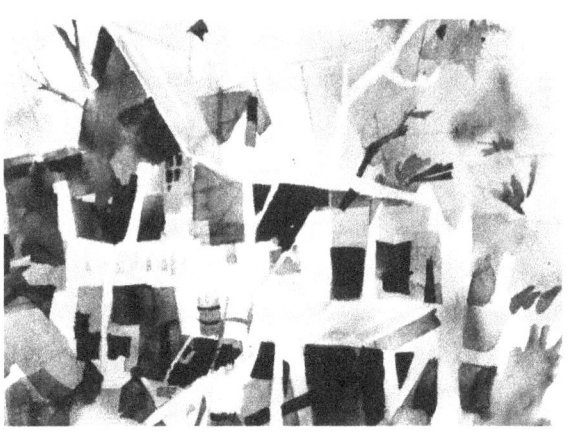

Squatter's Cabin, Erie Canal *15 x 22 inches*

Containment

A painting is unified when the parts are bonded together. When this "oneness" exists, the parts do not fly off the paper, but are contained. The following is a list of axioms for containment:

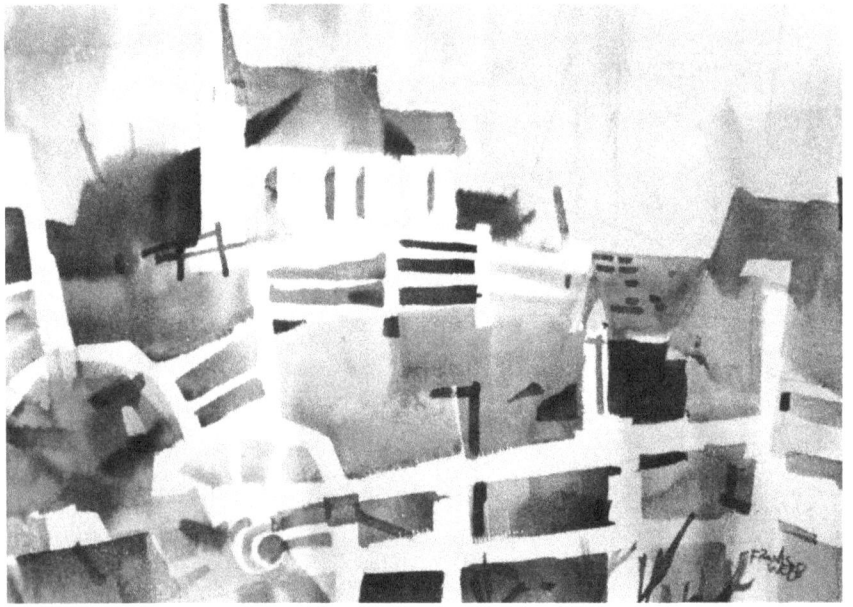
Within the Church's Pale *15 x 22 inches*

Do not point obviously out of the picture. The juror has every right to give an award to the painting to which your painting points. Pointers may be cars, people, houses, boats or abstract shapes, such as arrows. All of these should point inward. When painting arrow-shaped gable ends of buildings, curtail their direction by introducing some overlapping shapes, or reduce their tonal contrast. These shapes ought to be interrupted for another reason also—they are symmetrical, and since they are normally aligned with the edges of the painting in the vertical plane, they are static.

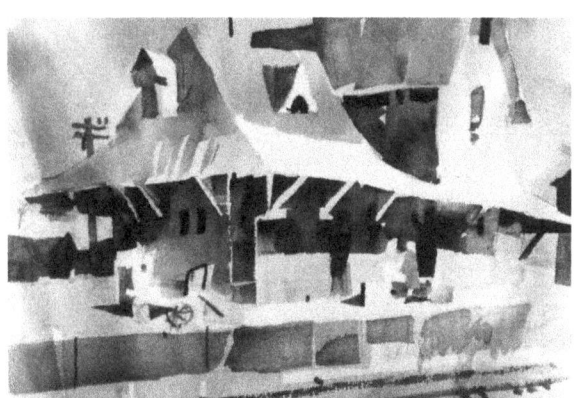
Antigonish Station *15 x 22 inches*

Down-play corners and borders. Corners are perfect arrows pointing outward. Therefore, keep contrasts out of the corners. If a line or contour runs directly to a corner, it completes the arrow with a shaft. Not only should corners be deemphasized, but the total border of the picture as well. This prevents the eye from being attracted to nonstrategic areas.

Surf at Nubble Light *15 x 22 inches*

Avoid indiscriminate cropping. If shapes must run off the edges of the painting, do not crop them at strange or undesirable places. For instance, a human figure should not be cropped at the joints, since those parts are the most beautiful, expressing gesture and articulation. Avoid using the edge of the paper for the edge of a thing or shape.

Wedge and interlock. When large shapes are interlocked, nothing shall separate them.

Design a vignette. The epitome of containment is the vignette, for it is completely surrounded by white paper. A vignette is a good shape made of midtone and darks, placed well on the paper. It might touch the border once or twice, but it is deliberately withheld in size, allowing white paper to surround it with an interlocking contour. The edges of the shaped piece should be mostly the normal edges of depicted objects. A small segment of the total perimeter may be faded away arbitrarily. The vignetted shape should not contain whites, since it is encompassed by white paper. The white around the vignette should be conceived as four areas, and each of these corners should be given a different shape and size, with one corner size definitely larger than the others.

Poor concepts of a vignette are: an ordinary oval shape centered on the paper with equal-sized corners of white; an oversized vignette which hits the border as often as it does not; a pull-down window blind effect in the manner of Gilbert Stuart's otherwise fine portrait of George Washington; a vignette with all-around fade-off which is flabby, and indecisive.

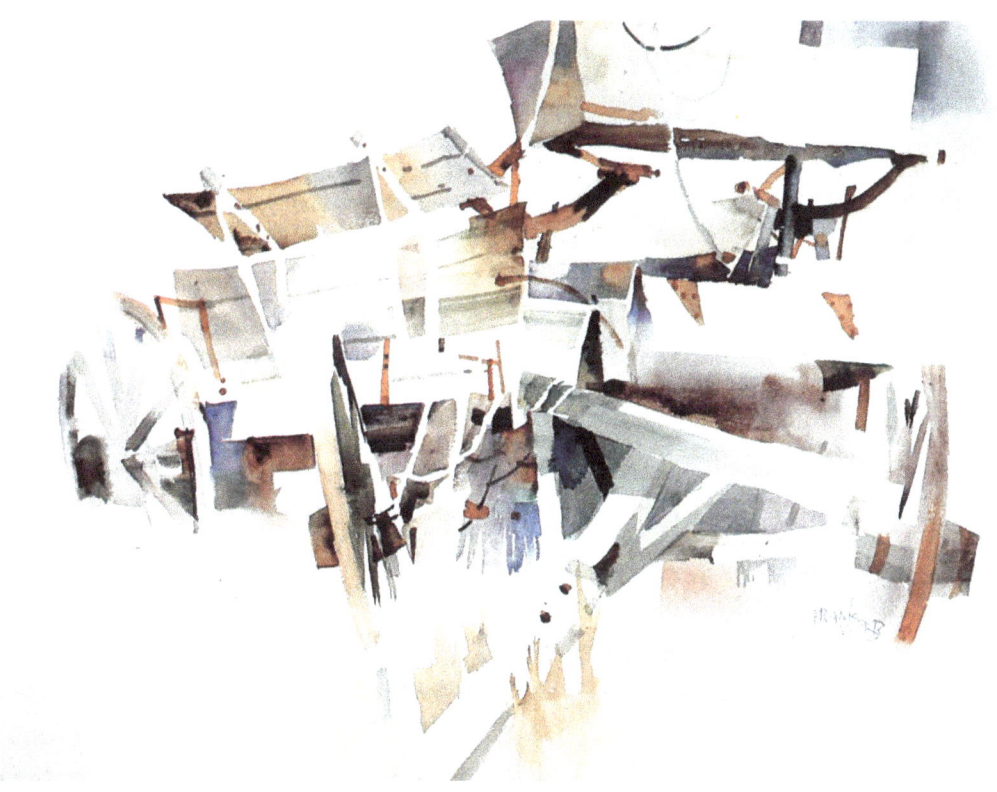

Wagon Whites *22 x 30 inches*

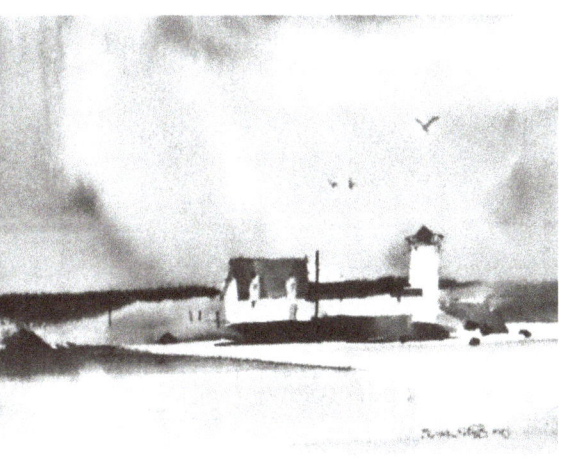

Goat Island Light *15 x 22 inches*

Reciprocal gradation. Gradations across two or more large shapes should not advance in one direction only, leading off the paper, but should oppose each other, directing inward from left and right. For example, if a sky has a gradation of tone from darker at left, toward lighter at right, then a gradation in the ground from the opposite direction will reinforce containment. Gradations are also made from hues, chromas, sizes, directions, textures, shapes and lines.

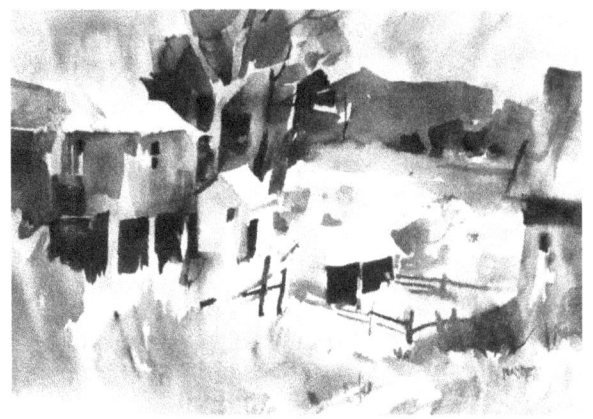

Decorah Farm *15 x 22 inches*

Three stages in depth

The three classic areas of landscape are foreground, middle-ground and distance. The three areas should be varied in size and distance. Generally, the mid-ground contains the center of interest. Keeping these areas well separated gives a spatial sensation. Converging perspective lines and larger sizes in the foreground should be suppressed, allowing the three jumps to create space.

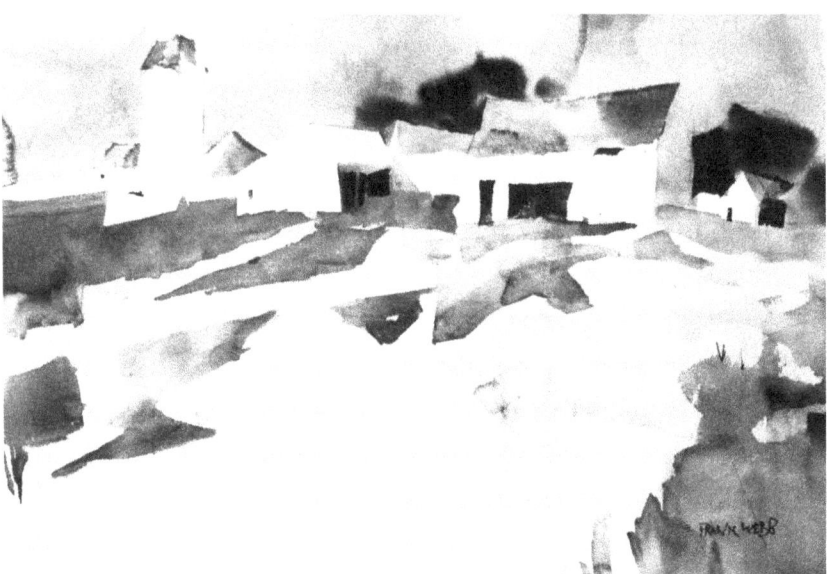

Creston Farm *15 x 22 inches*

Skate into the picture

Open up movement from the bottom inward with an oblique line. Then try to set up reciprocal oblique movements as in skating. Zigzag into depth with rhythmical movements left to right and vice versa. Avoid movements which go directly into depth, as though you were driving on the freeway.

Divide paper

Get a sense of the whole space by seeing your paper and the motif all over and at once. Then divide paper into expressive areas. The superficial, naturalist method of starting with a detail and adding all around it tends to portray things instead of shapes and space. Do not add. Divide first; then multiply by making repeats.

Choose format

The horizontal is expressive for most landscape subjects. The horizontal visual cone of eyesight further argues preference for this format. A square format suffers a lack of reverberation which rectangles have in their variety of dimensions. The whole shape of a square is static and boring since it has four same sized borders.

Alongside Aransas *15 x 22 inches*

Reading direction

Because most people read from left to right, it is useful to apply that knowledge when trying to express a movement across the paper. To show strong movement, go from left to right. More resistance is felt by moving in the opposite direction.

Spatial facets

A faceted area clinches solidity. Large facets are generally parallel to the picture plane, while facets on the edge of a volume become compressed as they turn away. This concept boldly clarifies and adds significance to any irresolute areas. Facets also increase vitality to an otherwise flimsy spherical or cylindrical mass.

In naturalist painting this idea is closely related to modeling. Modeling affirms the surface of a volume while chiaroscuro veils it. In painting from a model, these opposing ideas are illustrated. Modeling insists on the planes, enlisting light and shade to describe them. In chiaroscuro, light and shade are copied first, and the resultant planes are secondary manifestations.

This is important enough to state again. Modeling is used when the painter wishes to express the planes, regardless of what the accidental light is doing at the time. The painter uses "shading" insofar as it defines the planes. It is a conceptual study.

When the painter uses chiaroscuro, the light and shade relationships are copied in all their tonal relationships under the aspect of the moment with the expectation that planes and volumes will thereby be expressed. It is a perceptual study.

How many students in a life class could state their aim or be aware of the distinction? It was many years after art school before the conflicting approaches became clear to me.

The function of reason is to dominate experience; and obviously openness to new impressions is no less necessary to that end than is the possession of principles by which new impressions may be interpreted.
. . . Santayana

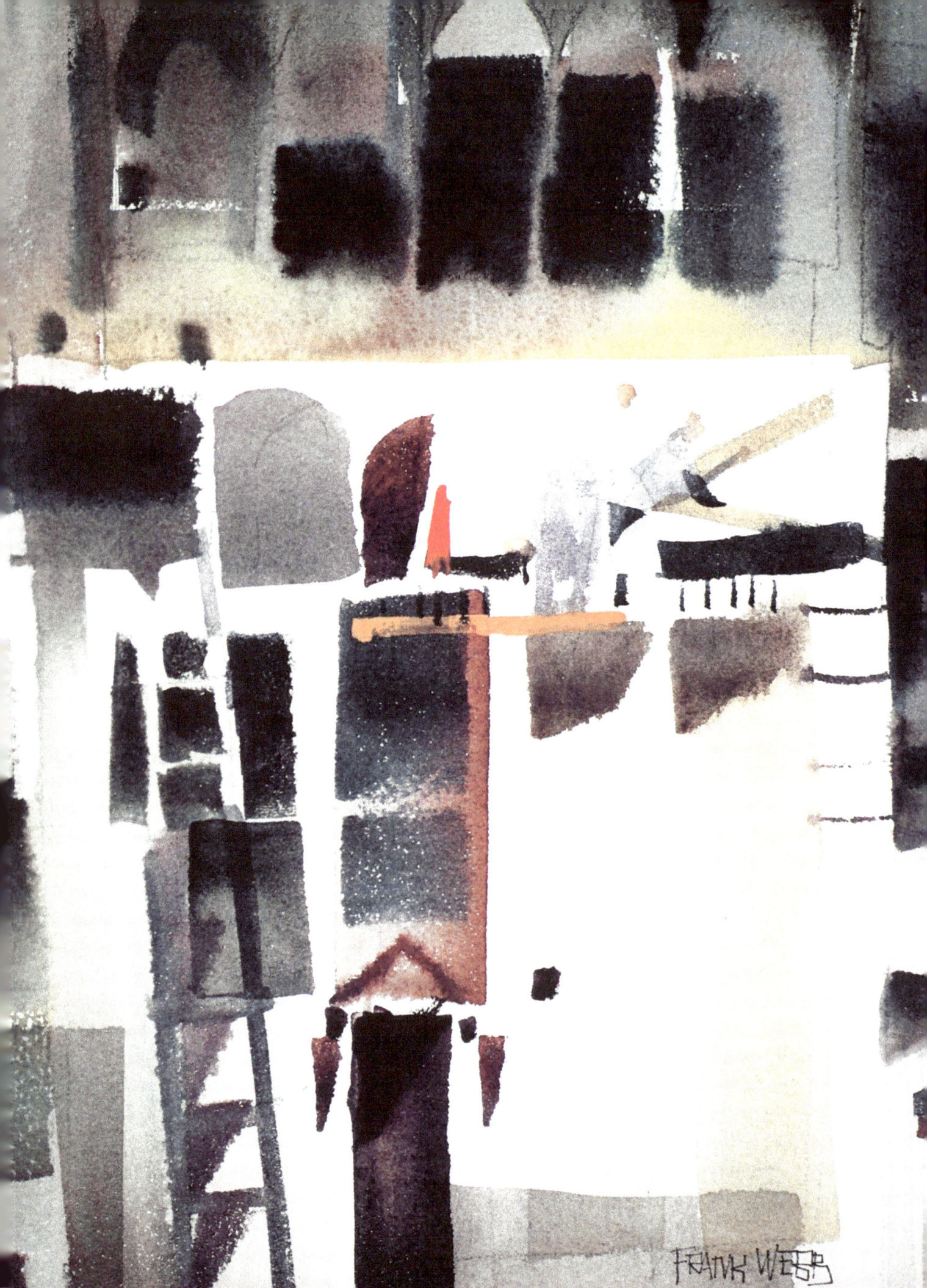

7
Execution

The making of the painting is the visible, practical aspect of the painter's working at the easel or board. This step is not as experimental as selecting convictions and choosing method. Here is where the battle is fought, for better or for worse. This is when the painter must serve as actor, critic and audience. This is the everyday job of engaging in dialogue with the paper.

These demonstrations and finished paintings are presented visually and verbally with a view to sharing the underlying principles, especially design principles. Design is the most public aspect of a work of art. Though there may be ineffable qualities of the creative concept of any work which remain intra-subjective, the design (or form) is fair game for discussion.

The invited artists included in the gallery section have, with few exceptions, not submitted words to accompany their images. The comments are mine. I am happy to put the paintings into context, for their esthetics suggest bonds beyond time and distance, a fellowship of many who have never met.

My own works are offered without apology or false modesty, because I like my work in the same way that I love my children. They are not faultless, but a parent is always right in loving offspring.

pg. 80
Facade *(detail.)*
The art of building a painting rests upon foundations as solid as rock. Henry Brooks Adams said, "All experience is an arch, to build upon."

East Liberty *15 x 22 inch watercolor demonstration.*
After the design is penciled, the cold pressed paper is wetted front and back until saturated. A squeezed out sponge picks up excess water from the surface. Midtone is put on with a two-inch mottler brush. The paper is slightly tilted so the wet wash runs toward the bottom. Taking a clue from my pattern sketch, I save a white at bottom right, by painting around it.

Opposite page, top: A second layer is painted. Note that this layer is painted around areas which are to remain lighter in tone. Since the creative concept here is a busy corner of the city, I begin to suggest the clutter with some small and middle sized brush strokes. A series of oblique, cast shadow edges not only express outdoor lighting, but add interest to both positive and negative shapes.

Opposite page, below: After placing some of the darks I am able to judge transitional tones which interact between the extremes of light and dark.

83

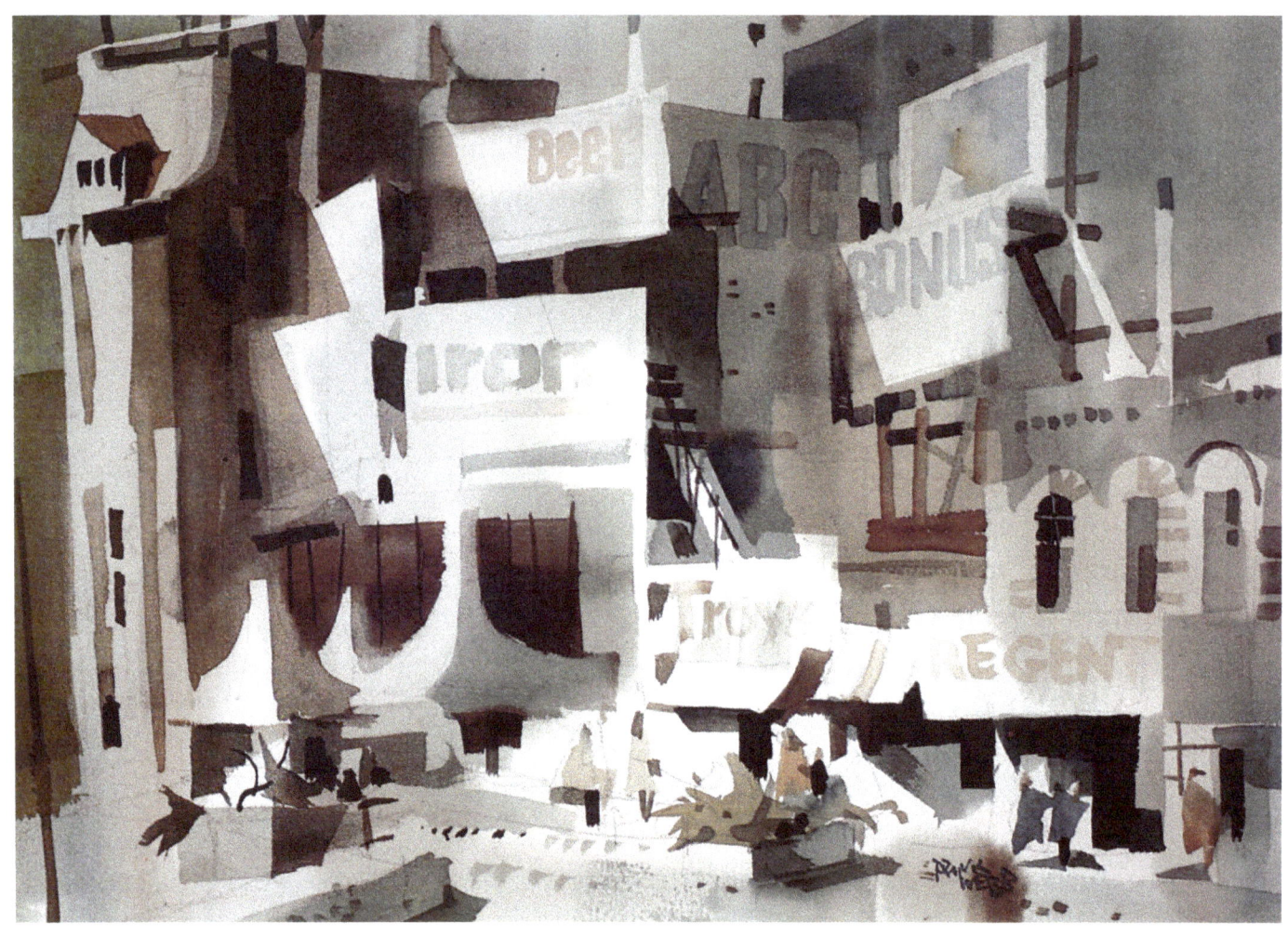

Finally, I indicate signage with characteristic scaffolding and lighting which attends outdoor signs. Kiosks and planters suggest urban renewal. Such renewal often reveals new perspectives and vistas of the city.

Dandelions *22 x 15 inch watercolor demonstration.*

Sketch data from the backyard reveals the metamorphosis of the common flower. Some are closed, some open, others have gone to seed. In this first wash on a saturated paper, I paint around my whites. The initial big wash on a wet paper is almost always beautiful if put down directly without endless adjustments. Variations in tone and color create interest in this layer.

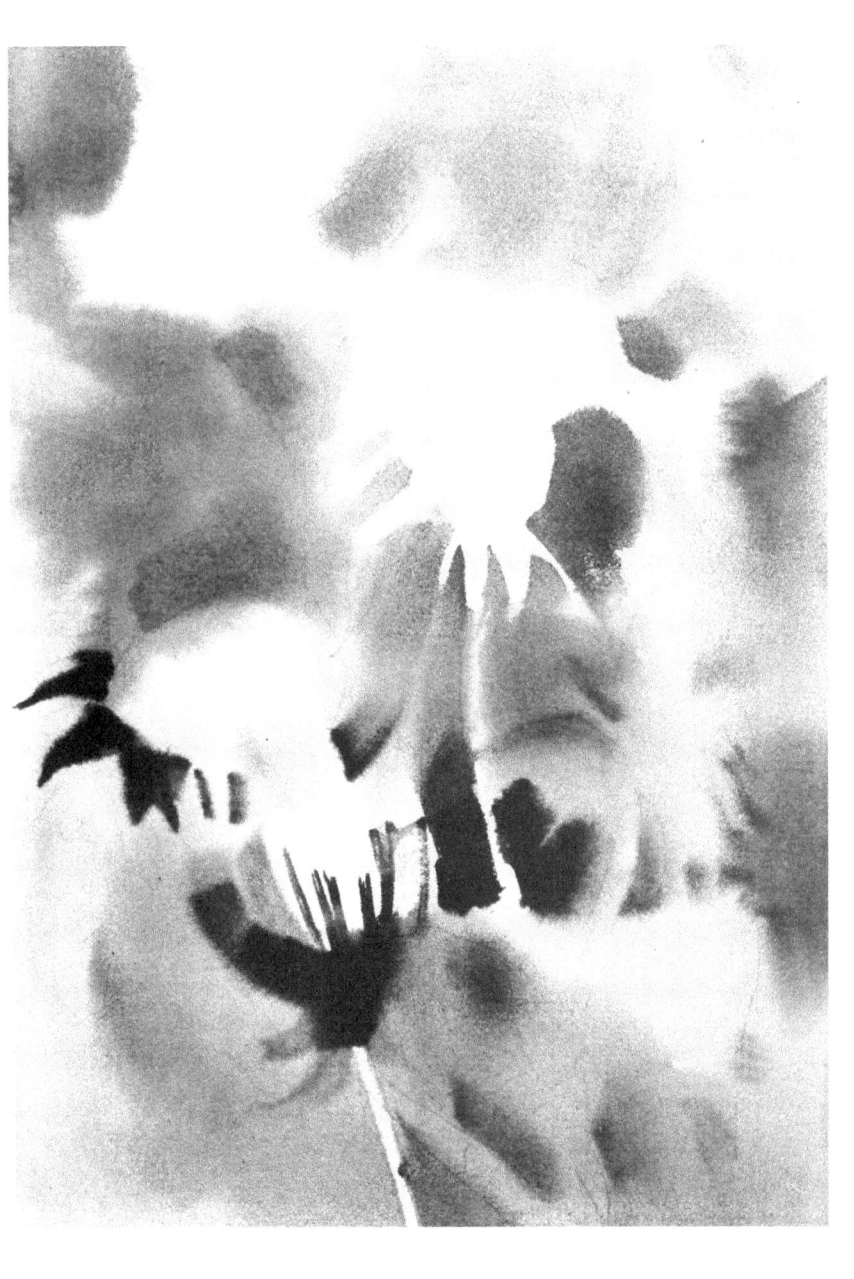

Next, while the first layer is still quite wet, I introduce a few darker tones using a resilient flat brush charged with moist, but not wet, color. Remember that plenty of water is already in the paper. If you thoughtlessly add water with each stroke, the paint becomes uncontrollable. Notice that some edges of this wash are somewhat softened by the wetness of the paper.

Opposite page: In these final touches, the paper is now drier. Certain midtone glazes are run. These have noticeably harder edges, with increased variety. Stems are added, not only because nature does, but in accordance with requirements of design and esthetic decoration. The terms decoration and ornament are not synonymous. Ornament is organic. It remains ornament when drawn on paper, but becomes an element of decoration when applied to an object. Decoration also includes geometrical lines, natural foliage, animals and the human figure.

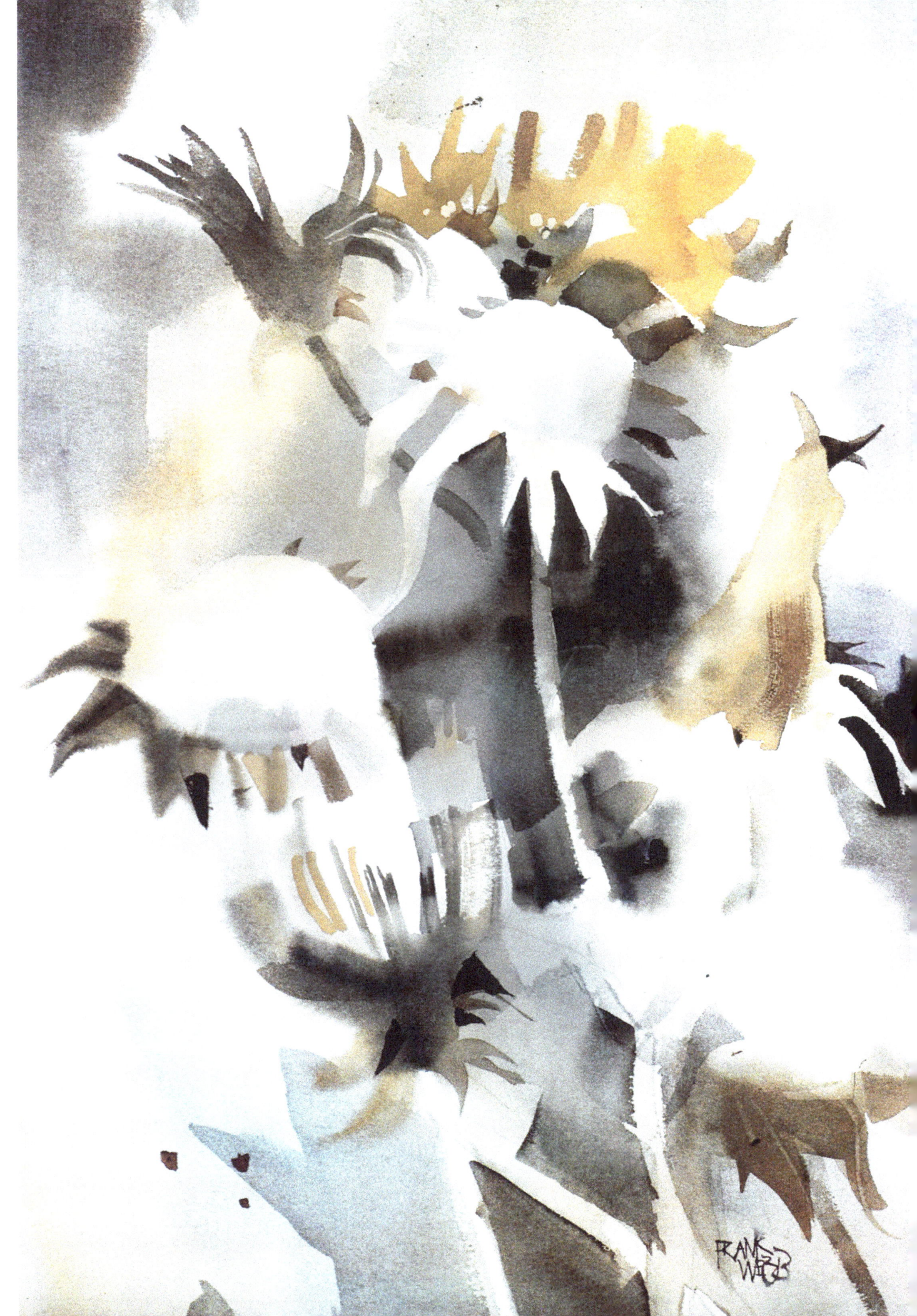

Previous page:
Edgewood Flowers
15 x 22 inches
Private collection

Dock Square, *15 x 22 inch watercolor demonstration.*
I am working on a 140 pound paper which has a hot pressed surface. The first layer is applied to the slick, dry paper and allowed to dry. Tonal variations which emerged were accidental. No attempt was made to obtain variations of tone, hue and chroma. Generally, those are qualities which I thirst after, but here those aims are ignored as I seek to replace them with watercolor's other great glory—transparency.

In the second stage, another layer of midtone is superimposed over the dry first layer. Although it does not show in this reproduction, there is a slight change in hue as well as tone. I try to feel my way with the two-inch brush, giving shape my entire attention. Notice that this layer, for the most part, does not attempt to coincide with earlier edges. In some areas, this second tone is applied to hitherto untouched whites, resulting in four discernible tones (and colors) which include the whites.

I preview placement, tone, size, direction, color and shape of darks with pieces cut from magazine pages. These are shifted about on the dry surface of the painting until the relationships prove satisfactory. At that time, I lift each scrap and paint beneath.

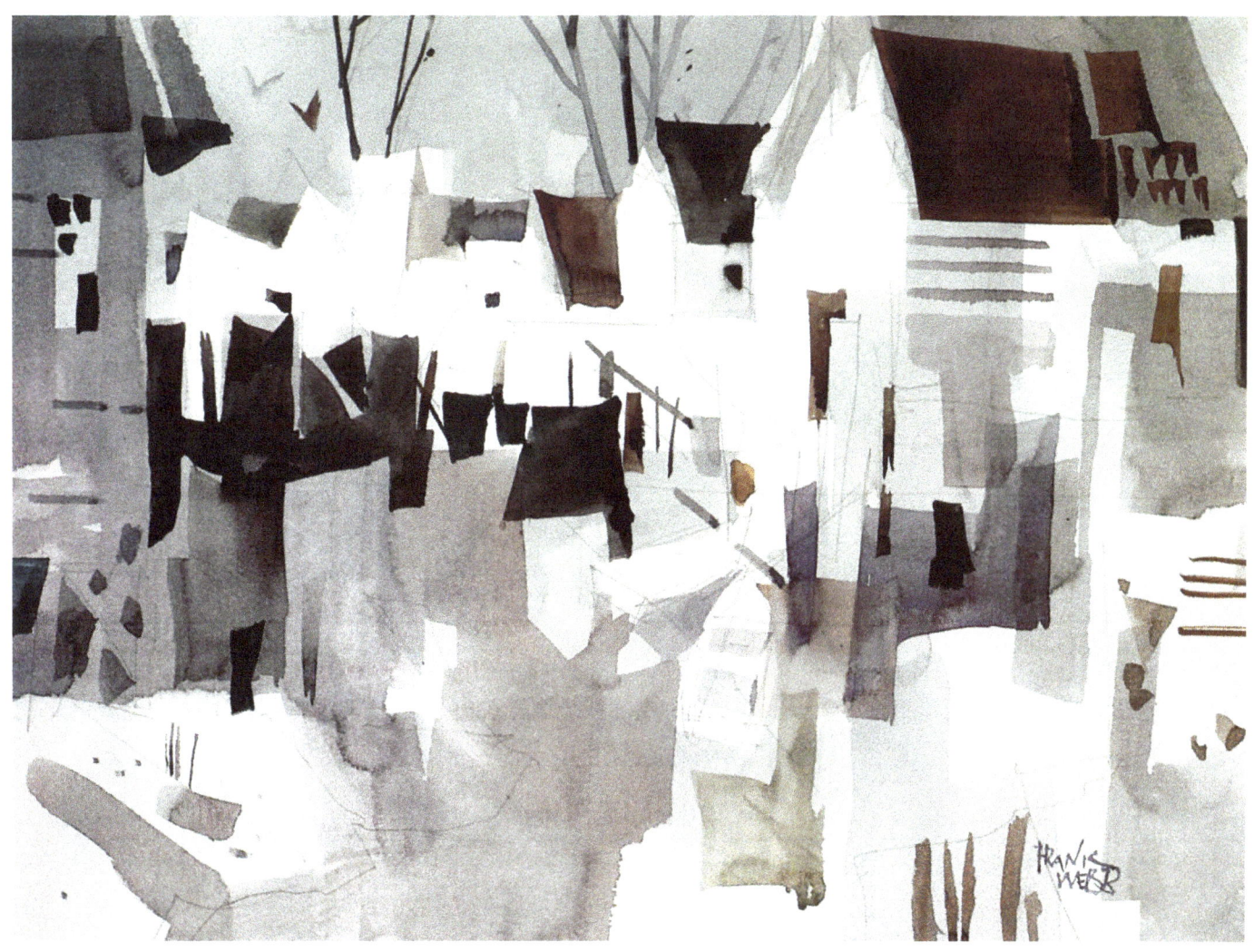

In the finished work is the clear separation of tone into four areas. Whites and darks stand forth from the two midtones. Shapes are varied in size and wedged together. Although it cannot be seen in this reproduction, transparent layers integrate contrasts of hue. Contrasts remain visible, but are synthesized, darkened and neutralized by overpainted layers.

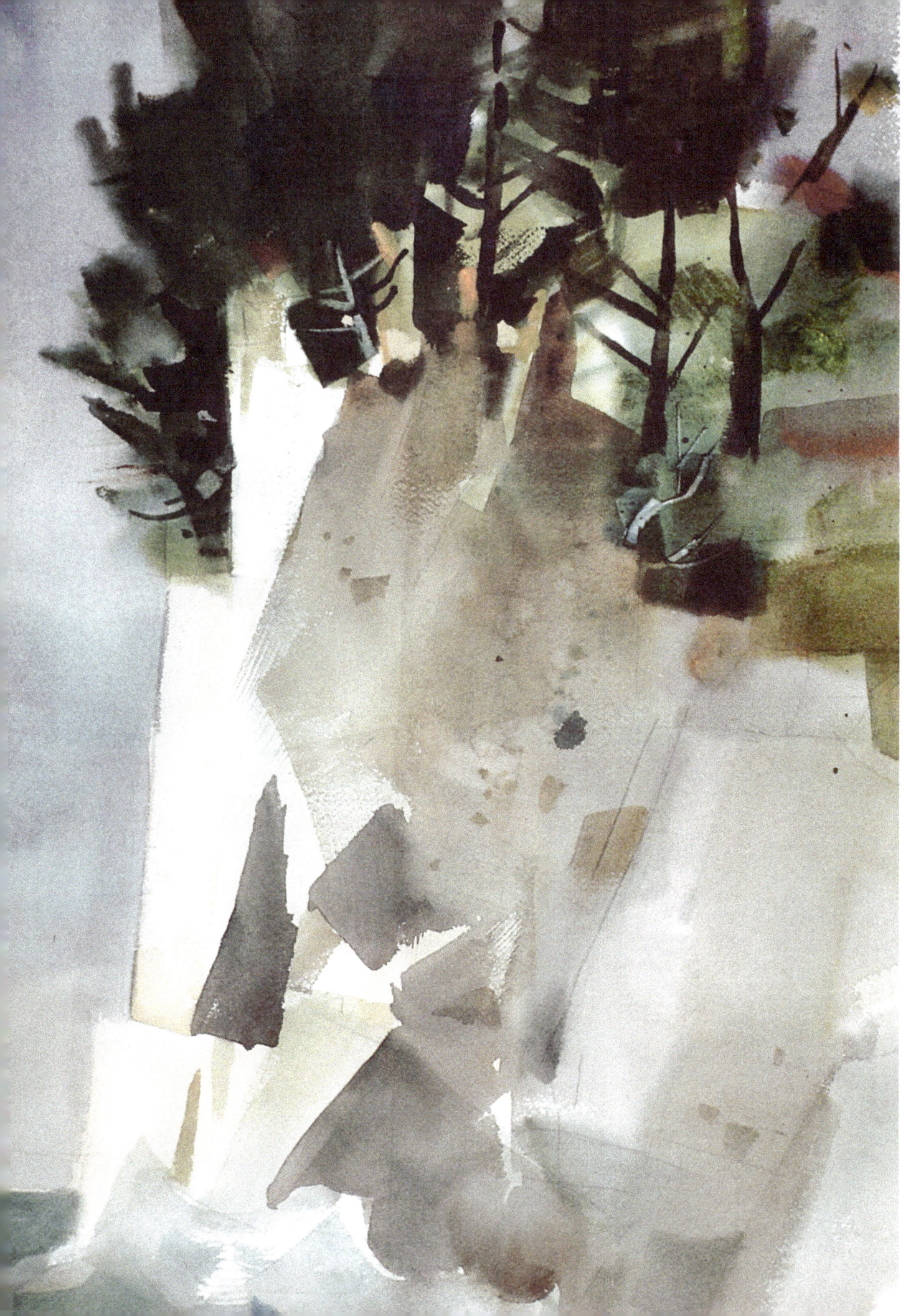

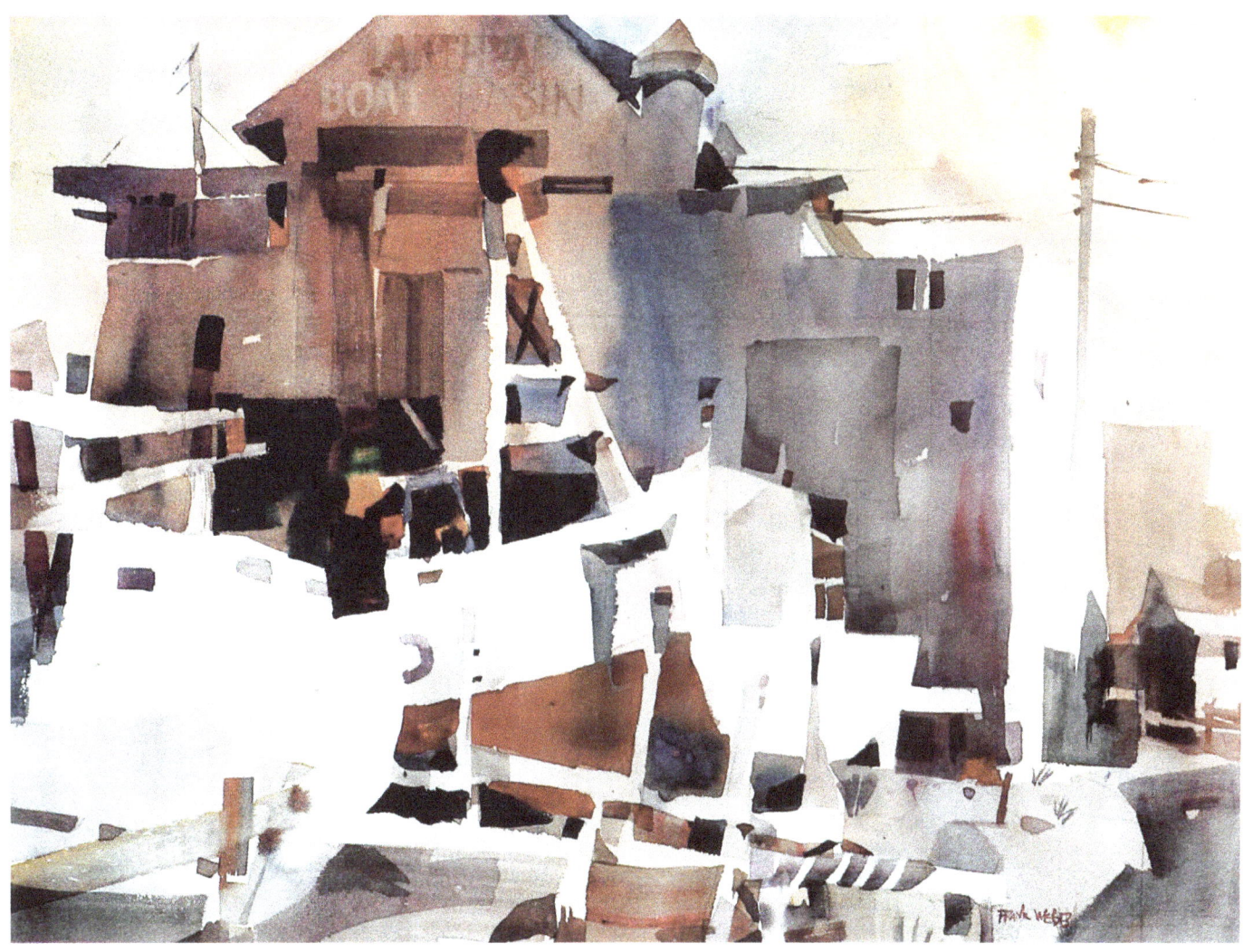

Opposite page: **Lake Champlain** *22 x 15 inches.*
A vertical format helps to express a high cliff near Shelburne, Vermont. The oblique white shape plays against the dark at the top of the cliff. The cliff's angular shapes repeat those of surf and forest. It is our job to look for connections and resemblances. Artists put together.

Above: **Duluth Boat Basin** *22 x 30 inches.*
Old wooden lake freighters were lying in a nearby field, so I hauled them into the marina yard. They have a character unlike craft from rivers or oceans. Notice how small I made my windows on the building and boats. If made too large it would break up the integrity of the walls. Half windows and half wall is always bad. Modern buildings will have all windows or no windows.

Wilson's Mill *22 x 30 inch watercolor demonstration.*
This pattern sketch was made during an outdoor workshop. I allotted an hour for preliminary study, made four patterns and chose this one. Note the truck facing into the composition, which in reality it did not. The illustration, opposite page top, shows the painting at the end of a one-hour painting demo made for the class. The illustration, opposite page bottom, shows the painting after some additional work in my studio. The demonstration emphasizes the use of three tertiary hues: citron, olive and russet. The dominant light blue color is olive, a mixture of purple and green. The subject, a fine old nineteenth century mill, is important enough to fill the paper. Its white local color dictates the high key of this painting.

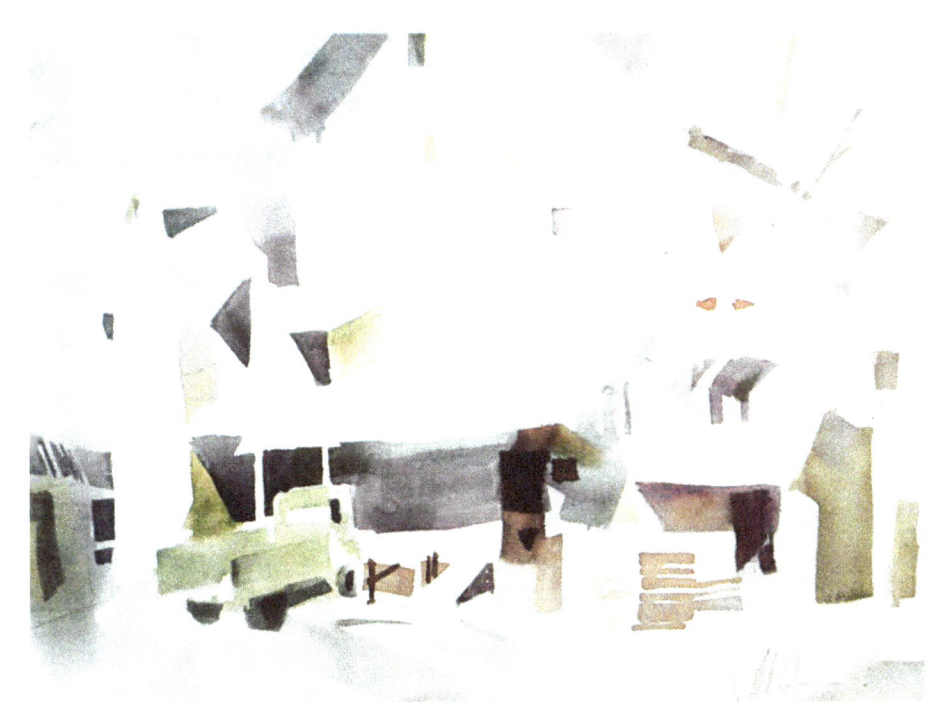

New Orleans Ferryboat *22 x 30 inch watercolor demonstration.*

This painting is being made from memory and a pattern sketch from several years earlier. River environs are familiar to me. Here are some of my convictions (axioms) which come to me as I contemplate this subject:

1 Noise
2 Sunlight/heat
3 A carnival of color
4 Movement
5 Circulation/passage
6 Lacey construction
7 Detail suggested—not copied
8 Interlocking which would express the confluence of land, water and people traveling

As to method, I elect to paint on dry paper, but resolve to make it look wet despite its dry origin. I am enthusiastic about the design possibilities and shrug off most concern for facts. Pink is chosen as the dominant hue, specifically phthalo crimson, a seldom-used color on my palette. I make several dry runs (gestures over the paper to encourage a broad handling).

To make the paper most responsive, I gently sponge it with clear water and dry it with a hair dryer. Since it is clipped to a hardboard, there is little buckling expected in subsequent operations. The paper is divided into major shapes, directions and gestures with a 2B flat pencil. I stab into crimson paint with a 3-inch mottler brush. Touching the paper at the top, right corner, I work pink into much of that area, fusing slight changes of hue with each brushload.

Moving counterclockwise, I paint around the whites, making eventful, wedged shapes. The sky color is too intense, but it will be an easy task to neutralize it later. I allow the paint to dry.

This shows overpainting of darker midtones. This second layer overlaps the whites and the dried layer—a procedure used to feature transparency. The pattern sketch is in constant reference to clarify, interpret and intensify my experience.

The darks are struck onto the sheet in a patchwork of varying hues to make them more entertaining. I use thicker paint with very little water. The gestures, sizes, hues and tones of these darks are placed in alternating relationships, yet they read clearly against the midtones.

This is how I view the work on the following morning. Previously I had been satisfied with many of its qualities. I see it now more objectively. The pink is too shocking. Do I really want to keep that spot of arbitrary dark, below center? I consider darkening the bottom midtones. To preview the effect of this, I cast a shadow on the paper by placing a cardboard between a lamp and the painting. Further appraisal indicates that my whites are too white, isolated and hard edged. I carry the paper to the bathtub, and using a soft brush, lick away some of the paint while the painting is submerged in cold water. On larger areas I use a natural sponge, gently. The paper is returned to the studio.

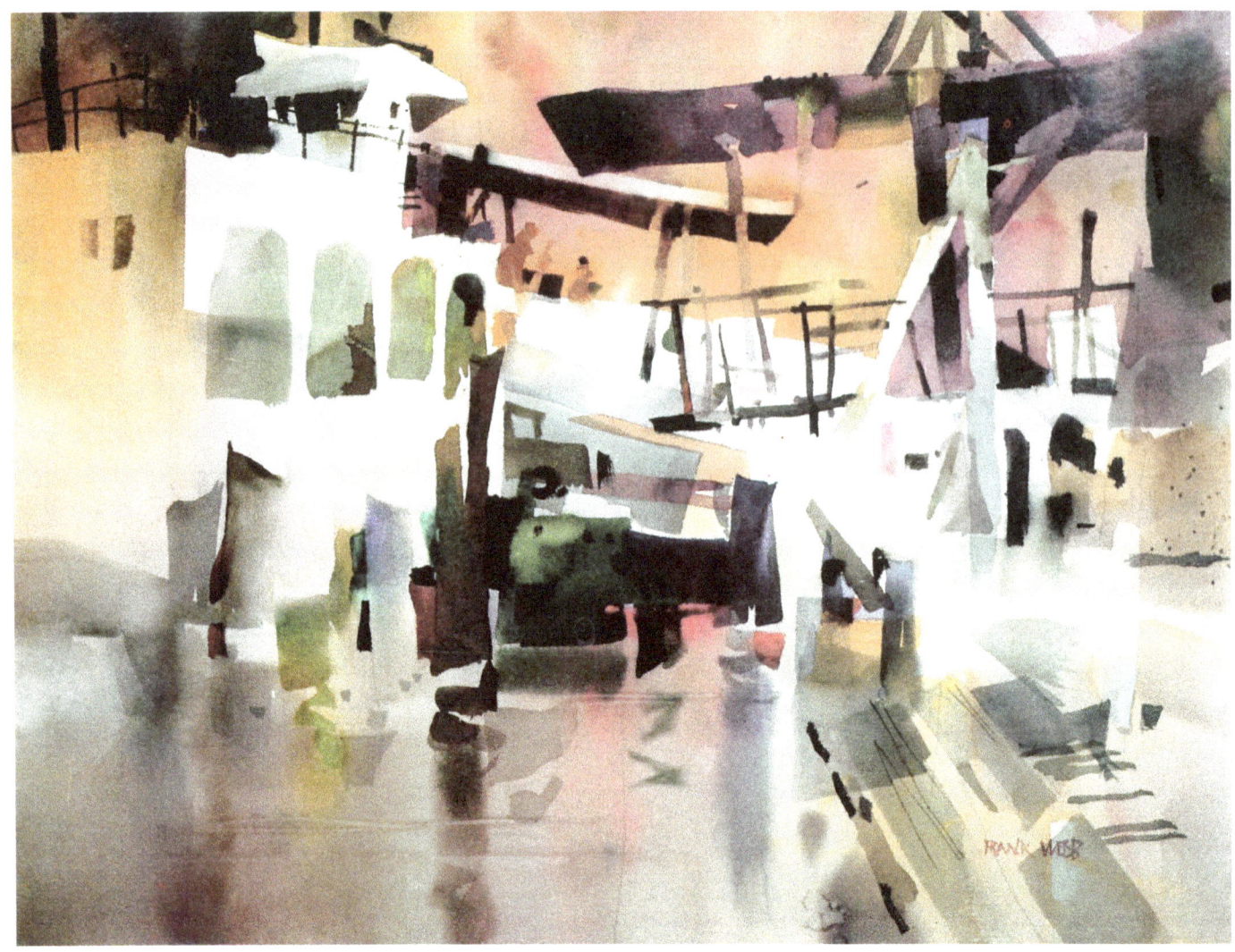

While it is still wet from the tub, I darken the bottom midtones, and indicate water reflections. The pink sky area receives a warm green glaze neutralizing that trite, right-out-of-the-tube pink. The calligraphy of a guardrail adds interest at top left. (Rewetting of a dried paper is always safe. The paint will not float away from a submerged surface unless it is nudged.) Additional brushline calligraphy enlivens dead and inexpressive areas. I add an automobile shape to the main deck, which clarifies the function of a ferry boat. This painting symbolizes the activity of a ferryboat as much as the appearance. It is not an actual copy of a scene, but a mimic realm where I shall never pay that fare, wait for my love or arrive too late. It is beyond the realm of anxious interest and selfish solicitude.

7a Gallery

Dinsey, Want'a Eat? *by Arne Lindmark, A.N.A., A.W.S. Watercolor, 22 x 30 inches.* A close harmony of warm hues and curved lines. The few straight lines on the cat are repeated in the book shape. Good white shapes are well related and easy to find. While most watercolor painters habitually work from light toward dark tones, Lindmark chooses to work from darker initial areas toward lighter tones. He establishes darks with drybrush strokes which allow light to show through additional layers. Larger, looser washes are then applied to establish color and tone. It is a controlled and deliberate method, relating to Lindmark's preoccupation with design. He generally works from pencil pattern sketches which provide the bones of his works. His works stand up because of those bones. Because he solves most of the important concerns of design with pencil patterns, Lindmark can concentrate on color, edges and texture.

Tulips by Teryl Townsend Speers. *Watercolor on hot pressed paper, 21 x 27 inches.*

Within the blue/green dominance are seven pieces of red. Observe that each piece is a different shape, size and chroma. One of them is decidedly larger and one of them is definitely brighter in chroma. Also, one piece is darker in tone than its companions. The whites are well related and varied. Blues and greens are set off as well. Organic, curved shapes pervade the scheme, but note that they are dramatized by the stabilizing influence of straight stems, background grid lines, and one straight tulip contour at the right bottom. It is not by chance that the ramifications on the green leaves are varied in size, shape, and chroma. The accents of calligraphy go along for a while then pause to do a little dance. Consider the interest resulting from the busy network of small touches under the bright tulip at left in relationship to another busy ganglion of decorative little pieces at bottom, right. This perfectly realized painting is successful because Speers has created wonderful relationships with minimum means. There is little reliance on esoteric method, multiple layers, textures, or edge interest. It is straightforward, flat, simple, authoritative painting.

World Ski Champion, Jean Claude Killy *by Henry Koerner, A.N.A. Watercolor, 24 x 18 inches.*

Stripes on the sleeve express the bulk and gesture of the arm. The head is modeled in planes of tone and color, first and more importantly the large planes which compose the head, and later the smaller facets which express the features. Oblique directionals on the figure and in the background express not only the locale, but the action inherent in skiing. The beauty and the challenge in painting flesh comes from its semi-metallic characteristic, i.e., its ability to reflect neighboring hues and lights. The translucence of flesh also makes it especially beautiful, as we can partially see into it. Great subtlety and taste is required to combine warm and cool hues in such a way that their interaction gives the sense of quivering, living flesh. Flesh might sometimes be sold in a tube, but the quality must come from the painter, and not the pot.

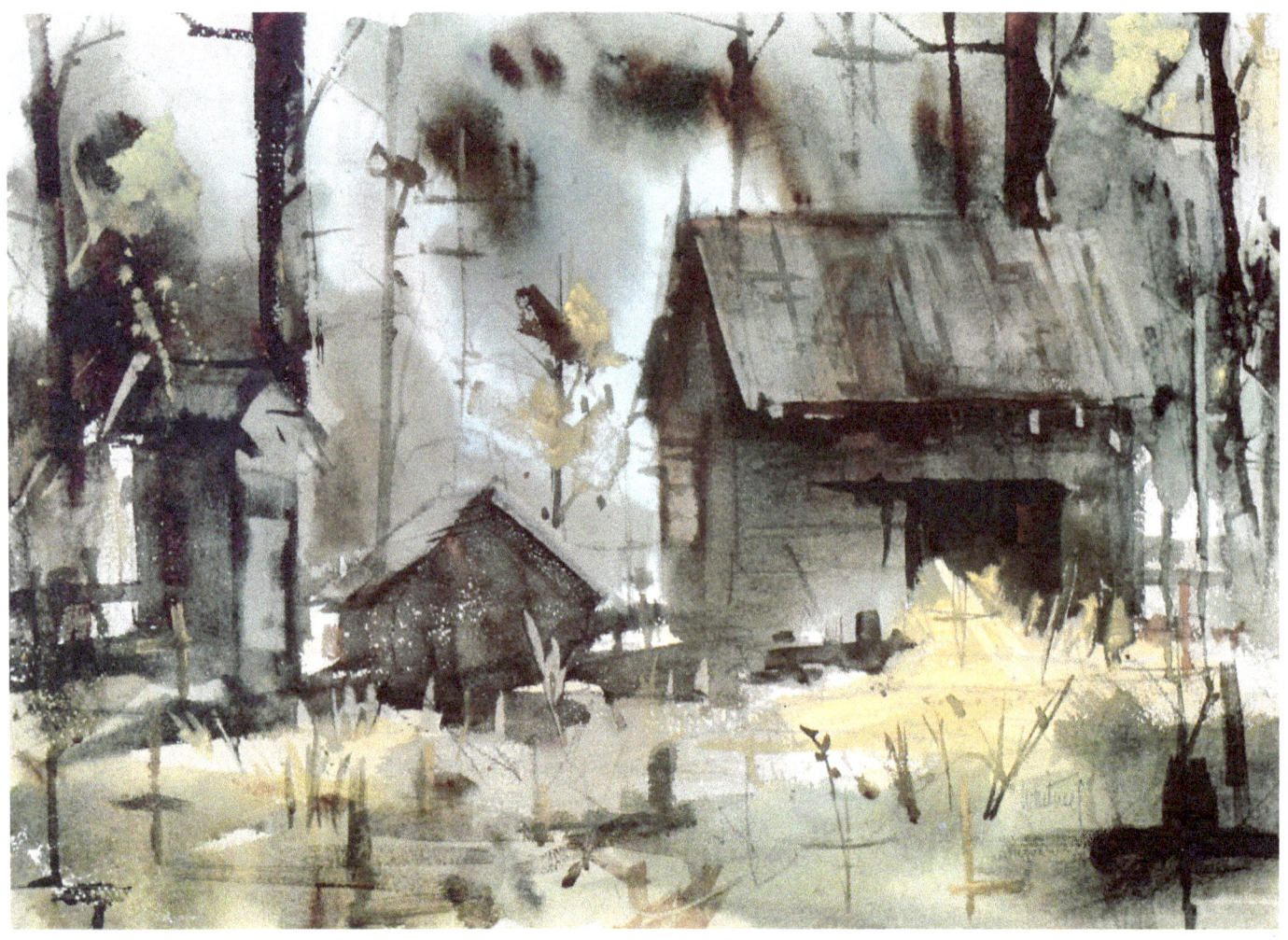

Greens and Browns *by Edgar A. Whitney, A.N.A., A.W.S. Watercolor, 15 x 22 inches.* Thousands of painters who have studied with Whitney will recognize here one of his recurrent visual ideas—mama, baby, papa. The relationship of these three sizes gives maximum contrast (interest) to areas. Two of the peak roofs are in the same plane, while the baby-sized center roof is turned in the other plane. Baby is placed closer to Mama than to Papa. Fence rail is used to tie together the little group. A sun-struck middle ground culminates in the yellow-white which sings out against the dark of the opened door. Against the light middle ground is a richness of calligraphic marks and variations of edge which express the tone, color, texture, and perspective of looking out from a forest into a clearing. The sky hole which leaps obliquely toward the house, provides an opportunity to show a dark tree trunk plus a couple of saplings. It also allows the barn to read dark against light on the left, while it reads light against dark on the right. Since the bulk of mid-tone is below middle, the painting is in low key, which logically expresses the forest interior. A lower key also allows more latitude in tone and color variations among the whites; hence the yellow, gray, and blue whites remain discernible in this context. Whitney defines the painter as a shape maker, entertainer, and symbol collector. Those three qualities abound in this work which I am proud to own.

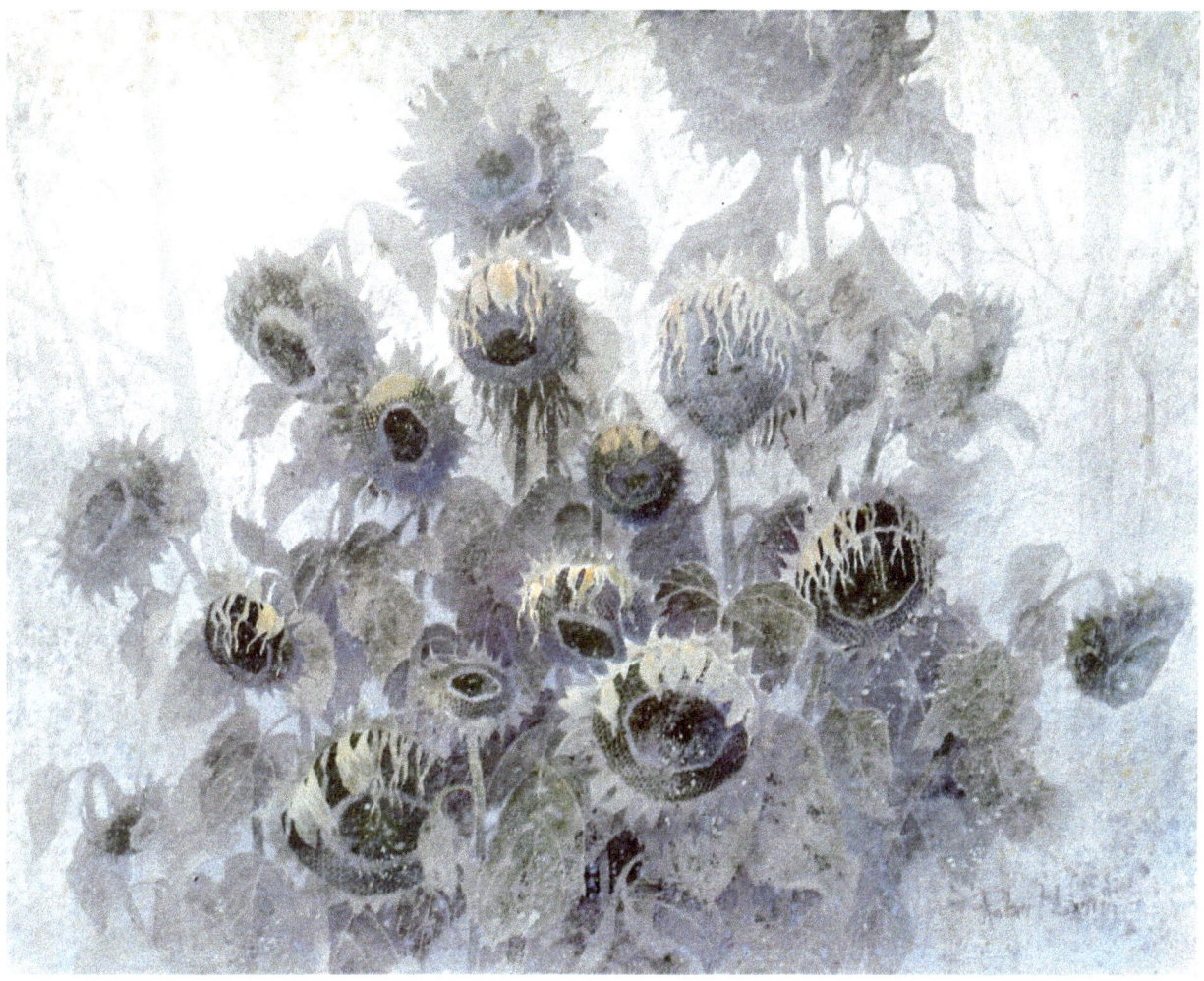

Rural Sentinals *by Robert Laessig, A.N.A., A.W.S. Acrylic and watercolor on man-made fiber, 36 x 48 inches.*

The "King of Wild Flowers" experiments with a wide variety of surfaces. His studio at first glance seems to be a dry goods shop—inundated with bolts of cloth, fiber and filter paper. It must be obvious from this example that Laessig has an abiding love of texture, both of nature and of paint. This painting is enriched by a wide variety of textures. There is also variety in the directions in which the flowers point. He has not placed the flowers in that trite "here's looking at you" position. Although flowers are circular and radial in design, Laessig does not give us a single ordinary circle. He turns, twists, overlaps, crosses with stems and extends leaves. He varies the axis of the oval shapes of each. In his tonal scheme, he provides a subtle gradation of the dark toward darkest at the bottom, left of center. He keeps the entire group simply contrasted against the lighter background. The height of these giants is suggested by the large flower which goes off the top. This flower, however, is kept light in tone to avoid the offense of calling attention to the border. Note the northeasterly gesture of the group, while only a few stems run northwesterly. Laessig uses wax resist, opaque passages, and reverse painting to enrich his surfaces. It may be a truism in art that among the three exclusive domains of tone, color, and texture, when one of them uses high contrast, the degree of contrast in the other two should be subordinated.

Wildcliffe *by Barbara Nechis, A.W.S. Watercolor, 22 x 30 inches.* Although the largest area in this fine painting is white, notice that Nechis has placed the whitest white in a good location on the total paper. Just northeast of that white is the darkest dark among darks. As a principle of reciprocity there is an area of light within the dark and vice versa. These incidents tastefully do not take place immediately above and below one another, but are staggered. There are warm hues among the cools and cool hues among the warms, providing another reciprocity. Mushy, thick paint stabbed here and there into saturated paper accomplishes a contrast with thin glazes laid on dry paper. The large white area contains variations of hue including blues, yellows and pinks. The above comments relate to matters of form or design of the painting. There is the content side of painting to be apprehended. Content is what the form dishes up. For Nechis this includes the act of painting: the love of paint, water, paper, the challenge, and the thrill of discovery. Many people understand content to be "what is going on in the picture" or the events portrayed therein (subject matter). I prefer to call the motif "object matter." Subject matter (or object matter) is here transformed by a creative painter into an integration in terms of paint. This transformation is what I have called, "the creative concept." Ben Shahn said that form is the shape taken by content.

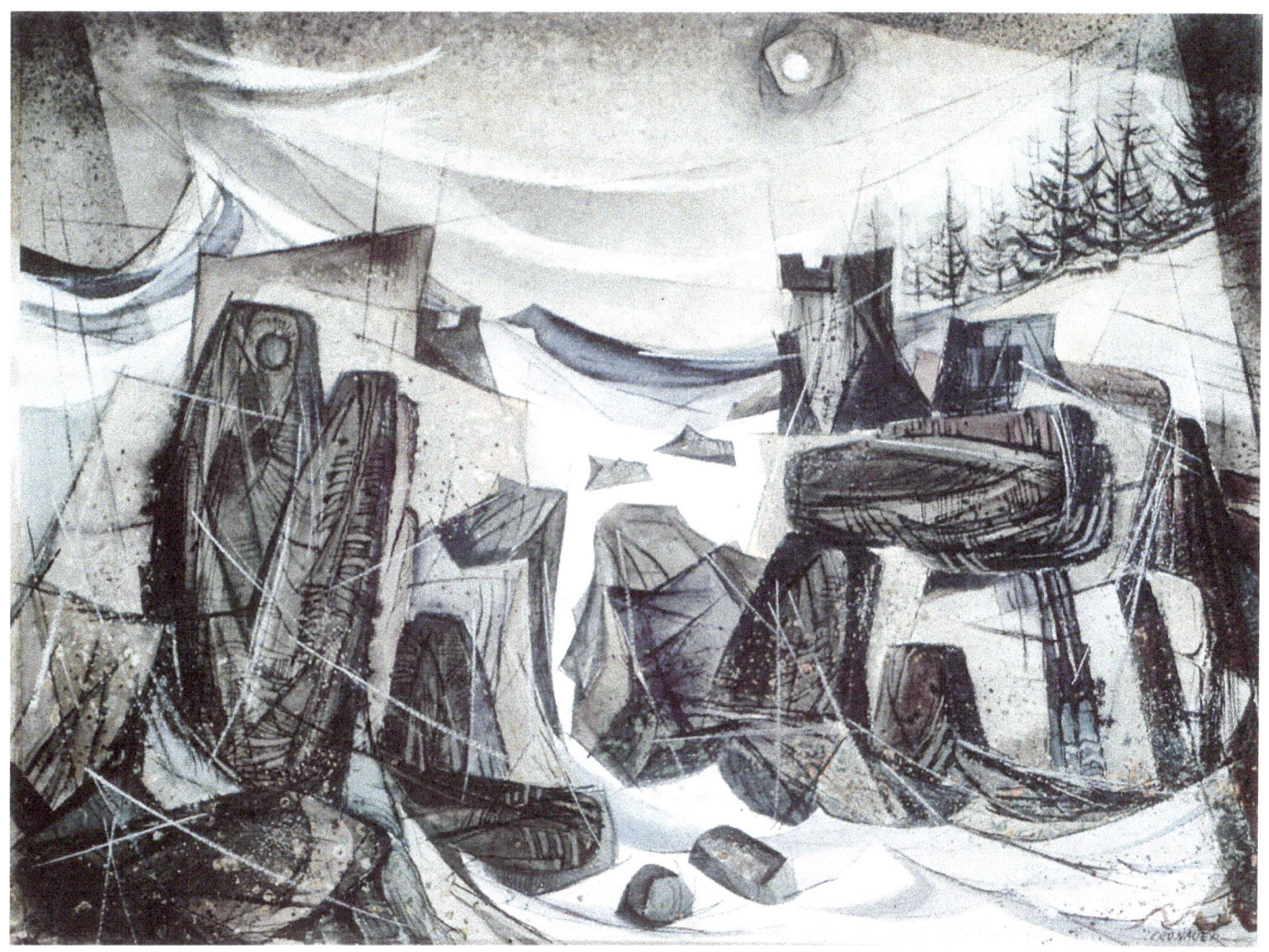

Rocks and Surf *by Robert Cronauer, Watercolor with crayon particles, 22 x 30 inches.* Line, the most ancient and direct of art mediums, is skillfully woven into this fine work. Line is employed to catch the eye over a given course, to establish contour, to make connections among rock shapes and the spaces around them, to symbolize a forest area against the sky shape, to create facets, to impose a cubistic grid, to foster interest by contrasting straights against curves, and to enliven uneventful areas. Cronauer's shapes place rock against ocean with that wonderful degree of apartness from actuality. Additional richness results from the texture of wax crayon shavings which are dropped onto the paper and heated from the underside to fuse them into the surface. Diluted ink washes are spattered with a toothbrush into wet and dry areas, especially at the borders where their darkening effect increases the sense of containment. Cronauer has been a salutary influence on hundreds of students who have benefited from his guidance.

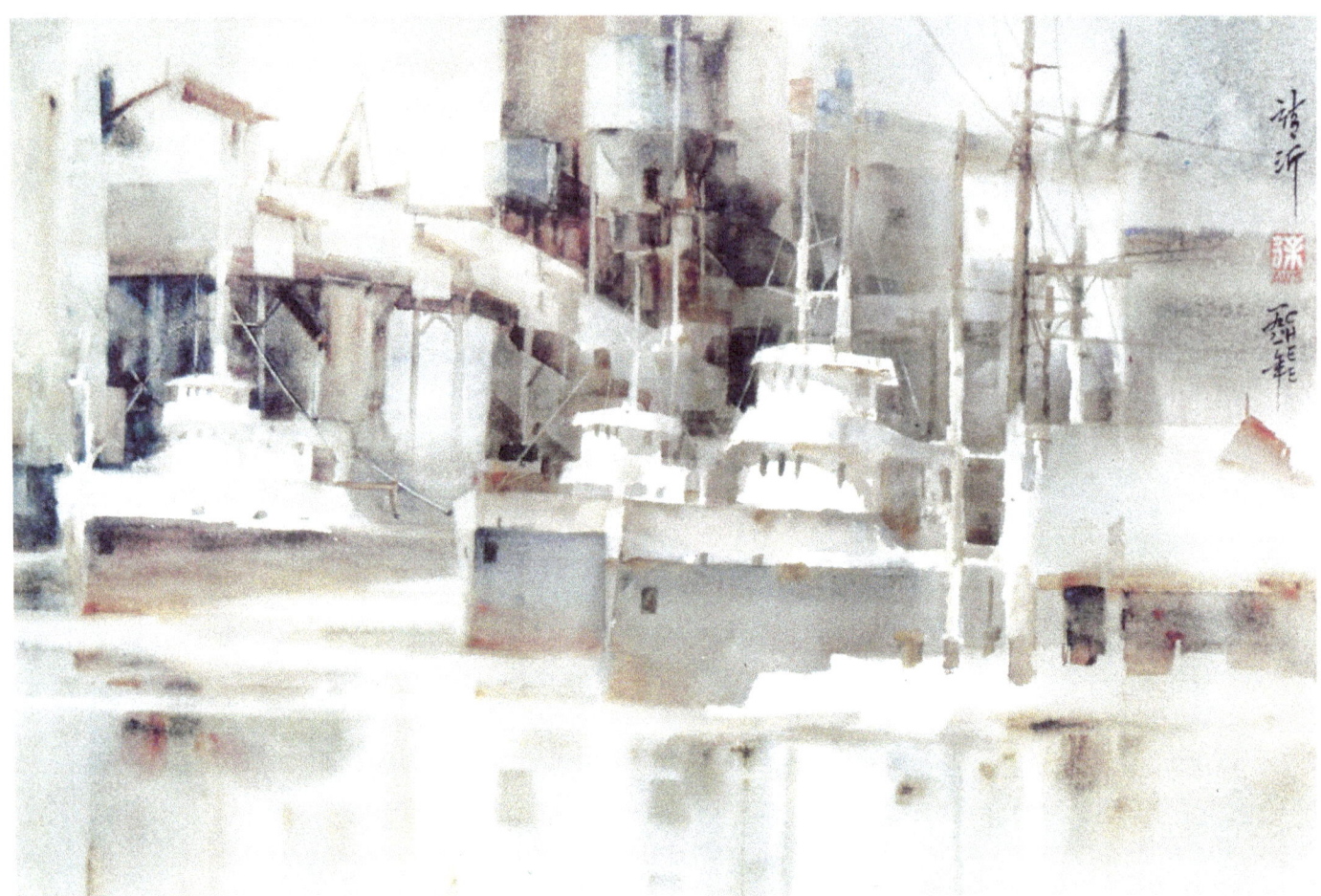

Grain Terminal II *by Cheng-Khee Chee, A.W.S. Watercolor, 24 x 36 inches.* Chee has roots in the Chinese tradition and he paints in both Western and Oriental styles. Oriental work employs more fine brush work while Western art is epitomized by wash areas and chiaroscuro. He aims to synthesize these traditions. Chee admits to greater interest in representational art rather than abstract. The motif of this painting is from the Great Lakes city of Duluth. Huge shapes of ore ships with lacey lines make a decorative pattern against harbor buildings. The superstructure of the ships offers a nice unequally-sized trio of whites with rhythmic placement and intervals. In placing his whites against the darkened harbor buildings, Chee has exercised his prerogatives as a designer. Notice the size variation of a large ship at the right, a small piece of a ship behind the former, and the middle-sized ship across the water. The step idea presented in the ship hulls is repeated in the steps of the chute-like structures above. The harbor water expresses its wetness with suggestions of calm water through reflections. Happily, the reflections are not exact reverse repeats of the shapes above. Chee has conveniently contrived a light area, top right, against which is the enjoyable dashing calligraphy of wires and poles. Of course these things happened because Chee has re-created nature for us in accordance with pictorial design and possibilities, rather than the world as it is.

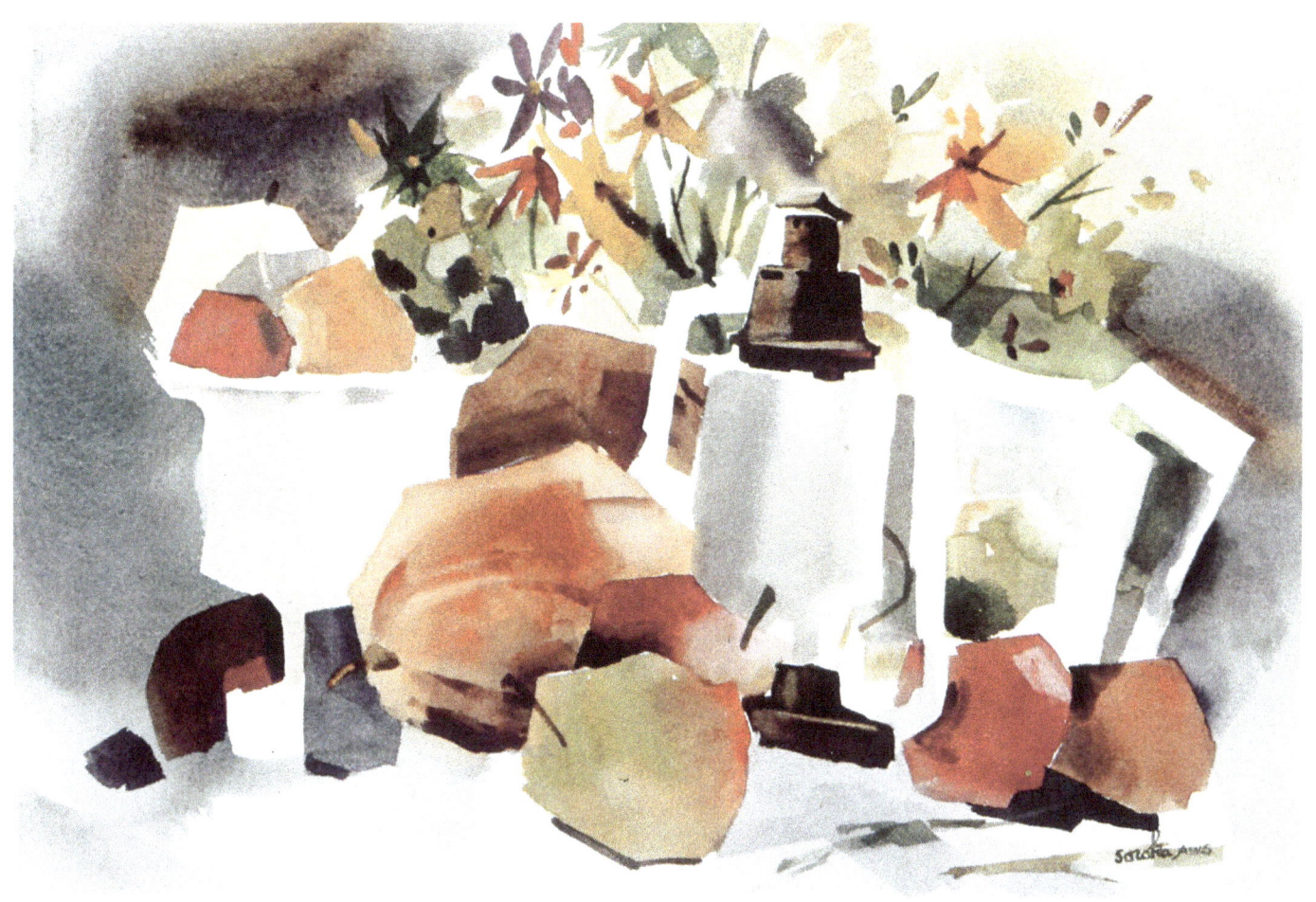

Still Life With Lantern by *Margery Soroka, A.W.S. Watercolor, 15 x 22 inches.*
Overlapping shapes re-create a reality of space while maintaining the essential flatness of the paper. In the words of John Sloan, these symbols are as real to the mind as they are to the eye. Soroka has energized her curved shapes with facets of straight contour, pushing the work closer toward abstractionism. Also consistent with that visual idea she has modulated the tonal areas into similar facets. The emotional content of brush marks is heightened by the simplified flat pattern. For the sake of design, Soroka has thrown her light from left and right directions as it suits her purposes. One can also appreciate this handsome work on the basis of the interest created by the great variety of sizes: some small, some middle, and some large.

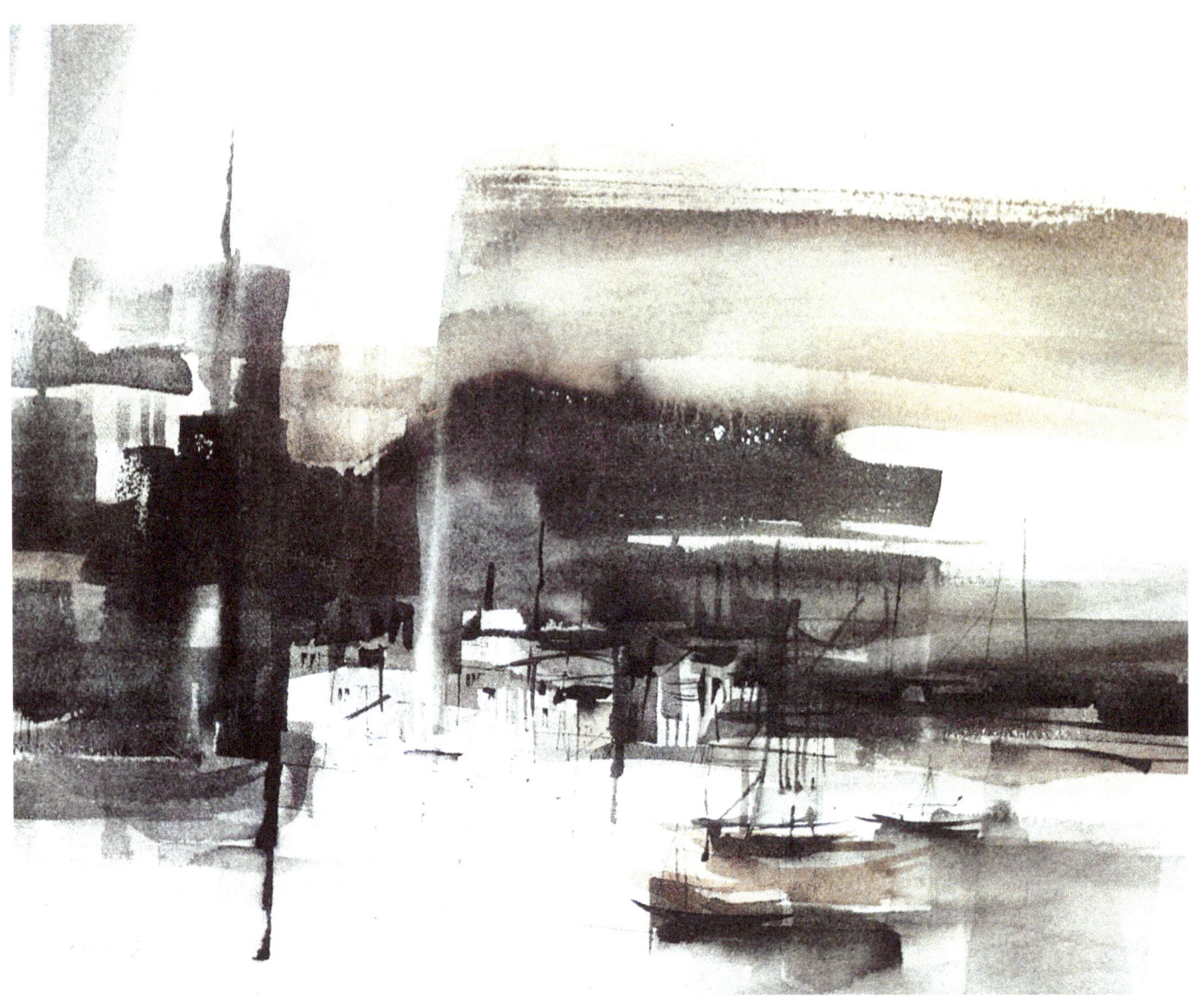

Autumn Harbor *by Doris White, A.N.A., A.W.S. Watercolor, 14 x 18 inches.*
Consider the unity of this painting. It hangs together just as fabric does. Large horizontals (woof) are woven through smaller verticals (warp). The clearly seen dark makes a fine shape which is rightfully wedged against the well shaped white. Although physicists disclaim white as a color, its effect in painting is tantamount to color. Chesterson said that "the chief assertion of religious morality is that white is a color." Noteworthy in this painting is the interest achieved by the extreme contrast of large brush marks with a very delicate web of fine line calligraphy. Between these extremes are intermediate sized lines. Large interlocking wedges penetrate from each border. Since color is restricted to a warm hue and a neutral gray, the gray functions as a cool contrast in this relationship. The suggested harbor and boats allow the observer to make visual discoveries. This painting has been in my collection for three years, during which time I have been able to savor its many qualities. I have often looked to the corners, where I find a maximum contrast of shapes, sizes, and directions with no two corners alike. It is difficult to linger in the corners, for one is propelled in a contripetal manner into the pictorial space. Inspect the edges of any shape in this painting, and see the wonderful variations of edges. A minimum of rough edge dramatizes the essential wet look provided by the soft edges and diaphanous glazes.

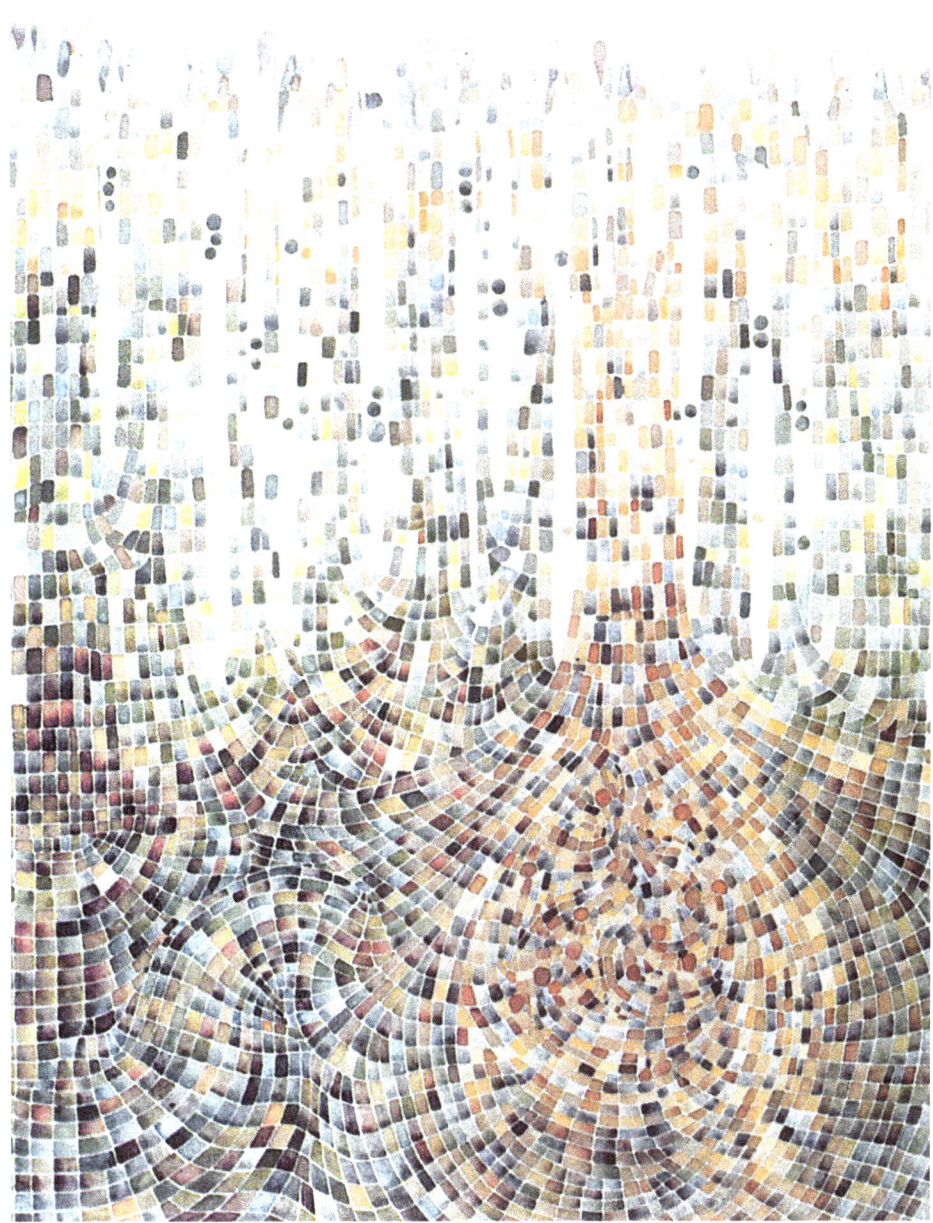

Cross Section: Ascus layer with Spores *by Bruce Bobick, 30 x 22 inches.*

The immediate impression here is one of a mosaic in which gradation plays a major role. There is a gradation of tone, from lighter at top to darker at bottom. Chroma grades from high within the bulb-shaped area to lower chroma in most directions away from that area. In the same location is a dominant red hue grading to other hues beyond its borders. Thus, coloristically, gradation is present in all three properties of color. The large bulb shape, has a gradation in width from thin at top to wide at bottom. Another variation of gradation is set up at the bottom where radiations (gradation in all directions simultaneously) overlap and interact. Close inspection will reveal that each single spot of paint contains a gradation. Although this work is very controlled in the deliberate rendering of cellular spots, they organize themselves into entities which possess gesture. An organization of entities constitutes a nexus, a pseudoscientific word which means the bond among parts. Sounds familiar since it is a definition of beauty.

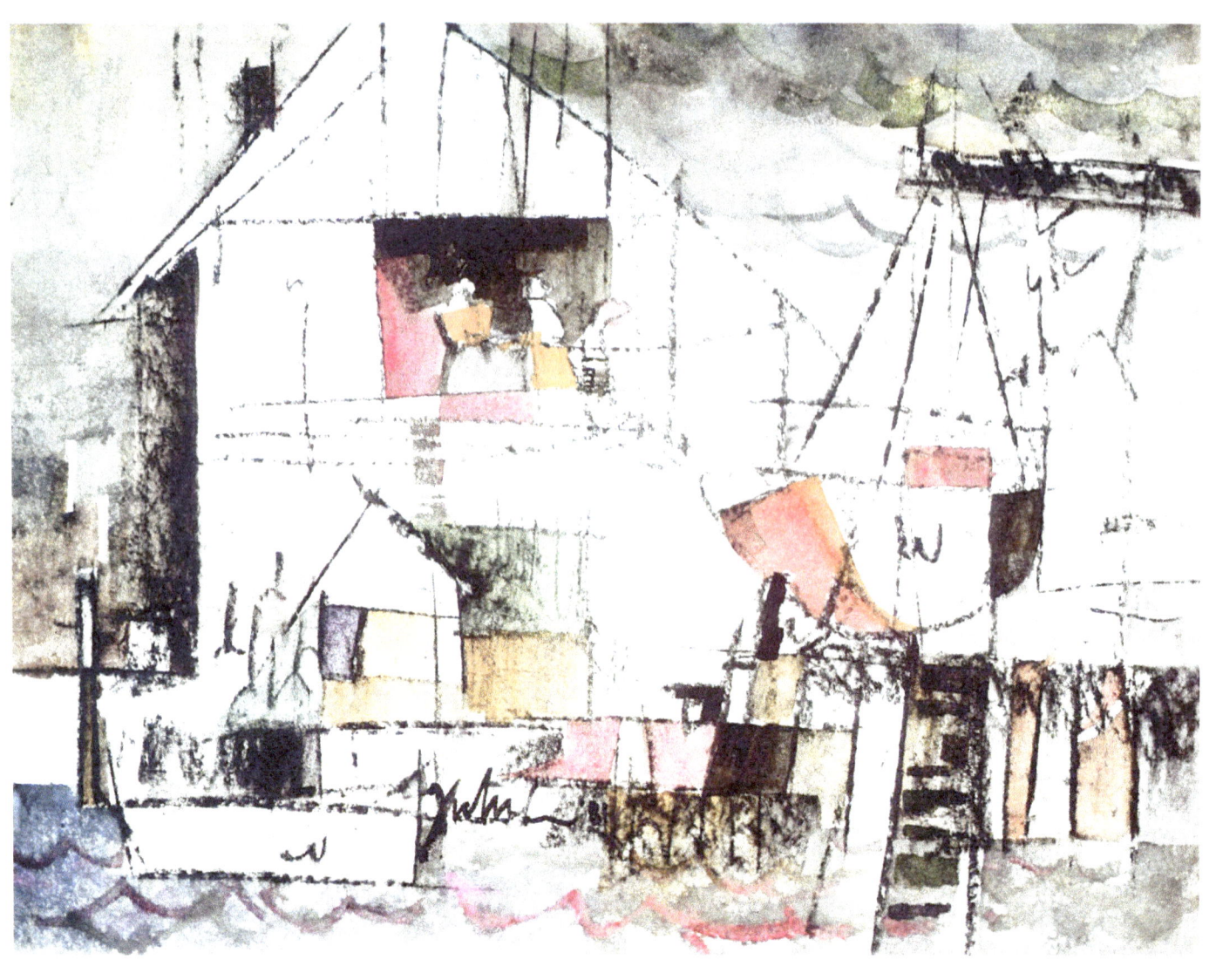

Boat Basin by Henry Fukuhara, N.W.S.
Watercolor, 18 x 24 inches.

Nature is re-created in synthesis of line and wash. Line for the sake of line (calligraphy) is skillfully woven into many of Fukuhara's paintings. In these examples, stick charcoal is employed, with the paintings receiving a spray of fixitive after completion. An absorbent, fibrous paper adds to the surface interest of both charcoal and washes. Space is controlled by the employment of flat shapes skillfully overlapped. Calligraphic water waves at the bottom are echoes in the sky, and in the boat sling which also creates a powerful spatial sensation. A thickness is given the otherwise flat boathouse by that wide charcoal tone at the left. This painting exemplifies the semi-abstract esthetic. It is also powerful evidence of Fukuhara's great interest in painting. Would anyone accuse him of indecision, timidity or apathy?

Park Division *by Henry Fukuhara, N.W.S. Watercolor, 18 x 24 inches.*

This black halftone reproduction reads easily as areas of tone. Anyone could lay tracing paper over this painting and outline the areas of white or dark. Vertical brush marks in the center sky area increase unity in two ways: first, they repeat the direction and straights of tree trunks; second, they help avoid the funnel effect of deep space (paintings should never contain areas which look as if there were holes punched back into space, or areas which look as if parts were tumbling forward, out of the painting). These marks keep us aware of the focal plane. Tree shapes make connections with sky tones and white, house shapes. Trees also wonderfully overlap one another, as though happy to be in association. Among all the well-defined obliques dominating this work, note the few verticals and horizontals which dramatize those obliques and relate the scheme to the vertical and horizontal borders.

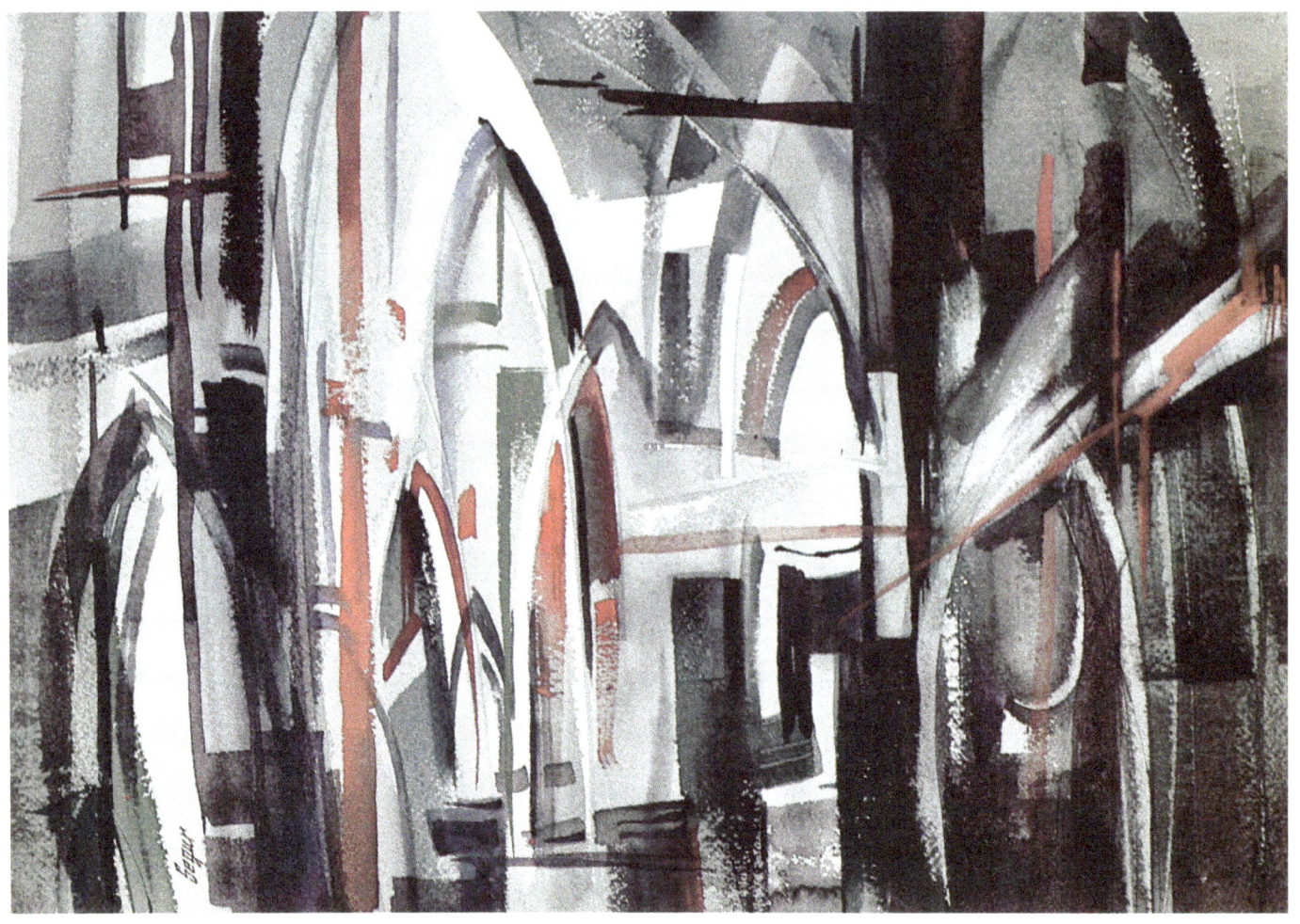

Cathedral of Pines *by Eleanor Segur. Watercolor, 15 x 22 inches.*

Gothic style church windows have been characterized by pointed arches since the 12th century. The concept of a forest interior as a cathedral has a visual and spiritual logic. Is there any kind of variation which Segur has ignored in expressing her dignified arches? Curves are slow and fast, quiet and loud, high and low, near and far. Not one of the many arches is a static, altogether complete arch. They each melt into others, interrupt, combine, or overlap, thus all are integrated into relationships by bonds. Since this work was painted on location within a pine forest, there is the vestigal imagery of the pine trees. An uplifting feeling results from the long Gothic arch shapes and trees presented in this watercolor. It is, therefore a direct presentation and not merely a representation of a forest. It is a communication not limited to what the forest looked like, but what the artist felt and thought at the time of execution. Since this painting hangs in my collection, I inspected the paper for a watermark and found, sure enough—Arches brand paper! Since rough paper was used, the texture of the forest is suggested by rough brushing here and there among the cascading brush marks. You cannot find any brush strokes which are not, at once, structural. Segur's students benefit by exposure to her creative convictions and commitment to craft.

Along the Ohio Canal *by Don Getz, M.W.S. Acrylic on acrylic gesso coated, pebble paper, 60 x 40 inches.*

A believer in fundamental draftsmanship and representational painting, Getz has developed a method of painting with transparent watercolor paint on acrylic gesso, which allows for repeated wipe outs and repainting. More important than what kind of paint is used, or what object matter is chosen, is what the artist asks the paint to say. What are the painter's findings? What kick does the painter get out of life? Don Getz enjoys close contact with his Ohio countryside plus excursions into New England. A subsidiary quality which arrives with this degree of naturalism is a sense of place. Triangular shapes abound in this painting. Calligraphic tree marks skewer areas together. The building and landscape areas read clearly against the white snow background. A small but significant detail is the triangular shape made by visually connecting individual triangular shapes of the birds.

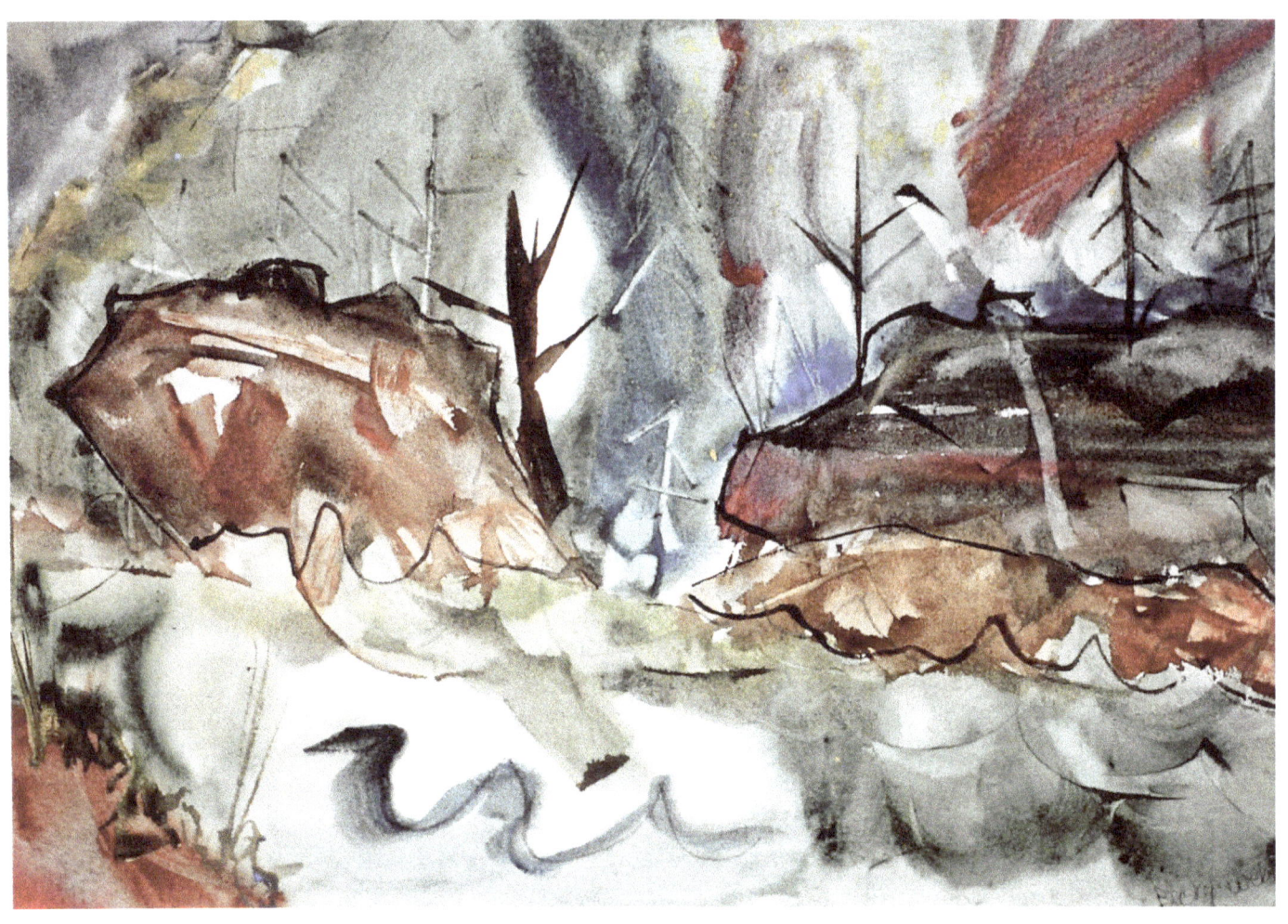

Wilderness at Ohiopyle, Pa. *by Rebecca Webb. Watercolor, 15 x 22 inches.*
This painting was made on location by my daughter when she was age 13. I enjoy watching the development of beginners in workshops, for they make more progress than others. This painting has a green hue dominance. The whitewater does its dance on wet paper while trees and rocks express the wilderness. Exemplified here are clear intentions of pattern, color and brush manipulation. After students gain sufficient technical skill many find what fun it is to paint, and are caught. Such enthusiasm should lead to serious study and constant drawing. By drawing, the student learns what to leave out, thereby developing a personal language of visual nouns and verbs. All across the country are people who "took" art in college and, after a hiatus, have returned to a concentrated study. Many of these have earned professional status. Moreover, they have enriched their lives.

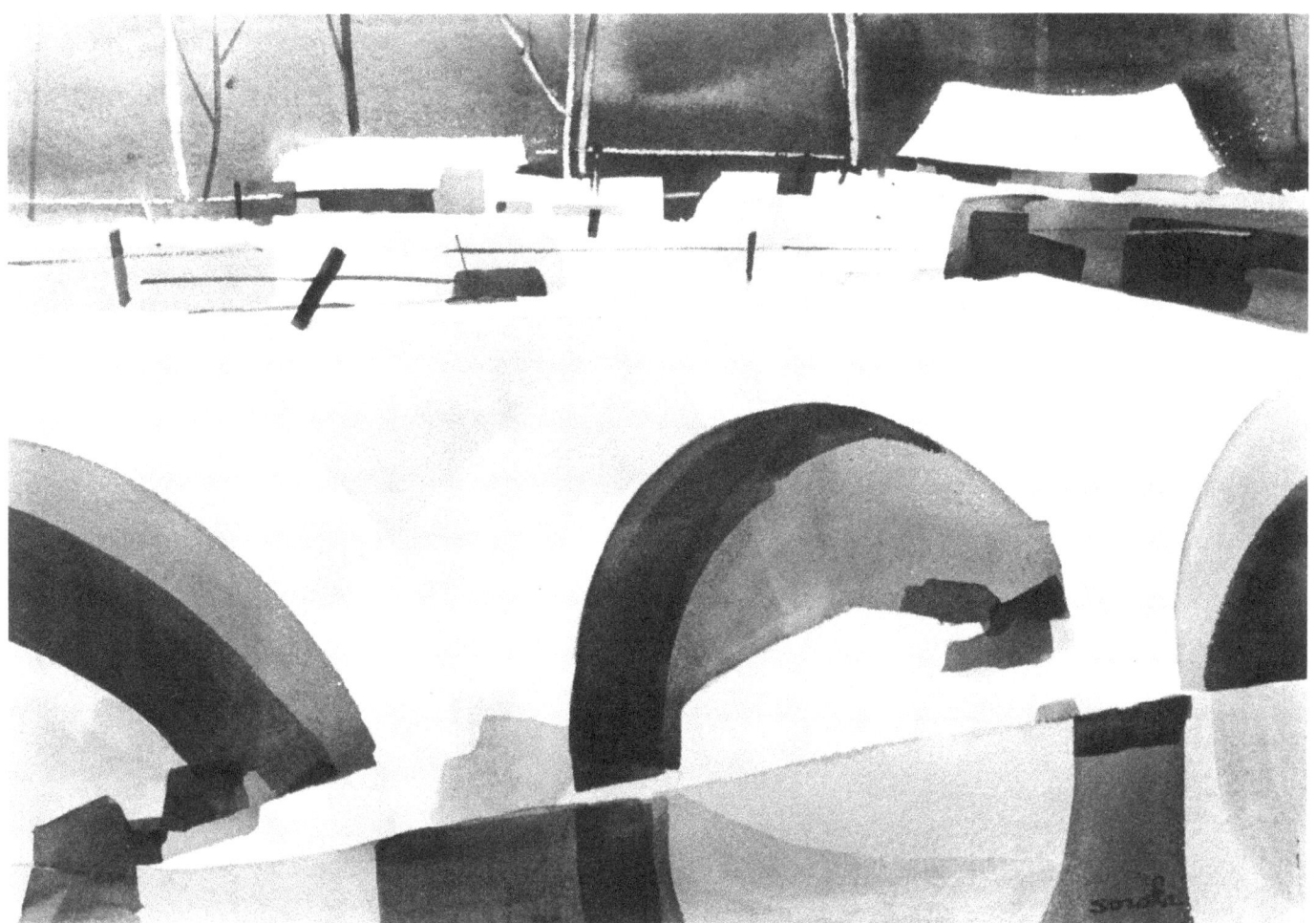

Bridge at Great Neck by Margery Soroka, A.W.S. Watercolor, 15 x 22 inches.
The bridge, though made of concrete, makes a leap through space. An interesting deviation from factual perspective is seen in the center arch where thickness is shown at the left of this arch rather than the right. Reflected tones in the water are arbitrarily opposed, whereas in ordinary reality they would mirror similar tones. Knowledgeable designers may (and must) exercise such deliberate liberties. Because the bridge deck travels continuously across the entire paper, Soroka introduces another space cutting waterline across the bottom which not only serves as a distinguished repeat, but helps to maintain flatness. I call this kind of device a "fracture." Using your eye, connect the three rock groups, starting from bottom left. Appreciate the direction of this axial angle which makes a nice rhythm in relation to the waterline. Bridges are connections between realms. Paintings are like bridges. A painting such as this makes connections between the objective world and the self, thus making us knowers. In this sense, all painters are teachers.

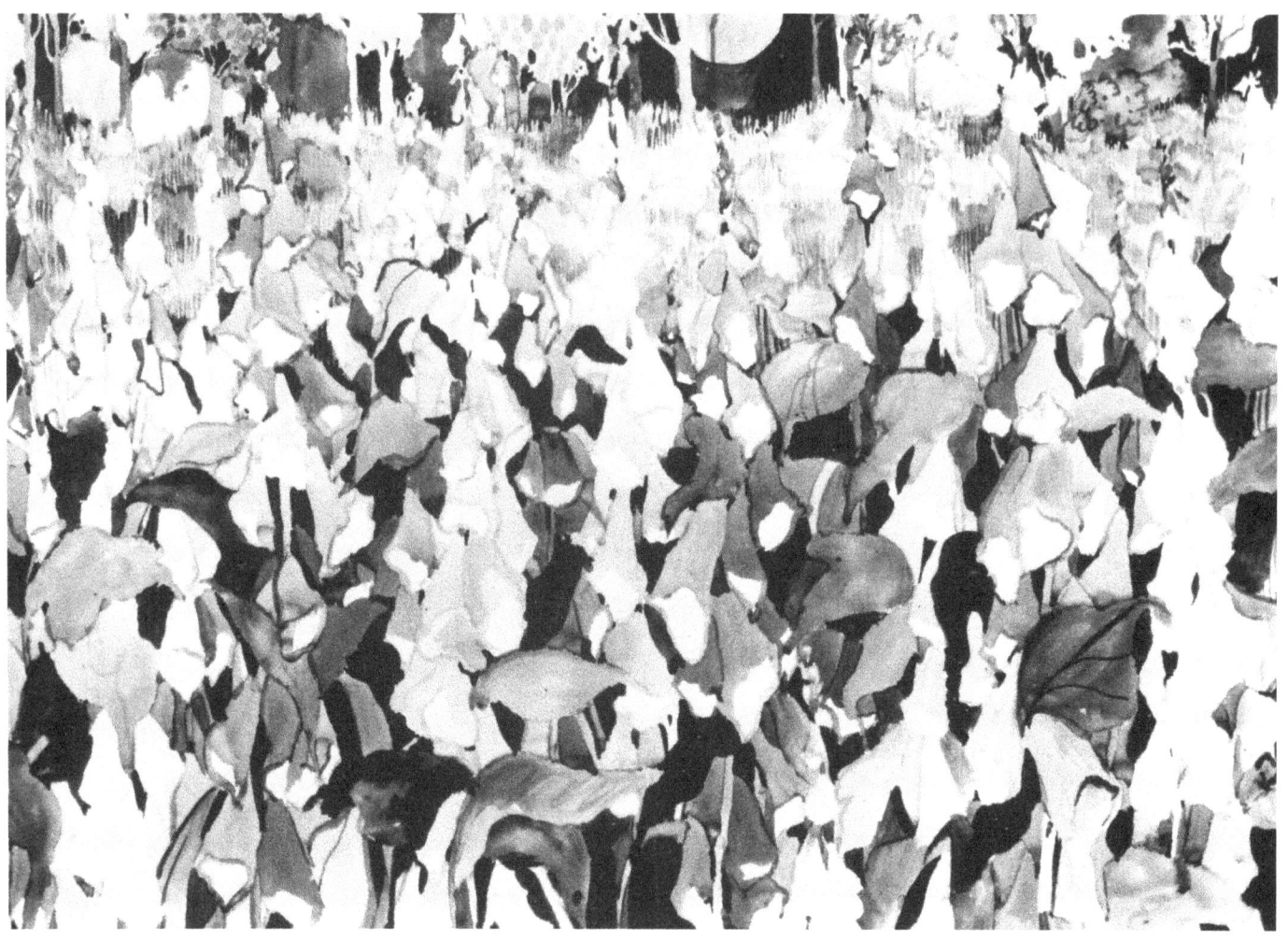

A Midsummer Night's Dream by Terryl Speers, Watercolor, 15 x 22 inches.
The Shakespearian title suggests the dream world of which Plato spoke when he said that a painting is a man-made dream produced for those who are awake. The flowers have people shapes, they wear pixie-like costumes and hats, and they dance in the field.
From Shakespeare:
> "I know a bank whereon the wild thyme blows,
> Where oxlips and the nodding violet grows
> Quite over-canopied with luscious woodbine,
> With sweet musk-roses, and with eglantine:
> There sleeps Titania some time of the night,
> Lull'd in these flowers with dances and delight;
> And there the snake throws her enamell'd skin,
> Weed wide enough to wrap a fairy in."

Concerning formal qualities: the most noticeable characteristic in this painting is that big piece of texture which reads as a plane (meadow) in recession. This effect is produced by diminishing sizes as they go back into distance.

Collapsed House *by Henry Koerner, A.N.A. Watercolor 24 x 18 inches.*
Koerner claims an affinity with such subject matter from his remembrances of wartime Europe. The visual crescendo or center of interest in this painting is the white area toward which we are expertly led. He requires a model or motif for each work. I was visiting as Koerner built and maintained a small fire on his side porch while he painted tones, colors, and interlocking shapes of flames and smoke. Koerner often makes huge works beyond the largest paper size by painting separate modules of paper stretched on canvas stretchers. When assembled, they constitute a jumbo-sized work which can be easily stored, transported and exhibited. A curious technical quirk was noticed; Koerner uses a small oil painter's cup clipped to his palette for a water container.

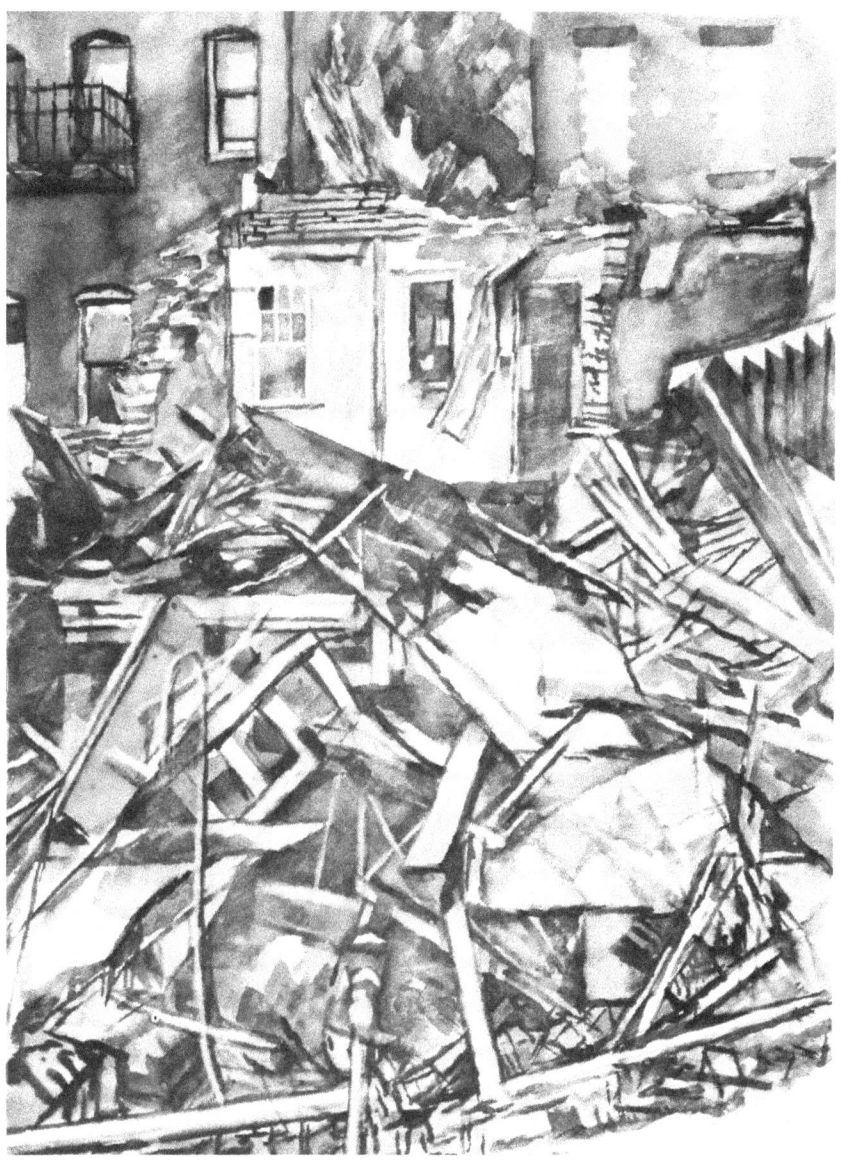

Ore Carriers *by Cheng-Khee Chee, A.W.S. Watercolor, 24 x 36 inches.*
Ore boat superstructures are on the extreme ends of the hulls. Thus, Chee is able to make significant shapes of white. His foreground suggests the busy activity of the locale. Although it is not apparent in this reproduction, the dominant color is akin to ore color (red oxide). Notice how the auto is integrated into the foreground shade, its windows blend into the surrounding similar shapes and sizes of the dockside boxes. I enjoy the lacey calligraphy of anchor lines, electrical lines, and ships' rigging, all of which decorate and tie areas together.

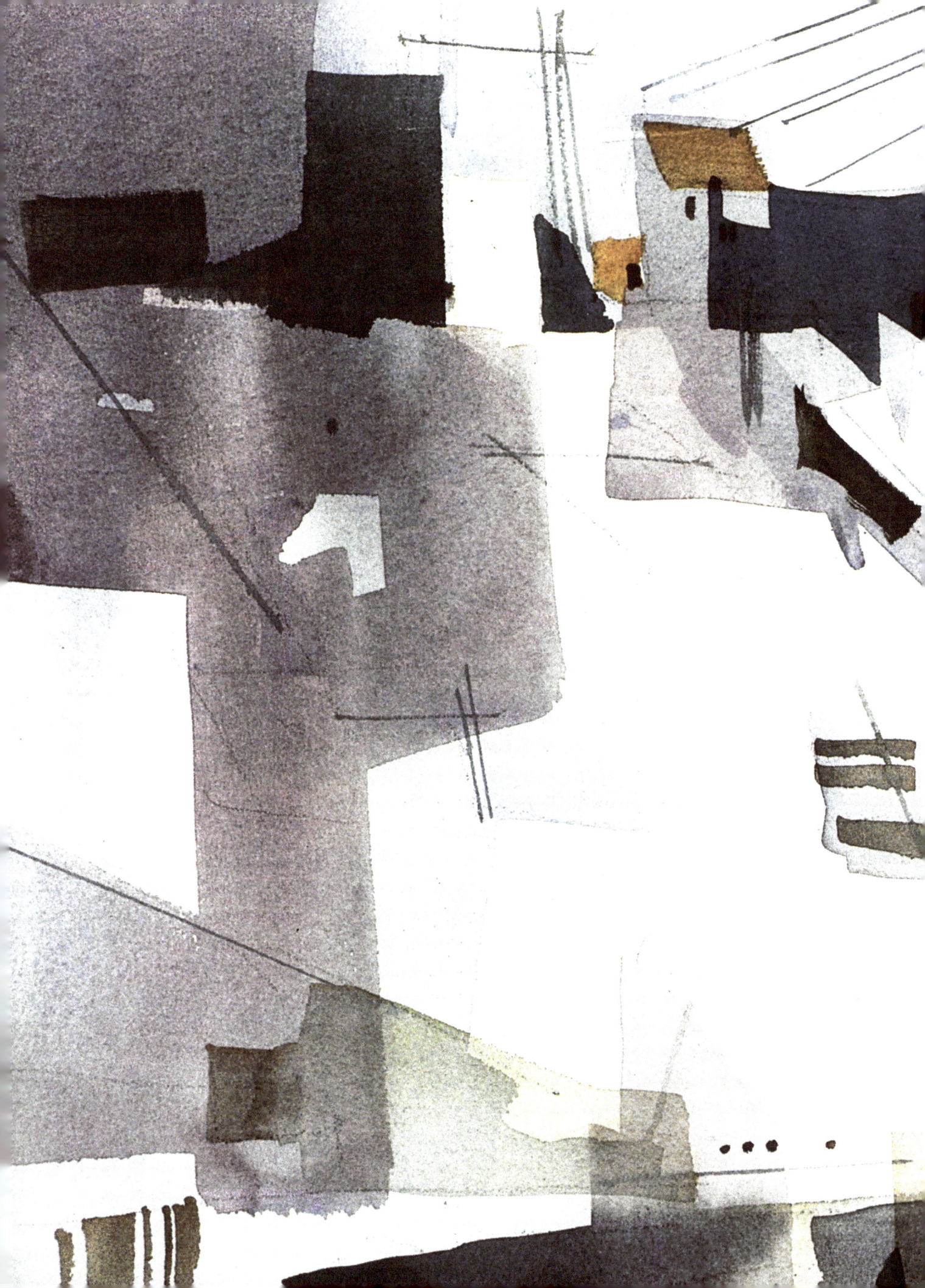

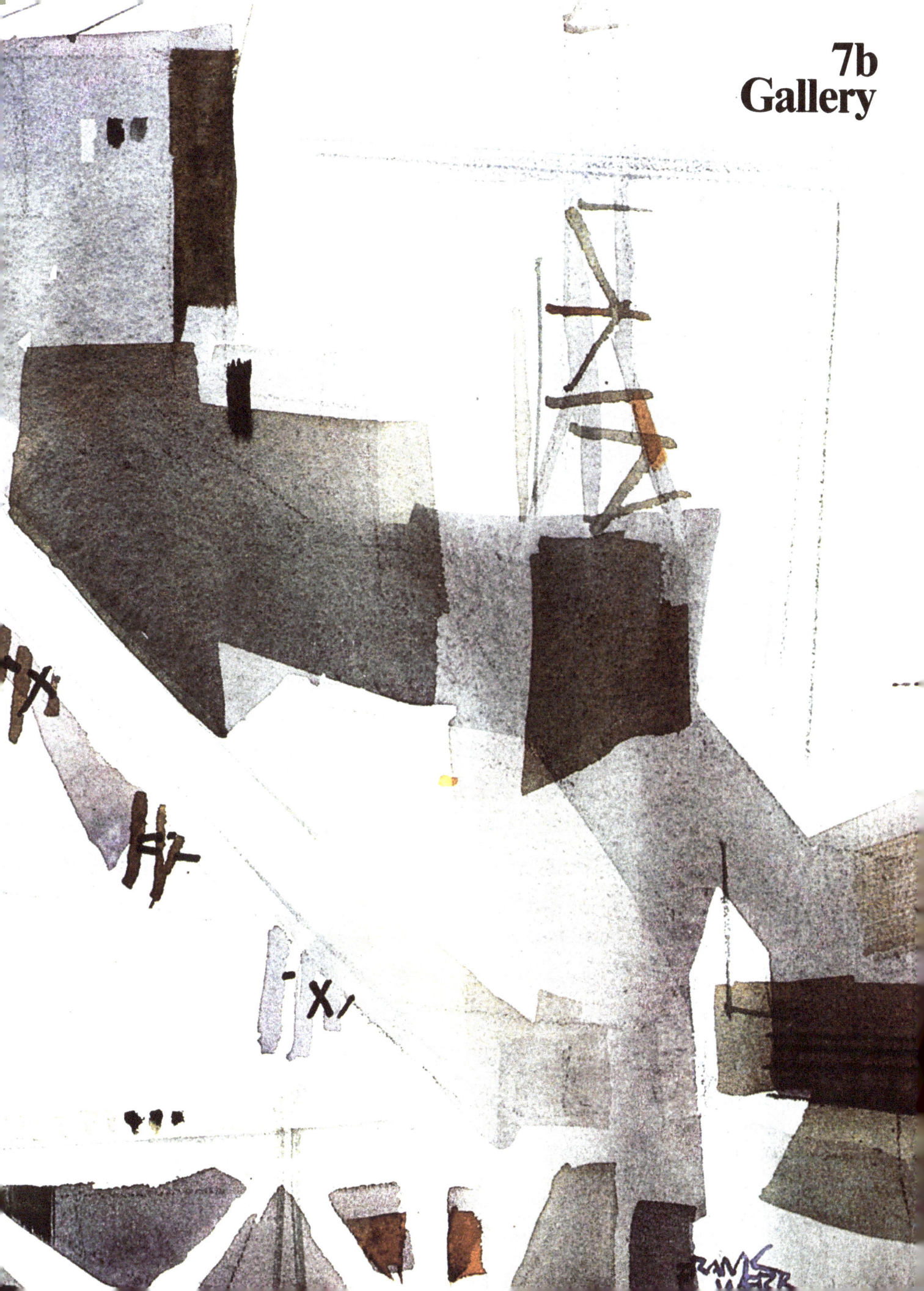

7b Gallery

Pittsburgh Incline *15 x 22 inches.*
Overleaf is the finished painting which began with the naturalist sketch at left. Buildings cling to the edge of a hill which flanks the Monongahela River. Indicated is the inclined rail on which a cable car operates. Man made towers, bridges, buildings and tunnels express the industrial character of Pittsburgh. The hill is resplendent with greenery. This sketch suffers from indecision due to equality of naturalism and man made subject matter (organic and inorganic data). I considered increasing the degree of naturalism while decreasing the abstract. However, I decided to do the reverse and increase the geometry while suppressing the natural.

I made a second sketch which clarifies my pattern and increases a unity of concept. The hill is divided into facets which interact with other areas. This sketch is made with a marking pen and with graphite pencil for midtone. The incline is enlarged and its function made more obvious. Here is semi-abstraction resulting primarily from shape distortion and simplification, a combination of man-made structures with a bit of naturalism. As the incline car mediates between high and low and between vertical and horizontal, so does this painting act as a synthesis between abstractionism and naturalism. As befits a work of art, it also serves as a mediator between the objective world and my ideas about that world; a reconstruction of reality according to my thoughts, feelings and actions.

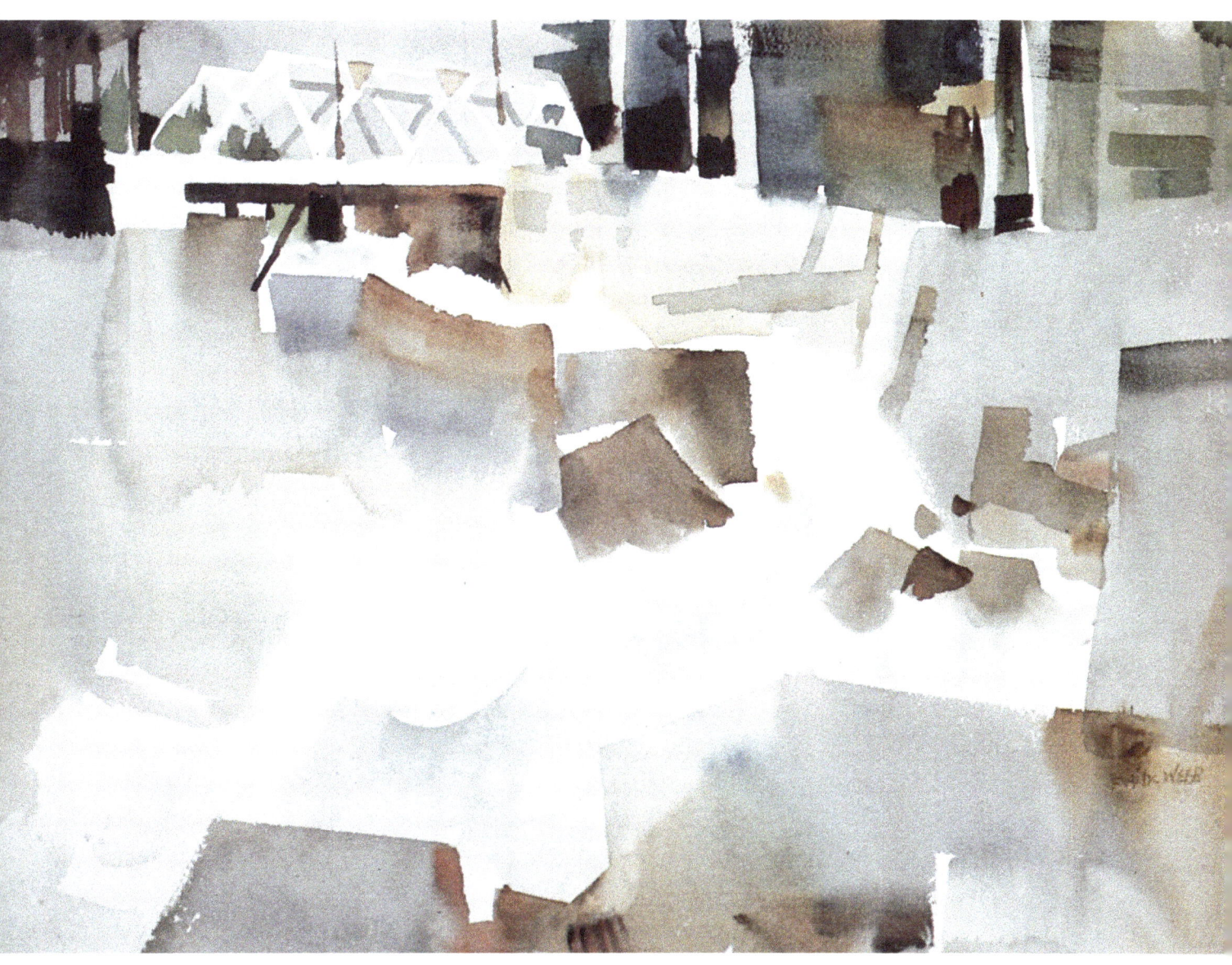

Laurel Highlands *15 x 22 inches.*
Water in nature either lies flat, is tossed into waves as in the sea, or it dashes forthrightly down, as does this mountain stream. No quibbling, water runs downhill. We readily accept the verb "run" as though water were a living thing. As Kuo Hsi, the Sung period artist has written, "Rocky formations are the bones of the universe. It is important that bones be deep and not superficial." The landscape painter should look at a tree-covered mountain just as the portrait painter looks at a head beneath the hair. First the shape or the bulk of the mountain must be expressed and later it can be covered with trees or grass. The superficial viewer merely sees the trees, grass, or hair first, whereas the artist must see surface manifestations only after conceiving the volume or the plane.

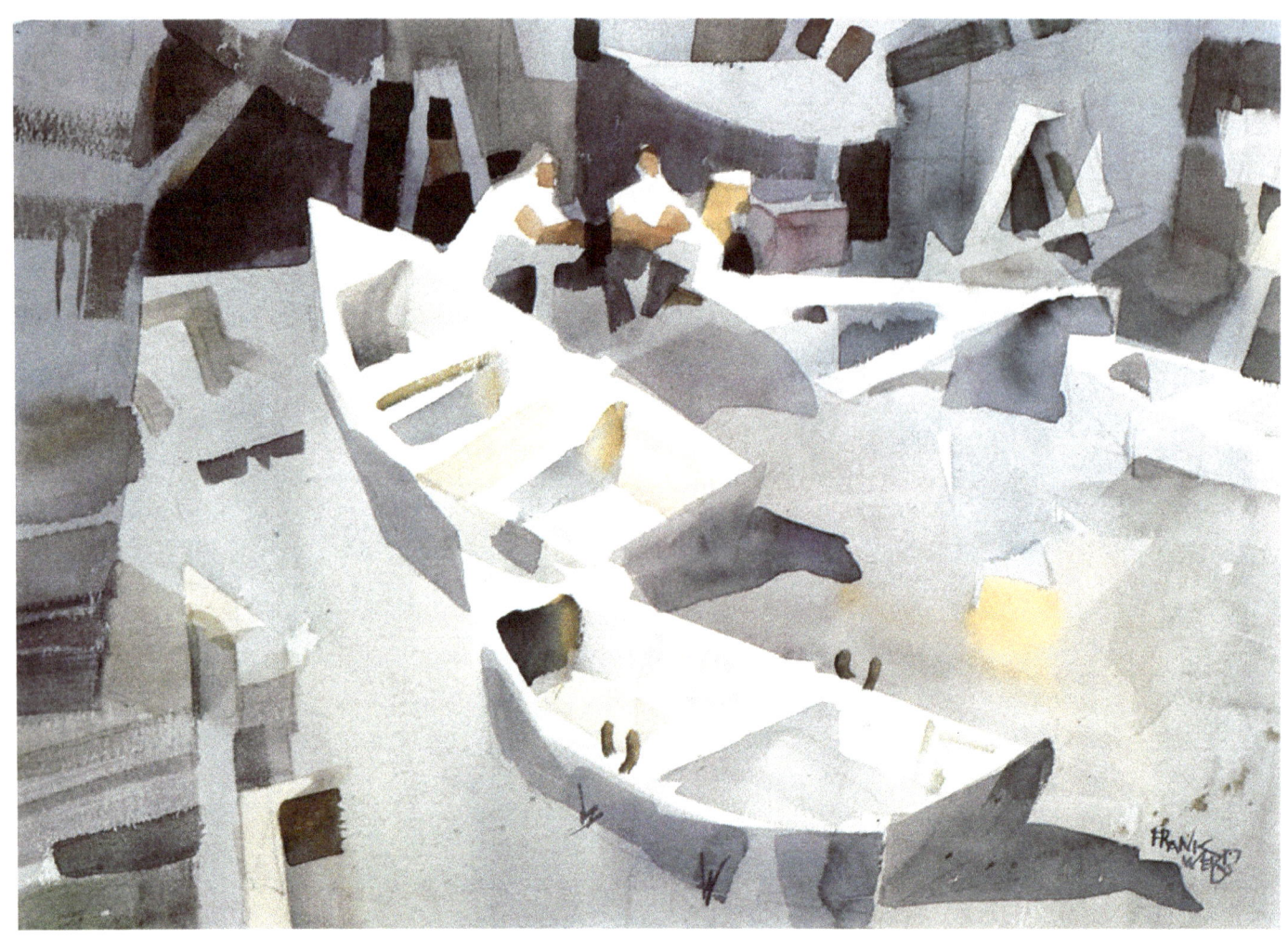

Beached at Isle Madame *15 x 22 inches.*
A blue color dominance unifies this Nova Scotia subject. The figures in this painting are not native fishermen, but fellow painters. The rhythm which exists in the relationship of positions of the two boats is not so much something that is a result of copying the scene, but a clue understood and consequently exaggerated. Fortuitously, the white bow of the boat overlaps the dark at the top left. This was not something that the motif was necessarily doing, but something that the designer is doing. In the dark area is an oblique timber which serves as a guide into the picture toward the right. This painting expresses a spiralling movement into limited pictorial depth which curves around and comes forward. A moment of appreciation and insight has been rescued from the flux of experience and given permanence.

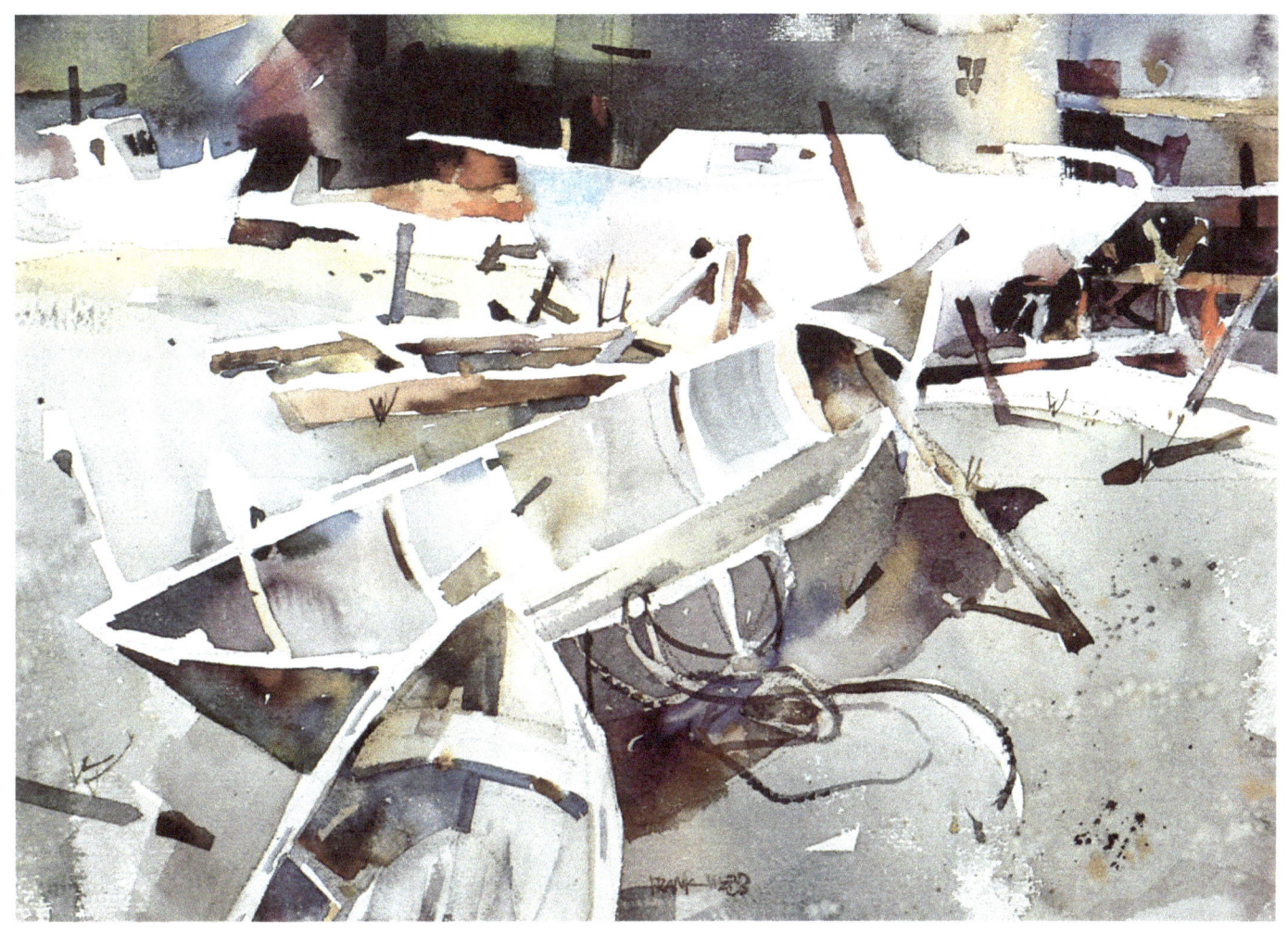

Whale Boat, *15 x 22 inches.*
Scraps of outline drawings of boats were put together here and lit from the top left. Zig-zag movements open the picture plane. These ideas are creations of the artist, not something that is found ready-made. Skids, props, building, sand and coils of line were added, not because they were there, but because I had seen and drawn these things previously. Memory plays a great part in re-creating the symbol which we call a painting. Overlapping shapes and calligraphy help hold it together. The beach with the boats is considered important enough to fill the paper. The picture culminates with the darkest dark against the whitest white at the top left. Clean water (spritz) is spattered on the beach while the large glaze is still damp. Later, some liquid paint is spattered on the dried beach.

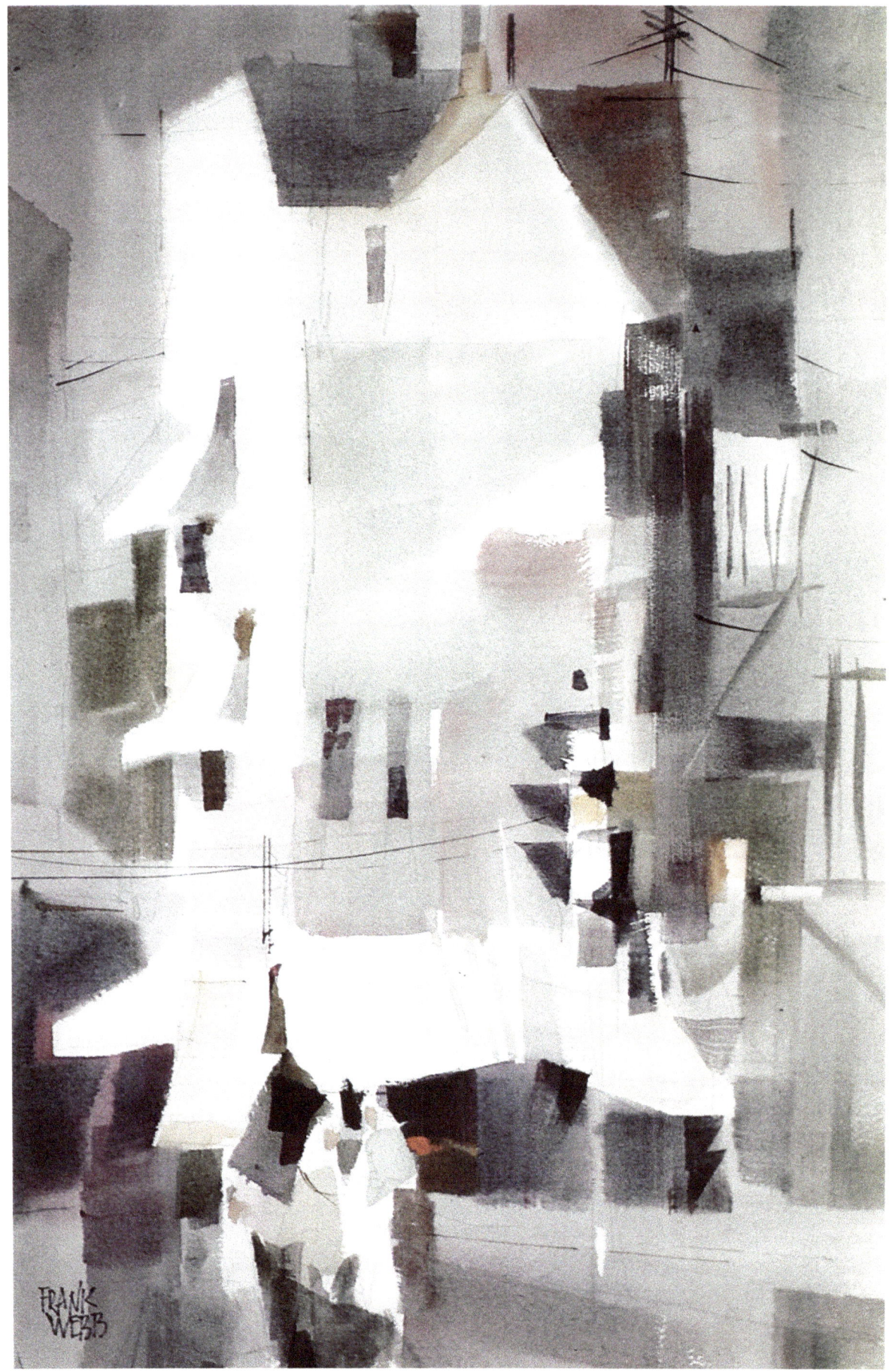

Grain Mill at Pittsford *15 x 22 inches.*
Painted in three separate layers with deliberate hard edges, this method ignores soft diffusions while stressing transparency, shape, well-differentiated tones and optical color.

Left and opposite page: **Flower Mart** *22 x 15 inches.*
This vertical format expresses an urban motif, making use of awnings to enrich shape. The awnings which appear in the photo begged for exaggeration to exploit the vendor idea. A decorative traffic light is enlarged and simplified. The entire concept is only vaguely foreshadowed by the motif (very little of the photo remains). I did not work from the photo. The painting was made long after the pattern sketch. The advantage of a sketch is that it is already a translation, and therefore a degree further away from reality.

Three interpretations of the same subject. In this version three heads are in the best relationship. The white hat integrates with its background. Best of all, the darks are well shaped and located in shifting and alternating positions. I gave this painting a dominant hue of blue.

This painting suffers from an exact repeat of two white sleeved arm shapes. The gesture of the hat and head of the figure at right is the most successful of the three paintings. There is more "edge" interest or variety in this painting, plus interest resulting from a tonal gradation—mostly darker across the top toward lighter tones across the bottom.

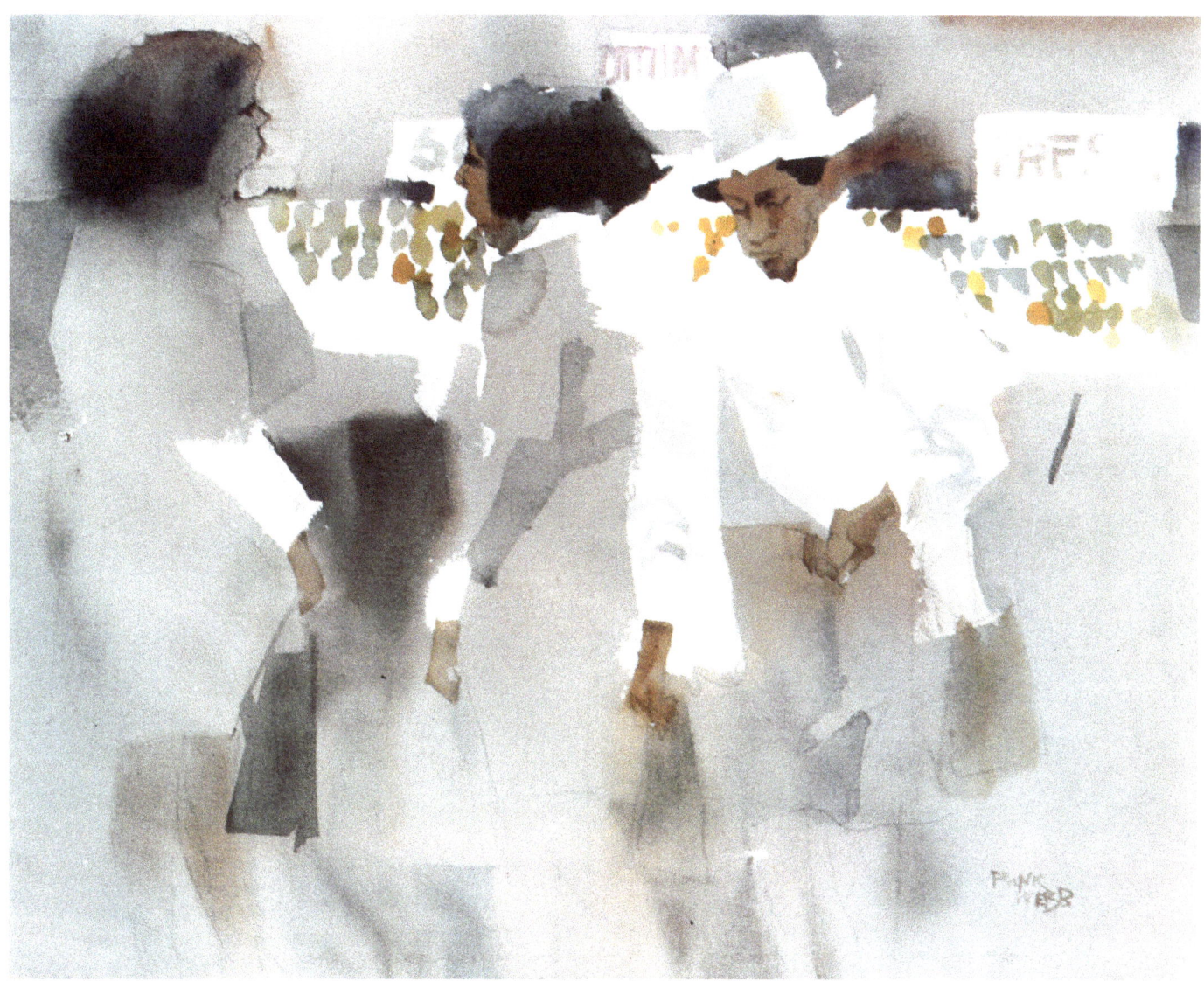

Gateway Shoppers *22 x 30 inches. Collection of David Morgenstern, Duluth.* A series of paintings which explore a subject in depth is often rewarding. With an interest in a certain motif, you are apt to become an expert. Making a number of studies in pencil at a location stores up many more impressions than can be presented in any single work. Watercolors can rarely be duplicated, even when this is the desired goal. All three of these paintings are partial statements. They each have their particular faults and specific glories. The two paintings reproduced on the opposite page were painted in the wet-into-wet method. The experience of painting these gave me more assurance in making the above version. I worked on dry paper with a large, loose midtone, simplifying color and tone, and making fewer patches. The missing patches make the surviving ones more significant. The white shape has more identity, its shape and gesture improved. If less is more, this job has much less; it is more decisive. The reader of this painting knows just where to look and to find. A painting should be built as a wonderful hierarchy. There is no place in a painting for "optical democracy."

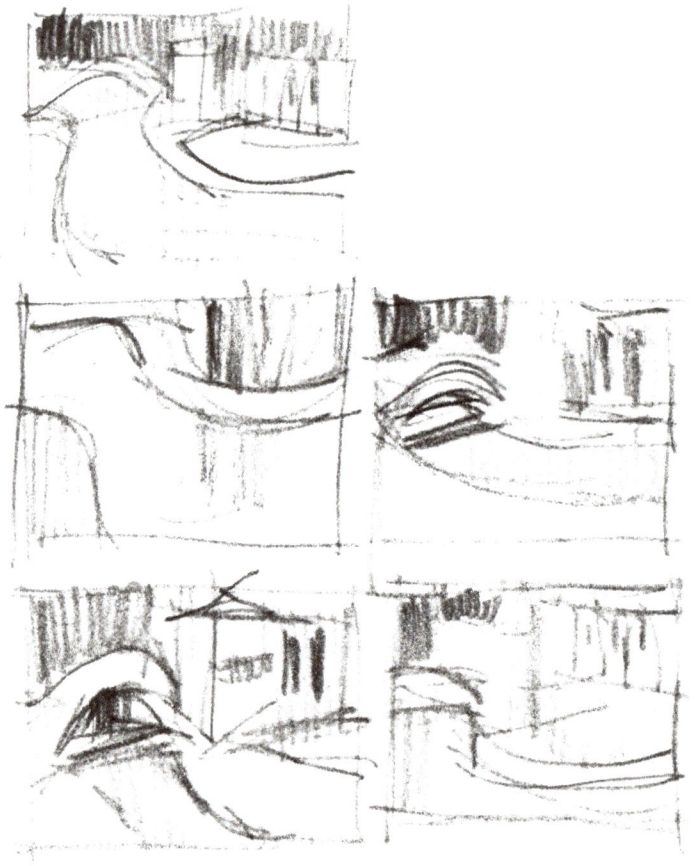

River Theater *Watercolor, 15 x 22 inches.*
A dominance of curves is more difficult to organize than straights. This San Antonio River provides a means of intensifying unity by imposing curves all over. Curves are echoed in the bridge, arches, stadium seating, and the top edge of the trees. Remembering some color-toned papers which were available years ago, I color-toned my paper with a light wash of pure cadmium orange. After it dried, I painted the sky shape with blue/green since it expresses the Southwest. My small pattern sketches helped me to apprehend the gesture of the big curves. Until the big gestures are found, the drawing is not a living design. In a living design the parts are held together by bonds. Beauty is precisely that—bonds among parts.

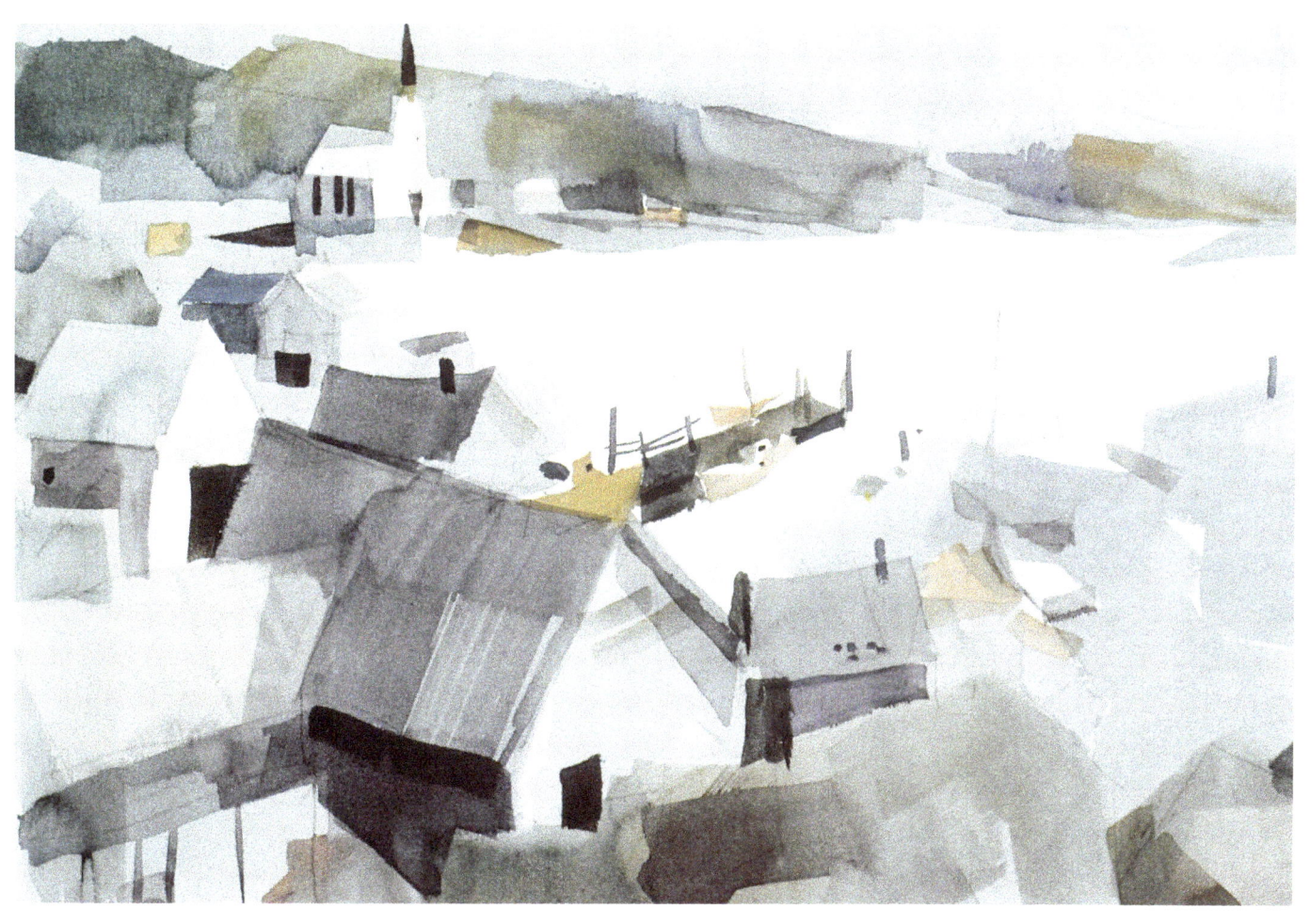

Arisaig, Nova Scotia *15 x 22 inches.*
This was painted as an outdoor class demonstration. We were located on a rocky promontory and there was no opportunity to view the motif directly as I painted. I stood up, took one long look and sat down to paint from memory. Even when copying a motif directly, you are working from memory when looking at the paper. The concept here was easy to hold: a well shaped white bay of water (it was not white) with rooftops rhythmically grouped around and upward from the cove. I brought the church in from its position a quarter mile away. A blue hue dominance was selected, with a few sprinkled warms for interest. As to method, I worked on dry paper. Most attention was given to the shape, gesture, and edge quality of the bay. Within my chosen blue hue dominance is a secondary theme of warm greens vs. purple. What shows up in this work is my delight with shape, design, paint, paper, color, tone, and subject matter; subject matter transformed into content.

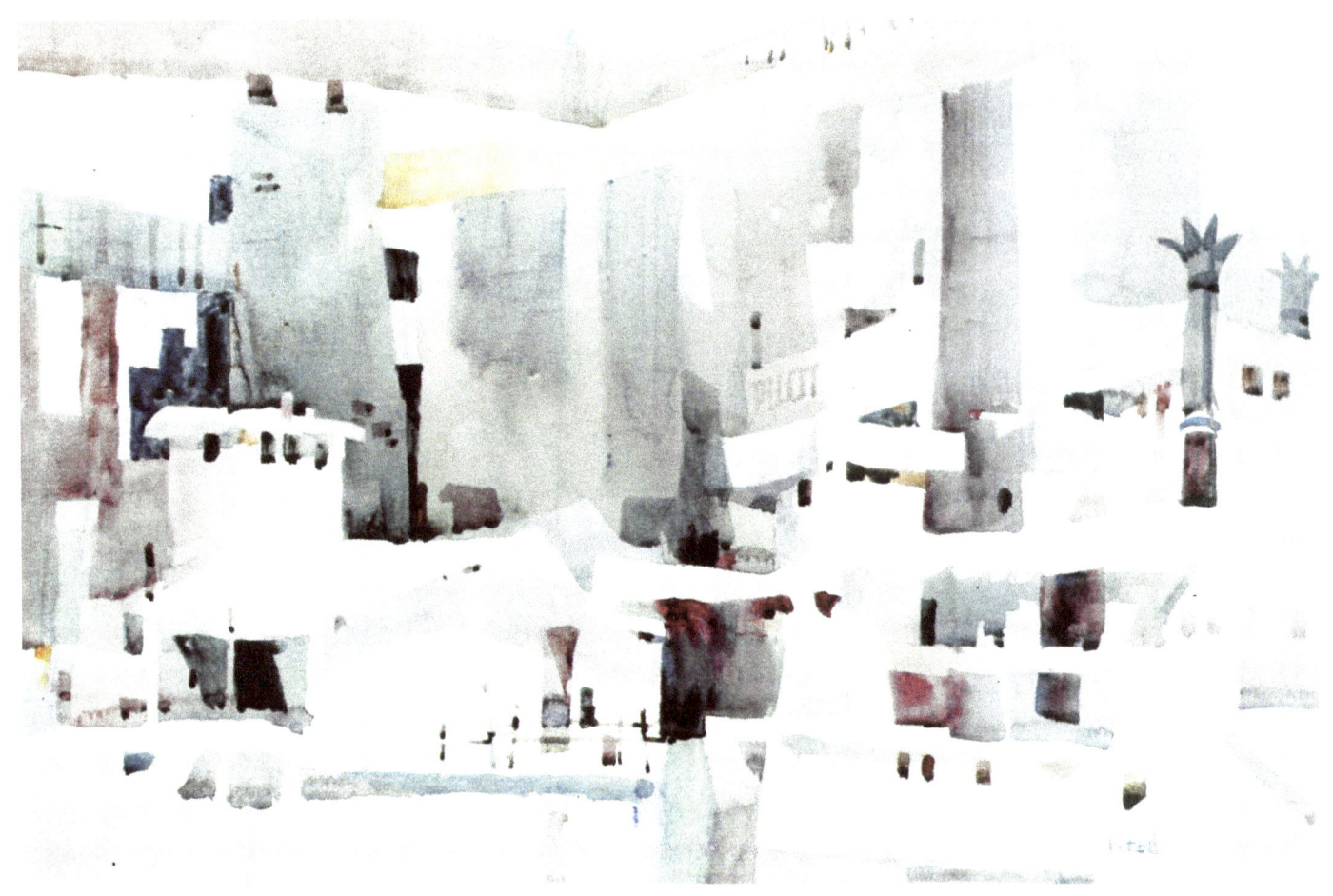

Gateway Fleet *15 x 22 inches,* Private collection.

A piece of hot pressed (smooth) paper is wetted and allowed to dry. This raises the nap slightly, making the paper a little more cooperative, for slick surfaces make the laying of large washes difficult. Small calligraphic touches are glorified on smooth paper. Without resistance, every tremble of the brush is registered. The group of excursion boats is huddled at river's edge, against an elevated boulevard. A blue hue dominates the color scheme with a little yellow ochre and alizarin crimson to create contrast. Most of my concern is with shape and the interlocking of those shapes. Anyone can learn to copy the contours of objects, but it takes a certain amount of knowledge and will to relate the parts of a painting. The last touches were the small spots and lines of the decorative window and fence rail. It was fun putting in these marks. I enjoyed it because earlier I had worried and solved problems of relating larger, more important shapes. Only after those concerns are met can one put in finishing touches with abandon.

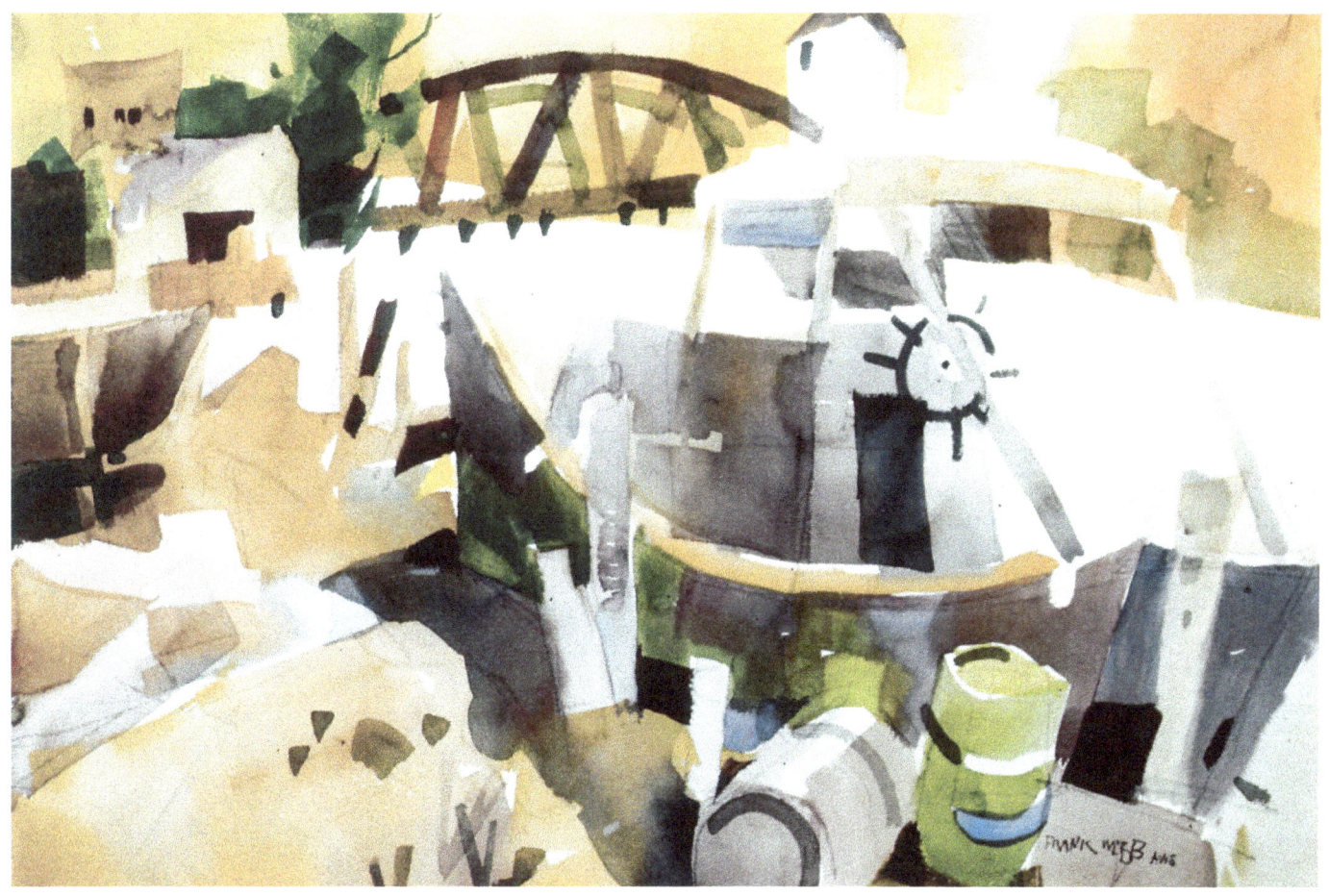

Canal at Fairport *15 x 22 inches.*
A lift bridge with a toll house and a clanging bell. A hot orange dominance. Most of my paintings tend to finish with little areas of unpainted, unplanned whites scattered about. Typically, as here, I tint them with ultramarine blue, giving the work an outdoor look even though the sky was not blue. I use the sun-struck canal as my excuse for white. You will seldom find whites; they must be invented. For integration's sake they should be treated with a little color. The canal white shape is warmed a little at the right, so that it consorts with the orange scheme. You can get along with untouched whites if you also have some ungradated (flat) midtones and darks. It is possible to get away with almost any esthetic deficiency if good shapes are maintained. Eugene Speicher said, "An artist is a distinguished shape maker: varied shapes in three dimensions, his main interest in color is in the coloration of the canvas as a whole. I believe that all art is built on a superstructure of abstract design, upon which and out of which the original idea flowers. In believing this, I am interested in acquiring adequate technical skill and concentration to express myself as clearly as possible."

Mauve Sunflowers *22 x 30 inches.*
With the exception of a little yellow ochre in small touches, this is painted in a limited palette of two colors: viridian and alizarin. They mix to a dull purple or mauve. "Mauve," said Mr. Whistler, "is pink trying to be purple." I began on dry paper, painting around the whites and lightening the midtone immediately as I moved outward from the flowers, using clean water. I insisted on color and tonal gradations in the background. Flower petals are grouped, twisted, overlapped, anything to avoid perfectly boring, circular radiation. Fortunately, the white shape has an oblique gesture. The two pieces of dark are shifting, varied in size, tone and color. Because I wished to express this subject with a positive feeling resulting from high key, I was unable to use local color (yellow) in the petals, for I would lose the whites. Therefore, I avoided the local color of sunflowers which is usually yellow and brown, but introduced a suggestion of that color with bits of ochre, which when mixed with viridian, also provided yellow-green.

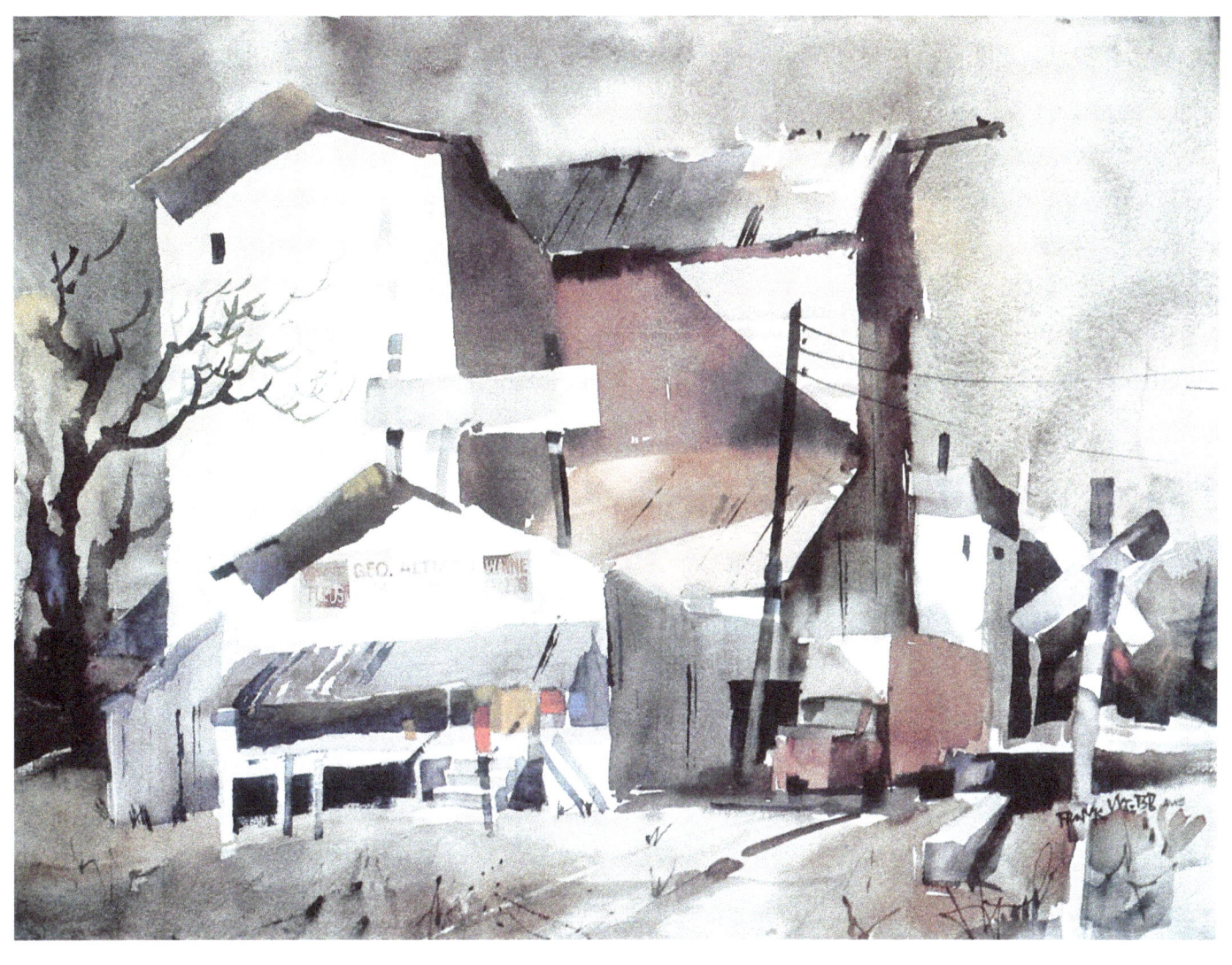

Saltsburg Grain *22 x 30 inches.*
My chief delight is the space created by the L-shaped building. Cast shadow shade is the chief pictorial means expressing that idea. The angle of the cast shadow and the resultant pink triangle of light not only expresses natural light, but adds angular shape to angular dominance already present. Lacey calligraphic tree branches at left decorate an otherwise boring white wall. Above the retail store area a sign is hoisted which improves the shape and gesture of the dark piece of shade. Painted on handmade R.W.S. brand paper, the luminous sky tone went onto the surface sweetly. Observe the alternating tonal contrast of sky against roof: light against dark and dark against light. Movement of the foreground railroad toward the right is contained by the signal which says, "Stop" (angles galore!). Highest chroma color is found near the store front, which is meant to attract customers.

Papa, Baby, Mama *22 x 30 inches.*
From a sepia photoprint of my wife's ancestors. Green is arbitrarily introduced for the sake of the Irish. There may be an inconsistency of lighting between Baby and Mama (Baby's lighting has less contrast). This lighting flatters youthful heads, but one must always be more concerned with the whole than with parts. The darks are not well organized, and are difficult to apprehend as areas of tone. I was a little too much concerned with problems of color and avoidance of academic realism. How easy it is to be distracted from concerns of pattern. Papa's complexion has a touch of umber added to contrast with the pure pink of the girls. Painted wet-into-wet with a large mottler brush, emotional content emerges from a direct, all over, at once, method of working. What does not appear here are the several preceding paintings which bolstered confidence and furnished knowledge. Make plans to cover all bases, imagine everything which might go wrong and have contingency schemes. Then jump in, take chances, fail, go down in flames if necessary. Get up and jump in again.

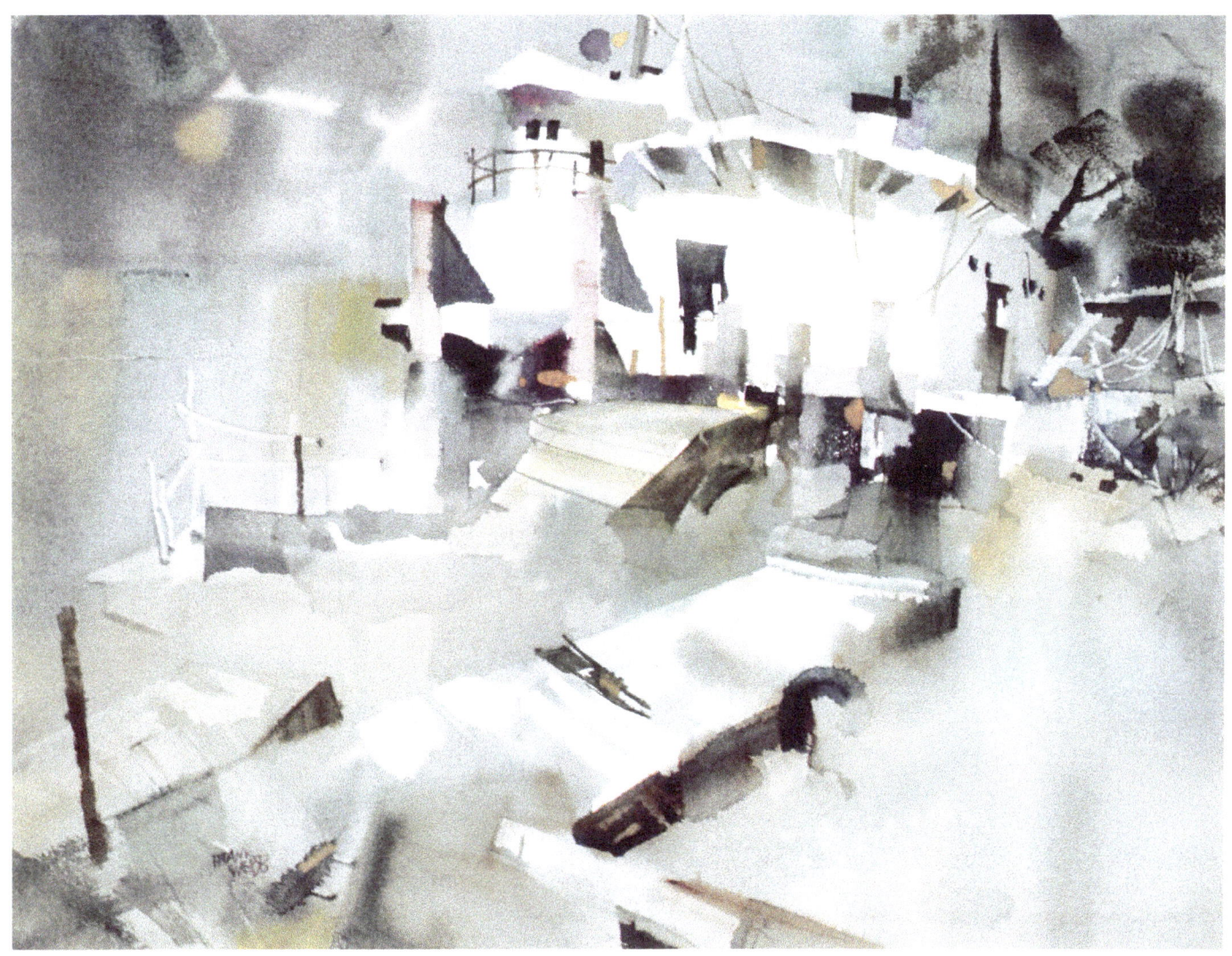

Campbell's Barge Line *22 x 30 inches.*
Typical river impedimenta includes washed up wharfs. Flooding and swift currents occasionally rearrange shore establishments. The wooden wharves zig-zag me into my pictorial space furnishing conviction of the foreground plane. These were not present during my drawing, but were remembered from experience of past occasions. Kierkegaard said, "Life can only be understood backwards; but it must be lived forward." The larger towboat is permanently tied, serving as an office for the fleet. The two boats together make a fine white shape. The painting began on a wet paper with a 3-inch mottler brush. Alizarin crimson and various greens were folded together so that pink wins here and green there. In other areas the two are more thoroughly mixed, making mauve. The greens are coddled toward higher chroma yellow-green. I try to formulate color convictions and intentions before touching paint. Admittedly, these intentions may be displaced or even replaced during subsequent operations. I bring my ideas to the paper. The paper speaks only after I make an introduction and a proposal or two. In this act of painting, the paper and I collaborate.

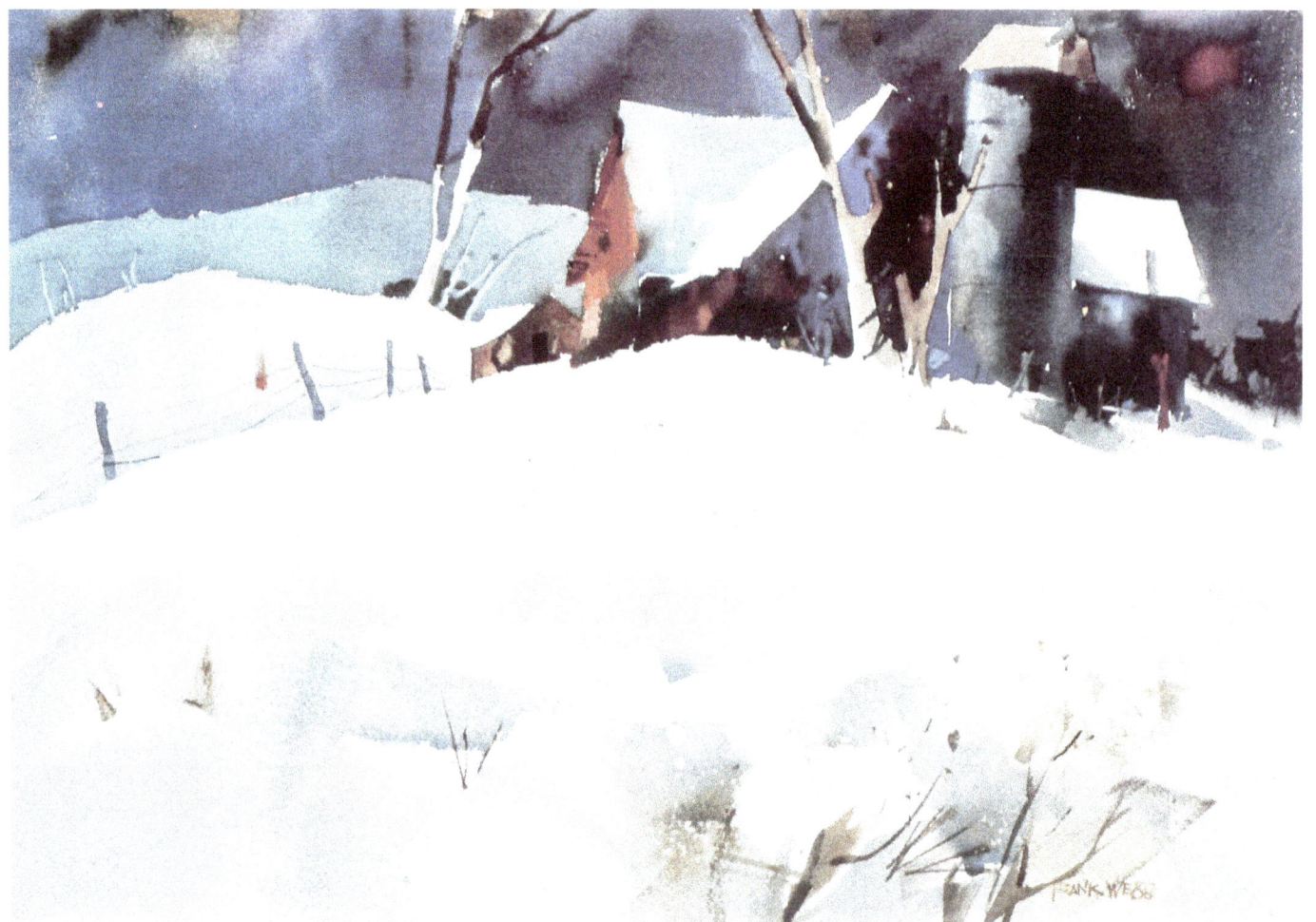

Punxsutawney Farm *15 x 22 inches.*
I painted the snow first, for it is the largest, lightest, wettest area. High key blues of the snow are warmed at left with Indian red and yellow ochre at right. Next, the sky is painted in a much darker than usual tone, making the snow appear lighter by contrast. I use most of my blues, charging the wet tones with warm minglings. The hue of blue can be modified toward red or toward yellow. Its chroma and tone can be made higher or lower within the available range that paint offers. Consideration of the sky as a piece of blue resulted in the following modifications: The blue of the sky is given a higher tone, higher chroma and a greener hue at the left side. On the right, it is darker in tone, lower in chroma and purplish in hue. The orange end of the barn suggests a patch of sunlight, dramatizing cool colors elsewhere. The largest area is the big field of snow, which is repeated in two pieces of snow-covered roof. Each painting should have one area much larger than all others. Look, for instance, at a well designed coin. One important idea fills the coin. Other ideas require other coins. Fill your paper with one major idea. Because the sky tone is rather dark, I must use the darkest tone available for the barn sides, thus making sky tones appear brighter and more luminous.

Youghiogheny Whitewater *22 x 30 inches.*
Private collection.
The feeling of being tossed is created by dancing marks of the brush. Its gestures are similar to the convolutions taken by the water around its rocky bed. A red-purple dominance, a wet and soft texture, a majority of curved contours, and one largest-sized area (the water) helps to produce unity. Paint spattered on a wet area at top left, and salt dropped into a wet wash above the raft suggest splats made by leaping water. Contrasted with these large wet areas are smaller strokes of calligraphy in curves and straights, some of which indicate natural phenomena (tree branches), and some of which are used only for decoration. Although the foreground, or rather forewater, is uneventful, it has a large gradation of hue, warmer at left, which changes slowly to cooler as we read toward the right. Painters are often tempted to use drybrush effects for water edges, foam and glitter where sun strikes its surface. Though I use a little rough brushing to suggest foam against the raft, I try not to contradict the wet look of the large areas. Those few roughnesses used dramatize the larger areas of soft wet.

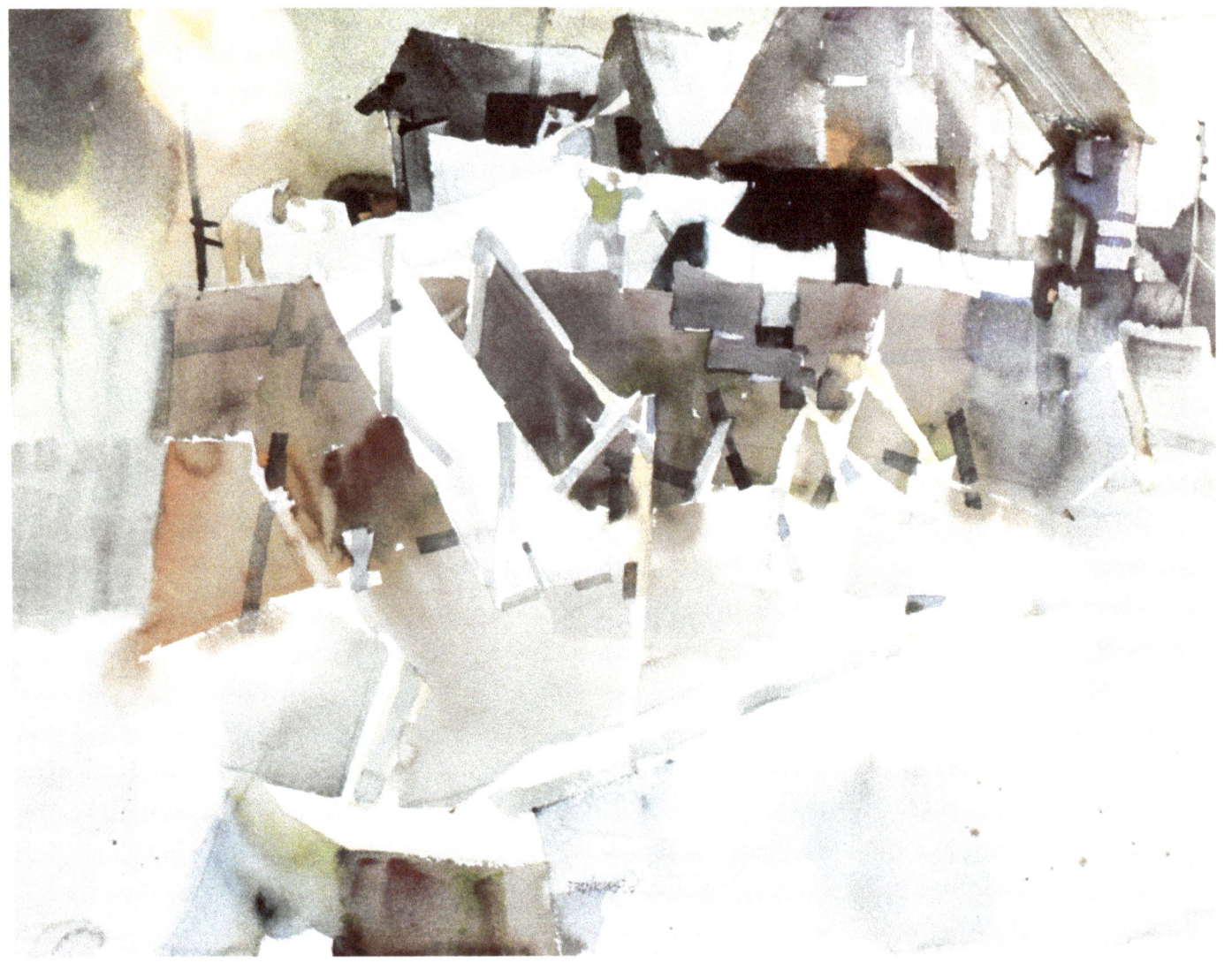

Marine Moonlighters *22 x 30 inches.* Private collection.

This painting was begun on dry paper which was earlier sponged with clear water, removing surface tension and making it a little more sympathetic to wash operations. It is painted directly in the manner of patch against patch with allowable fusion of some edges. Despite its dry beginning, I think it has a wet look due to the generous amount of water in brush chargings. The white shape is an angled check mark, relating to roofs, boat braces lying about, stone wall, and pieces of beach as seen between the scraps of lumber. Spidery whites suggest a web which holds together parts. James K. Fiebleman wrote in his book, *The Quiet Rebellion,* "Art is no substitute for ordinary existence but makes up a kind of commentary on it, and by resting us in another world helps us to bear the ugly and the painful parts of our lives. Art is the domain in which, for purposes of constructing a world of sheer delight, all facts are temporarily false and all theories provisionally true. Consistency is the only criterion in art."

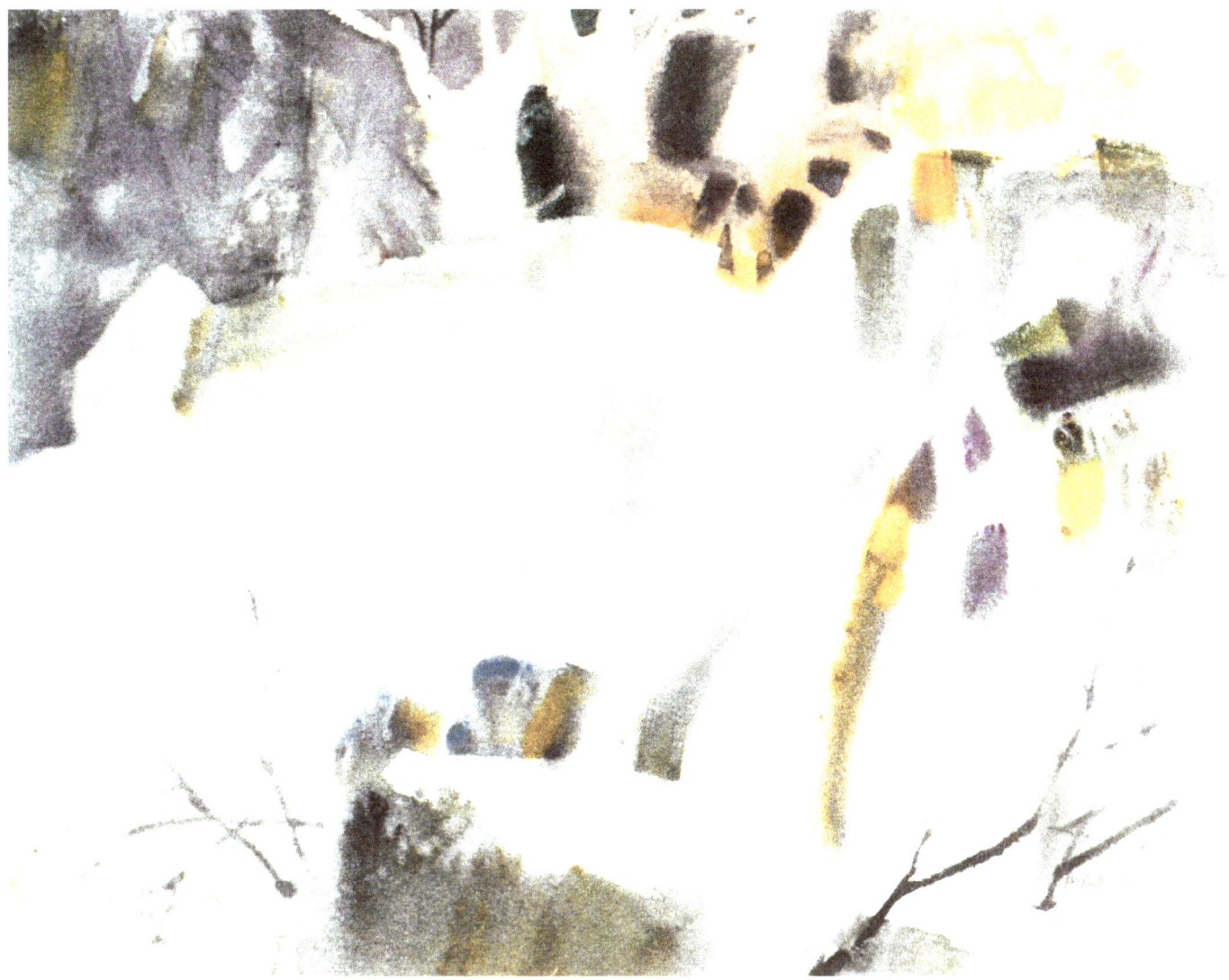

Bear Run at Fallingwater *22 x 30 inches.* Private collection.

A mountain stream dashing downward like a living thing; fresh, soft, swift. These qualities are obtained by painting around whites at just the right time, with just enough of the correct hue and tone, in a suitable viscosity. This was painted on a saturated paper, with removal of the surface water using a squeezed out natural sponge. I overlapped the cascade with a rock at bottom, which also establishes a base from which to skate into the picture. Rock occupies the majority of my paper space with forest at top establishing textural and spatial interest. I congratulate myself for dividing the forest into unequal areas of hue. Two-thirds of it is purple, and one-third, yellow-green. I give myself a demerit for centering my large tree group and also for placing them equidistant one from another. Small hints of warm color provide hue interest among the dominant cools. Have you discerned the gradation produced in the total piece of rock which is warmer at left and cooler at right?

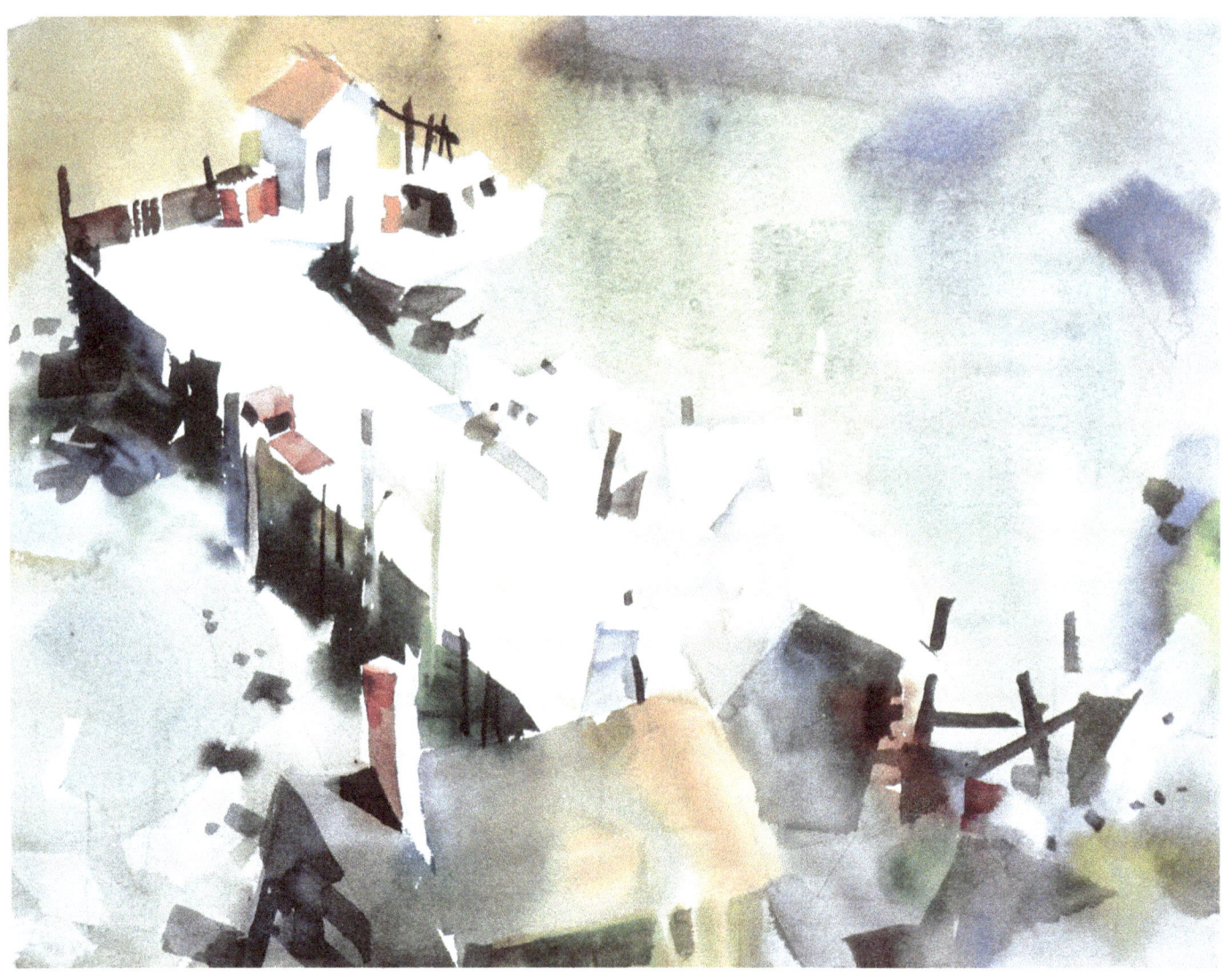

Cribbon's Point. *22 x 30 inches.*
The creative concept is a big cove seen from a high station point. I open up my pictorial space with a movement inward toward the right, then turn somewhat toward the left at the second shack, followed by a long trip into space along the wharf. Then, helped by the boat, I turn right to be caught by the purple-blue symbols of a shore, impelled downward and forward toward the focal point at the bottom and from thence, back into space again via the second shack. All this traveling is in the direction of an inward spiral. The large cove at the right is repeated in a smaller cove with a cooler hue at the left of the wharf. Such echoes are the stuff by which we relate areas in a design. They must be recognized as possibilities rather than dependence upon actualities of nature. The technical approach was wet-into-wet, which helped make the large ocean area fresh and wet, thus expressing its essence. Because it was painted wet, gradations were easily introduced; purple and green fusions at the right creating color interest. The use of viridian added a textural quality produced by a sediment wash. Paint which has a tendency to form sediment will do so with ease in loose wet washes where pigment easily separates into small clusters.

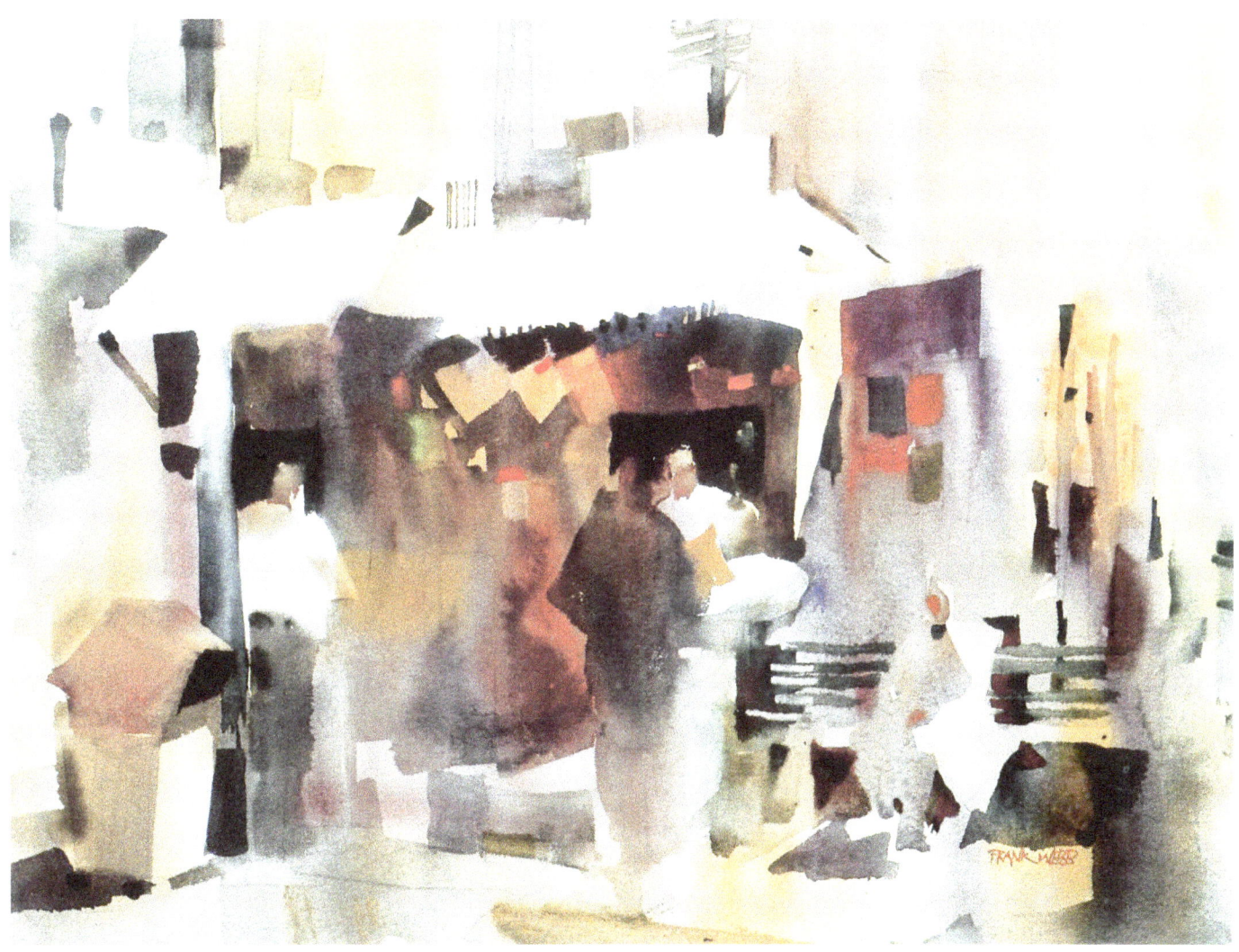

News At Noon. *22 x 30 inches.*
Strong overhead light gives the impression of noon. The casual shack is an endangered species, but is one of the unlimited non-trite motifs which can be found in any city. All city motifs, like their country cousins, express changing moods as light and seasons change. Here, a warm hue dominance is kept, with the coolest hues restricted to grayish purple (Payne's gray and alizarin). The dark area beneath the sheet metal roof is a superimposed wash over earlier warm washes as evidenced by the tones of the publications hanging on the wall. The seated figure is apprehended as two pieces of tone expressing light and shade. Simultaneously I thought of a figure shape and a good abstract shape made directly with the brush. These arrived from inside out, not outlined and filled in. In reality, there were city buildings in the background, but I ignored them except as suggested vertical shapes. My darkest darks are the open window areas' mixtures of alizarin and phthalo green. Darks made from such transparent dye or stain colors give a transparent "looking into" feeling, whereas opaque colors make a dark which says, "Stop," no peering into, no mystery.

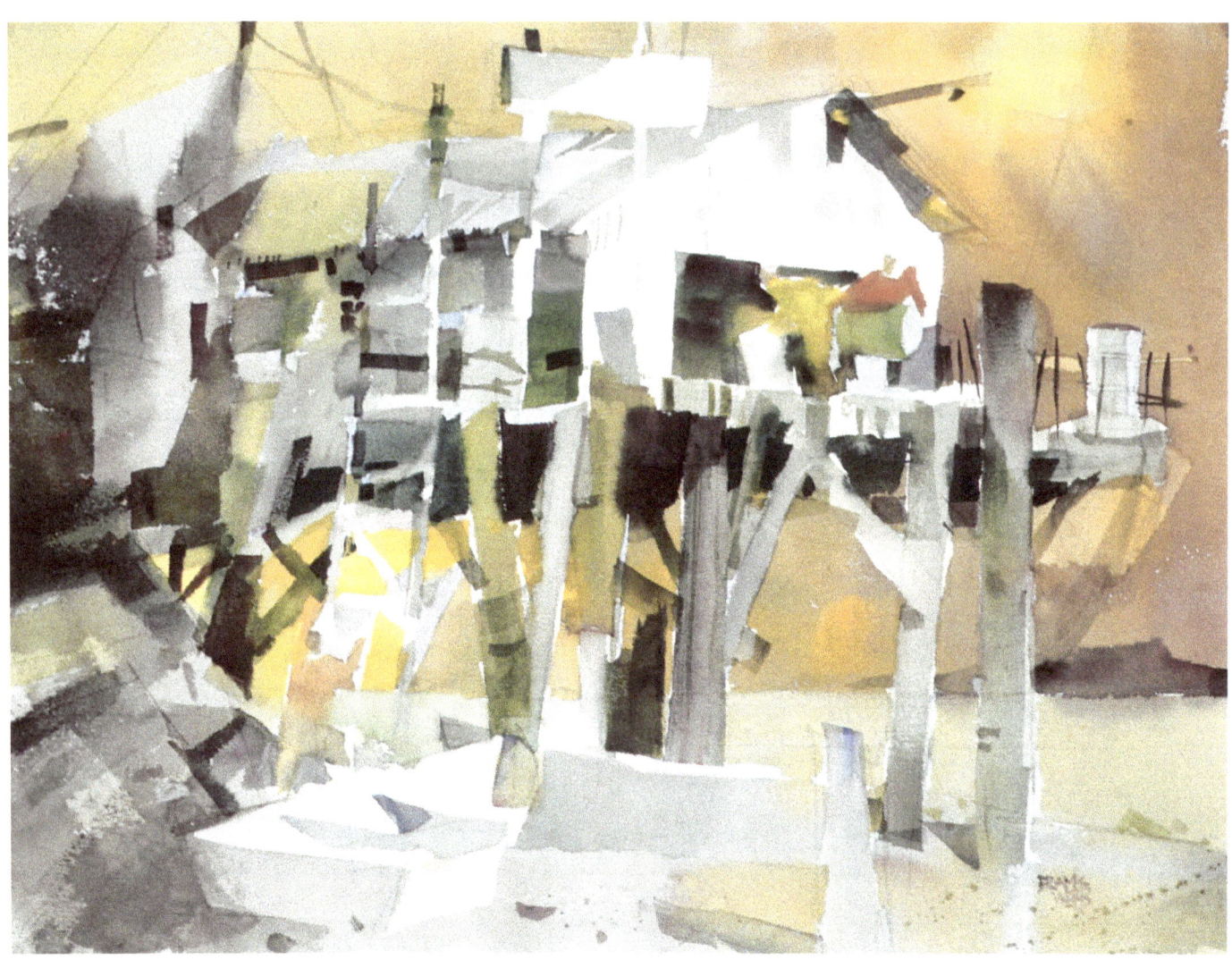

Public Wharf *22 x 30 inches.*
A triad of secondaries: green, purple and orange. Though these are easily found, I did not use ready-made tube paint, but mixed as I painted according to my concept. (Greens and purples are better as mixtures.) Most hues were made from mixtures of hansa lemon yellow, alizarin crimson and Prussian blue. A little Payne's gray was also introduced for making low chroma greens and purples. Again, more pertinent than a list of specific hues are the concepts or intentions held by the painter. I conceived the large sky area as beginning at top left with orange under a greenish influence which would shift toward purple (russet) as it moved toward right. Then the right side and back across the paper toward the left to reach highest chroma yellow and orange in the sky just above the white boat. My shape concept is two large interlocking comma shapes in the manner of the Oriental sign of yin-yang. This powerful device locks up a painting even in advance of its frame. Pilings and braces are greatly varied in hue, size, direction, tone and gradation. They are greatly irregular in their groupings and, more importantly, their intervals.

8 Pattern

A pattern is an archetype, an ideal, and a scheme of constituents within a given system—the painting. The artist organizes large areas of tone into a well-related visual pattern sketch. This small scribbled pattern is a summation of intentions. It snatches possibilities out of the rapid flow of experience and becomes the esthetic embryo of the creative concept.

Translation

The task of making a work of art is so great with its many concerns, methods to choose, realities to communicate, that the artist could be paralyzed with fright. The superhuman aim can only be achieved by dividing concerns and execution into workable units. Working by stages will enable us to eventually build a house, write a book or paint a picture.

Watercolor landscape painting can be built on a foundation of knowledge gained by years of studying with a pencil. The pencil eliminates the buzzing confusion of nature and furnishes a simple, paintable motif. The objective world is used, but only as an instrument of expression. Nature is re-created on the basis of your life experience. The pencil enables you to express directly. Out of the unlimited possibilities, one major idea is selected.

Leo Stein wrote that nature is an overloaded property room. While there is something to be said for direct painting from nature, most good paintings are produced in the studio. Pattern sketches provide an outdoor motif for indoor work. I paint from a pattern sketch even when on location, for it helps me to concentrate on design, and reminds me that as a painter my job is to make a translation of the visual facts into the language of paint. A proper translation cannot be made unless the painter is knowl-

edgeable about both languages, nature and art. Remember that those two realms are not the same. Let us consider some of the factors involved as we face a motif in nature, assuming that we are ready to see, think and respond with some feeling.

Imagine ordinary seeing; seeing objects only in the ordinary, practical categories of their familiar usage. Shadow colors, tones, connections, edges, and other qualities go unnoticed. Four individuals went out to look at a tract of land: an artist, a realtor, a geologist and a farmer. What did they see? They each saw a different landscape.

Artists see in terms of interest and medium. Seeing is also affected by the context of previous and recent seeing experiences. Experience includes life events, the things which have happened in us. Things are not seen simply as they are, but more importantly, we see as we are. The casual observer sees only things, while the artist sees relationships among the things and the intervals between them. While looking at phenomena, people see with the idea behind the eye. The eye is merely a sensitive instrument which reports light but does not see form. The brain provides light sensations with its symbol transformations. Therefore, objects are seen through the eye more than with the eye; the eye is a lens.

Though everyone sees subjectively, the artist sees also objectively, for art training fosters disinterested seeing. An artist might look at a human being and see that person with a great deal of empathy, but simultaneously as a spot of tone and color against other spots. Under the creative impulse, the artist looks for verbs which establish connections, conditions and possibilities.

Consider the devices through which the painter can receive fresh perceptions: (1) a mirror which suddenly reverses the scene or the scheme on the paper (2) an upside-down look at the motif or the picture to set up new relations and to glimpse new connections (3) a telescope or a microscope to reveal new and unusual relations.

The medium itself intrudes on behalf of the painter's seeing. The watercolor painter sees areas as brush shapes of tone, color and gradations. One of the most readily available aids for the painter is squinting through almost closed eyes, eliminating the trivia of the world's details. Only large and most important areas are seen through the screening eyelashes. Look for the gesture of a motif from which concepts and design follow. Gesture is an action against something. The painter sees more than mere appearance, more than from one station point, and more than surface effects of incidental lighting. Visualize a transparent picture-plane somewhat in front of the motif. On this plane, the artist creates a pictorial space.

Visual organization of the spacial field is apprehended not only by the eyes, but by the whole body. To bring a work of art into equilibrium, it is necessary to regulate the dynamics of felt tensions.

The eye may see for the hand, but not for the mind.
　　　　　　　　　　　　　　　. . . Thoreau

Finding a motif

A motif is whatever gives the painter an impulse to work, a launching point where subject matter comes directly from the objective world, as the painter sees it. It can also come from the imagined world of "what ought to be." Other sources include:

Sketches	Photographs
Human figures	Commissions (other people's motifs)
Memory	Still life (set up)
Abstract shapes	Close-up of anything

Many painters are known through their associations with certain motifs, e.g., florals, marines, still lifes, figures, etc. People who know little about painting give subject matter major importance. Unable to see esthetic qualities, they see only "things." Viewers with more discernment make distinctions regarding matters of technique. The most knowledgeable among the viewers appreciate the creative concept and the esthetic synthesis.

When confronted with subject matter the artist responds emotionally. An emotional involvement is necessary to make a visual statement, for if the painter is not excited about the work, no one else will be either. Following the initial seeing is a long or short period of investigation. This results in a percept which leads to generalizations and cross fertilizations of previous seeings and conceptions. A flash of insight might clarify the esthetic problem.

Again, what is important is not the motif itself, but the painter's capacity to imagine, speculate, simplify, organize and relate. The perception of a subject, transformed by design, under the impulse of intention, gives artistic import to a work. An intention is an aim which guides action.

Even though solipsists believe that the self is the only reality, there is an objective world which exists independent of mind. Certainly both realms exist; art is the bridge between that island and the mainland.

As sensations are integrated with an awareness of the present, they become percepts. Continuity is made possible with the formulation of a concept; thus re-creating perception according to schema which can be held in the mind's eye. Art moves from image toward concept, while literature works from concept toward image.

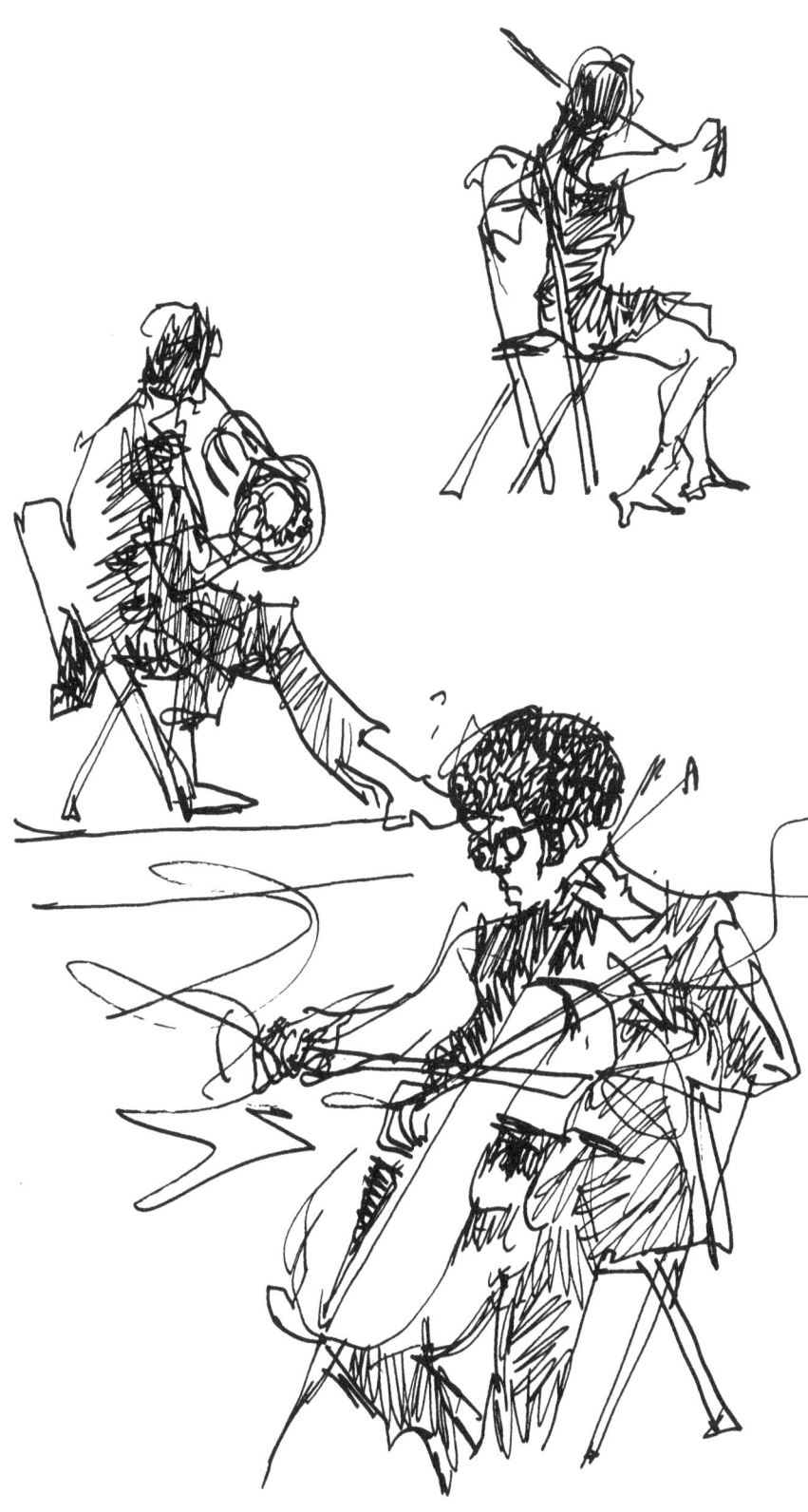

Outdoor landscape

Many nineteenth century artists left their studios to work outdoors, aiming to copy the light of nature in the manner of a camera. They brightened their palettes admitting sunshine into their pictures and into the dark salons.

The advantage of working outdoors is considerable, even when the artist entirely changes the facts of nature. On location data is received via all five senses. Stalk the motif to see objects from more than one station point. Include those which are hidden or out of range. Impart a sense of place, and develop sensitivity to variations in character of different locations.

Temptations lurk on location. There are many things clamoring for attention. The majesty and glory of light might seduce you into trying to copy this with those few miserable tones and colors. The actual physical space might intrude, suggesting that your job is to represent space with eyesight perspective, and a single station point, though from a fixed station point, a rural mail box might loom larger than the barn behind. There are also sensuous textures everywhere, purring, seeking to be stroked. You can cleanse your way through this valley of temptation by taking heed of the 15 design words found in Chapter 5.

Nature and art are not the same. A color photograph proves that nature is not in the picture-making business, for there is seldom a satisfactory relationship among large areas. You will often be disappointed when viewing a photo of a well studied motif because the camera did not see with your selective viewing. Even the nonartist sees selectively. The artist is in the picture-making business, and is therefore required to recreate, using man-made order—design.

Pattern making

On location make a small tonal pattern sketch with a soft pencil or another marker capable of making midtone and dark. Start by drawing a borderline around your sketch. As a designer, think about shapes of the big areas of the design and how they relate. If a borderline is not supplied, the artist simply draws "things" in juxtaposition which are unrelated. Learn to see the big divisions of the whole, within the borderline. Make sure that the large shapes relate to each other and to the borderline.

Next, make provision for the whites. If they are not in the motif, create, invent, lie, borrow, steal, but get some whites. White is the strongest, most important tone at your disposal. It comes free when you buy the paper.

Scribble midtone over the whole area within the borderline except for the whites. Most of the area should then be midtone. After the midtones are down, add the lush pieces of dark. Darks should be played against the whites. Of course, these whites and darks must be good shapes covering generous areas. At this time avoid making little lines and details. Nature does not necessarily do this for you, unless you have learned to see nature. The little pattern sketch is a recreation of the motif in terms of broad areas of tone.

While working on a pattern, give 100 percent attention to design. This is not always easy. Students often sketch objects using contour, and then add what they call "shading," a lot of northeasterly lines which look like hay. They do not use a borderline, but claim to see the edge of the paper as the edge. They almost always work too large, complicating the provision of tone. Thus, what many people call "sketching," simply does not include design.

A good professional will make several patterns of various concepts, choosing the most exciting. After an acceptable pattern is made, most of the attention during painting can be given to color, edges and technical problems. This procedure enables the artist to proceed without trying to solve problems of pattern and design during painting. This is especially advantageous for watercolor painting, because a pattern sketch enables the painter to place paint precisely, with fresh, direct applications. Watercolor loses freshness during endless fudging and readjustment of sizes, tones and colors. Some editing and revising can be made, but always accompanied by a loss of sparkle and charm.

In making a pattern, the designer chooses only those qualities which lend themselves to integration. The pattern should emphasize the essence of the motif, exaggerate the gesture and provide readability. The audience must be able to read shapes, therefore allocate tone in a readable pattern.

Some erroneously claim that a preliminary "sketch" dissipates emotion reserved for the finished work. On the contrary, a small, simple pattern whets the esthetic appetite, creates excitement, brings momentum into all subsequent operations, and enables the painter to place each large area with assurance that is in the most distinguished relationship possible.

Siamese and Afghan
Fine point marker with graphite pencil

Hints for pattern making

- Investigate and absorb the motif.
- Look for continuations, parallels and repetitions.
- Conceive the motif as volumes in a planetary space.
- Comprehend the motif not as it looks, but how it operates.
- Select a creative concept of the motif.
- Start when moved.
- Decide on a vertical or horizontal paper format, whichever expresses the motif.
- Put a borderline around the pattern to become more aware of shapes.
- Proportion borderlines to the format of the paper on which you will paint.
- Keep the size of the pattern within six inches.
- Look at the pattern more than the motif, after an initial long look at the motif.
- Shape the whites by scribbling midtone around them.
- Shift and alternate the sizes and locations of whites.
- Put in the darks, shifting and alternating, in the same manner as the whites.
- Draw with broad strokes of a soft pencil, held on the top end.
- Keep patterns flat looking by scribbling tones in the vertical direction.
- Avoid static shapes such as circles, squares or equilateral triangles.
- Stabilize an oblique dominance with some verticals and horizontals, or use obliques to energize schemes of horizontal or vertical dominance.
- Make one area larger sized than all others.
- Open up passages among shapes. (There should be a way in or out of any shape or tone. See the work of Cézanne.)
- Avoid excessive tickling and linear elaboration.
- Try a high or low horizon.
- Throw the light from different directions on different patterns. Lighting is a creative job, not a copy job.
- Use tones and accents, not only for chiaroscuro, but for the sake of pattern, decoration, repetition, gradation and key.
- Separate or combine shade and cast shadow according to design needs.
- Plan edges (even though the crudeness of the pattern does not provide a means to refine them).
- Feel the weight of the mountain, the hardness of rock, and the softness of the cloud.
- Make lines convex, not concave. (Suspended vines, sand and snow drifts, and the tops of waves are exceptions.)
- Write notes of interest in the area outside the pattern to help recall present awareness of nature and design.
- Avoid erasers except to regain lost whites.
- Do not work mindlessly, like a machine.
- Stop when finished.

Pattern directs attention to the creative concept, while detail is subordinated to big lines, tones and shapes. The art is in the pattern. Do not paint things. Do not paint light and shade. Paint patterns.

Art is the imposing of a pattern on experience, and our esthetic enjoyment in recognition of the pattern.

...Whitehead

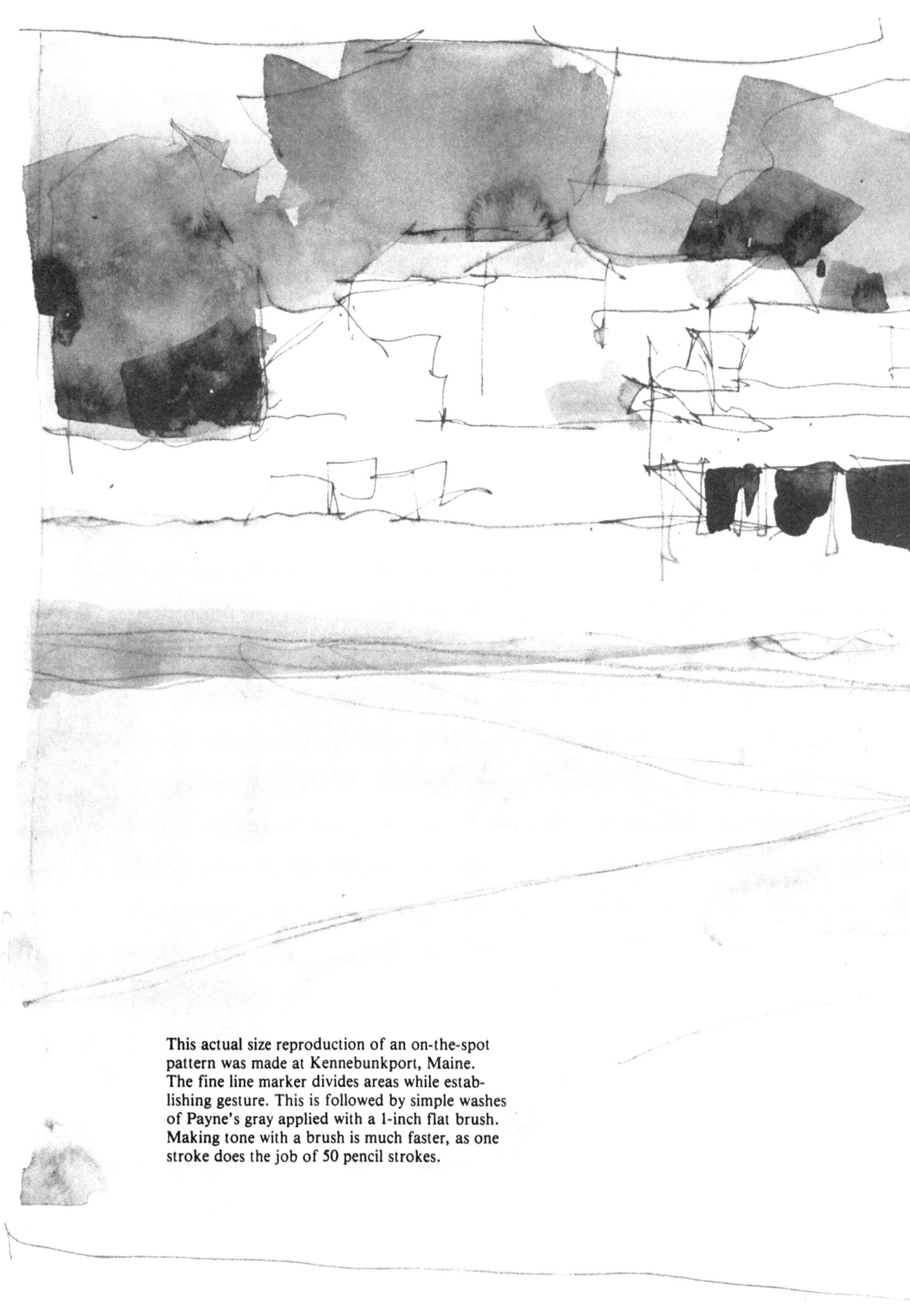

This actual size reproduction of an on-the-spot pattern was made at Kennebunkport, Maine. The fine line marker divides areas while establishing gesture. This is followed by simple washes of Payne's gray applied with a 1-inch flat brush. Making tone with a brush is much faster, as one stroke does the job of 50 pencil strokes.

9
Esthetics

Esthetics is the criticism of taste; the sense of the beautiful and the artistic. It includes the judgement and analysis of qualities and relations. Esthetics begin when the artist attempts to discern and cultivate powers of perception, conception and technical mastery with emotional intensity. These qualities, when embodied in a work of art, communicate some of the felt wonder of life. A personal esthetic is established when the painter has in-dwelling knowledge and is no longer wafted by every esthetic wind.

Esthetic camps

The visual arts developed a schism in the third quarter of the nineteenth century. In reaction to extremes of naturalism, philosophical idealism emerged with symbolism as one of its manifestations. Thus the arts were split even before the coming of the avant garde. However, the rift opened by abstract art was more profound. Unlike all previous art, it does not proceed from a study of the objective world.

Therefore, artists have been divided since the turn of the century. Manifestos have been written, and camps have proliferated under two different banners. In the abstract camp are the non-objectivists, modernists, expressionists, constructivists, formalists and many other "ists" of the avant garde. In the opposing naturalist camp are the representationalists, surrealists, academic-realists, photo-realists and magic-realists.

Early in the 20th century, proponents of abstract art used the term "new" art, implying that naturalism was old, although these painters claimed Giotto and El Greco as their progenitors. They labeled realistic art as "non-art." Abstract painters assumed the position of martyrs, and suffered real and imagined ridicule and censure. Their vaunted assertion of an esthetic utopia was frustrated by World War I.

Diamond Meat Market *(detail).*
Goods are exchanged in the market place. Art satisfies another kind of need. Art puts people in touch with feelings about realities which are normally beyond reach.

One definition of abstract art is *away from nature.* Another is *a simplified, selective seeing in terms of the artist's medium, within the requirements of design, and attending to those qualities and relations rather than to others which are present in a particular reality.*

Rhythmical space, expressive color, gestures, shapes and relationships are the curricula at this end of the esthetic scale. The best of these works have great affective power which comes from an intensified expressiveness with little regard for nature.

In reaction to abstract art, the esthetically marooned naturalists resorted to name calling and jokes about monkey-painted canvasses. They charged that their enemies "could not draw." They questioned the motives and sincerity of the abstract painters. Naturalists, interested in continuity, found no connection of abstract practice with tradition.

Naturalists paint what they see. A glimpse into any life class reveals that this is easier said than done. Included in this study of visual phenomena are the usual subjects of light and shade, perspective, anatomy, materials, technique and their application in making compositions. The student is occupied with rendering three-dimensional objects including still life, the human figure and landscape.

The camps exemplify two kinds of truth. Naturalism seeks the truth of correspondence to facts, while abstractionism seeks the truth of coherence. These are roughly akin to content and form.

Deficiencies

Abstractionists stress the subjective at the expense of the objective world. The world of nature is a rich storehouse, though our knowledge of it is only partial. By ignoring or minimizing the objective realm, non-objective work has limited content and can be understood by only a few.

Naturalists often present recognizable subject matter with little or no qualities of design (form). In its extreme, it is mindless copying without intervention of thought or an understanding of the plastic means of articulating pictorial space. The argument is the old conflict between mind and matter.

Glories

The abstractionists are committed to creativity and form-building. They are not here to do what has already been done. They give great personal power to painting. They ask that painting be freed from story-telling and sentimentality, stressing direct presentation rather than representation.

Naturalists' works speak to the man in the street. Naturalism basks in the glory of light as it falls on three-dimensional objects. It can include the human figure which is always interesting and will never be out-dated.

Students should have broad exposure in production and appreciation of naturalism and abstractionism. Good works are found in each realm. The student has the obligation to eventually find an esthetic home. The current art scene tolerates many "isms" which are capable of generating interest.

Esthetic Knowledge

Classification of "isms" and the history of art does not exhaust the study of esthetics. Directly felt beauty emerges from qualities and relations in individual works of art. In the making and appreciation of art, critical judgements must appraise the relationships among parts and the whole. Organic unity is thereby tested, according to esthetic standards. Those who have no standards are barbarians. They are not innocent, but ignorant.

Knowledge about the subject of esthetics does not, of itself, make a fine painter. Only the embodiment into works proves esthetic power. The painter possesses this power when it seeps into muscle and bone as well as head and heart. Esthetic knowledge is direct knowing. It is the knowing implied in, "I know my friend."

Semi-abstract esthetic

I use the term semi-abstract to define the esthetic integration of abstract and naturalist art. Juan Gris, who introduced synthetic cubism, began with form (abstract) and worked toward representational elements. It is logical to work in this sequence, because it is difficult to impose formal qualities and

relations into a naturalist drawing. He compared his aim with weaving, where one set of threads is the abstract, and the other set is the representational. The fabric does not exist without both sets.

The paintings of Cézanne illustrate this transubstantiation most vividly. There always remains some degree of the representative object in his work. Every artist knows that even the most realist art has some abstraction.

With Cézanne's realizations came an architectonic ordering of relations, patterns, rhythms and tone. His dynamic space-forming and structural use of color are most instructive for the student. Previously, painters relied exclusively upon chiaroscuro, drawing, or the plein-air of the impressionists.

The lessons of abstract art can be integrated into works when the following items are introduced:
- Equalized surface tension
- Working in terms of the medium
- Rhythmic dynamic form-seeking
- Tension of volumes in axial relationships
- Design seen as subject matter
- Color used as a structural means

Find and learn your own lessons of esthetic value, make your own integration. Each starts from zero and goes the way of trial and error. There is no grand scaffold of procedure as offered by the sciences.

I believe that the whole tradition of naturalist (superficial realism) and realist (profound realism) art has value. I also believe that the abstract art movement has value and that the two can be integrated. The common denominator is design. The actual world of naturalism and the possible world of abstract are both real worlds. Seeking after the possible rather than realism only, will help you to avoid the extremes of depression or elation over reality. Double-track, and you will find a rich storehouse of thought, feeling and action. In short, find a philosophy and forge a *what ought to be* out of *what is*. It is useless to look for a consensus in forming your point of view. Truth is not found by a show of hands. The *now* world of quick change, instant communication, and dissemination of new slogans offers few clues. One clue suggests getting your act together and formulating your visual (design) and verbal (philosophic) principles.

In designing your life, you encounter conflicts. Some of these cannot be resolved since they are totally opposed, such as good and evil, right and wrong, true and false. But you also must deal with lesser conflicts. Chart your course between Charybdis and Scylla: Charybdis, the fearful whirlpool where you are drawn into professional oblivion for playing it safe; Scylla, the six-headed monster representing pride, sloth, circumstances, ignorance, avarice and jealousy.

In design you must maintain equilibrium between oppositions via the poet, not the computer. Your productivity depends on the polarity between inward and outward perception, plus many other oppositions:

aspect	vs.	concept
assembly	vs.	design
performer	vs.	composer
response	vs.	intention
chance	vs.	order
seeing	vs.	knowing
actual	vs.	possible
differentiation	vs.	integration
subject	vs.	object
content	vs.	form
naturalist	vs.	abstract
image	vs.	idea
prose	vs.	poetry
existence	vs.	essence

These listed pairs are glass slippers to try on for size, one for each foot. In the Cinderella tale, they lived happily ever after. In the real world, one must live with many contradictions.

Finding a personal esthetic

An artist receives data from the actual world through the senses. Sense perception is an animal property. Esthetic knowledge added to perception provides awareness of qualities and relations. Esthetic power and creative intuition arrive while the painter is on the job, brush in hand.

Shape provides the most direct means to make a personal statement. The degree to which you abstract or distort shape for the sake of relationship distinguishes your work from another's. Each sees in terms of recent seeing interests. The phenomenal world appears very complicated, but personal need limits the response to organic demand. You should select only those qualities which lend themselves to integration.

The whole visual field is distorted by an individual's interests. Therefore, it is unlikely that any sincere work will resemble another's production. The making of deliberate shapes puts a work outside the "fact" world, into the world of the imagination. Imagination is not only image-making, but relation-finding. Steady production over a long period of time results in a recognizable "handwriting."

As a result of convictions, each painter's works knowingly or unknowingly criticize

and oppose all other works and world views. The artist says, in effect, "This is the way light falls; this is the way the world is; this is reality." These convictions also influence selection of subject matter.

All your works of art are autobiographical. They are portraits of you. Selfishness, generosity and curiosity will surface. Enthusiasm or half-heartedness cannot be concealed.

A practical attitude toward achieving style is to expect a gradual and natural unfolding over a period of time. Your work, as it grows toward maturity, will show organic connections with your earlier work. You must be patient and accept slow growth. Growth and personal style are always linked. Concern for immediate growth and professional status can shift attention from productivity to publicity.

Publicity, though necessary and useful, is no substitute for esthetic power. The engines of publicity currently and historically prove that the known and unknown do not necessarily correspond to the great and the mediocre.

To attract publicity, some artists adopt curious life-styles. Bohemia, which is social irregularity, appeals to those who wish to be "free." The mission of many artists is to shock the middle class. Now that large numbers of nonpainters have adopted the artist's haunts, clothing and life-styles, why should the artist feel compelled to play the stereotype role?

Attention to work, steady production, plus sincerity, thought, contemplation and worry opens new doors. There should be no need to resort to novelty, as it is impossible to shock the already benumbed bourgeoisie.

Behaviorists account for human activity as reaction to conditioning. Among the things which we need are works of art. These works give us a glimpse of connections and qualities which are generally remote but brought into proximity. Creative production and appreciation requires taste, and a system of value judgements. The opposite of appreciation is indifference. Indifference is one of the signs of decadence. It is the ultimate crime against commitment and is a serious disease of our times. Art has always been the fruit of individual artists many of whom have endured indifference. The study of art history is the study of heroes and heroines. They were people who insisted on their convictions and developed an appropriate esthetic for the communication of their art.

The following painters evoke summary images in my memory. The ability to remember visual character proves style, providing clues which might make your work memorable.

Van Gogh—*writhing strokes*
Feininger—*planar interpenetrations*
Avery—*simple, well-shaped areas*
Albers—*the square*
Burchfield—*calligraphic symbology*
Delaunay—*circular synchromy*
Giotto—*isometric space*
Picasso—*powers of conception*
Pollack—*drips, spatters*
Seurat—*pointillism*
Gauguin—*flat decorative shapes*
Cassatt—*peachy flesh color*
El Greco—*flame-like shapes*
Modigliani—*elongated necks*
Kollwitz—*black and white expressionism*
Hals—direct *brushwork*
Sorolla—*sunshine*

These may or may not coincide with your appraisal of the work of these masters. My point is that they are memorable because they have characteristics which differ from all others' works. These characteristics were not simply tacked on mannerisms, but they grew out of daily production, year after year.

Simplify

The quickest way to develop an esthetic is to simplify. A painting is simplified just as life is simplified, by omitting needless items. The only person who is free is the one who has few wants. Subtract, do not add. Be a miser, do not use more tones, shapes, lines or colors than is absolutely necessary. Emphasize these elements which are constructive of your idea, then when a change is made, it will be significant. Small pattern sketches show what to throw out. Leaving much out, puts much into your work, conquering multiplicity with simplicity. Connect patches of similar tones and colors, making your areas more generous. See color as a simple chord or group of chords; do not just hatch out new color. Until those large areas are wedged together, well shaped, and beautiful, do not go further. Constant production and thought will establish your style. There is no other way for style to be reached except through sincere work, where eventually you will be able to discern what is truly yours.

Stop when you have expressed your creative concept with your chosen shapes, tones, direction, sizes, lines, textures and colors, lest your work becomes redundant.

Our life is frittered away by detail...simplify, simplify.
　　　　　　　　　　　　　　...Thoreau

10 Routine

Time should be organized not only according to immediate need but also to reach goals. Routine is a prescribed, detailed course of action or procedures to be followed with regularity. Establishing a professional routine divides intervals of time toward the realization of long-range goals.

Professional

A professional artist is one who has earned technical and esthetic competence. While the amateur gloats over successes, the professional learns from failures. It is not necessary to make your living at painting in order to produce professional work and to consider yourself a professional.

Associations

Watercolor societies have flourished since the nineteenth century. These societies range from national to non-geographic, state to metropolitan. Many societies offer open membership, while others select members on the basis of reputation or by a screening of works. The bylaws of most groups state an aim to encourage watercolor painting and appreciation, primarily accomplished by annual exhibitions. Societies also support traveling shows, paint-outs, paint-ins, workshops, lecture-demonstrations, scholarships and group tours to distant museums.

The success of most of these endeavors is directly due to their artist member volunteers who serve in many capacities such as receiving and return of entries, workshop organizers, catalog production, gallery sales, public relations, mailing, newsletters, advertising, patron contacts and many other services. These activities provide artist members with wall space for public viewing plus opportunities for education. The generosity of these workers is more notable when services are extended to include non-members in an "open" show. The best exhibitions require that all accepted work be selected by a competent jury.

Juried exhibitions

Competition might serve as an incentive for excellence, but should not be the sole aim of the painter. An artist competes with self, not with other artists. Acceptance can, however, lead to honors, invitations and publicity, all of which help the artist gain an audience. It is also instructive for artists to study the public's response to their work.

Increasingly, national and regional shows are selected from photographic color slides. This system offers both pluses and minuses for the artist and the sponsoring group. On the plus side, the artist is spared the high cost and time of crating and shipping, which seems especially extravagant when a work has been rejected.

On the minus side, lowered costs and ease of handling have increased the number of entries, minimizing the artist's chances for acceptance. The artist's work, if accepted, must be held in reserve for a considerable length of time while the sponsors go through administrative procedures. Upon receiving the shipped works, sponsors are sometimes dissatisfied with substandard framing, unavailable work, attempted substitutes or altered artwork.

Color slides offer sponsors the option of mailing entries to an out-of-town juror. This lessens the concentration of duties when the juror visits the exhibition galleries to select awards. Entry fees from the increased number of entries help defray the mounting costs of exhibitions. Expensive space is not required for jury viewing and crate handling, since only accepted paintings are handled.

Solo exhibit of Webb watercolors in the lecture gallery of the Tweed Art Museum, University of Minnesota—Duluth

Photo by Cheng-Khee Chee

Selecting work for entry

When the artist first decides to enter juried shows, it is feasible to enter local or regional ones. National exhibitions are quite competitive, with only a tiny fraction of acceptances. Familiarity with the juror's work does not necessarily give a clue to that juror's preferences. Works rejected from one show may be welcomed into another. Choose your work carefully in accordance with criteria as you perceive it. Some artists enlist the opinion of painting friends. If the show requires a slide entry, make sure that your slide is of professional quality. Thousands of otherwise acceptable paintings are rejected due to poorly produced slides. Submit only works which have a creative concept. Just another pretty picture will not make it.

Rejection—acceptance

Painters should develop a stoic attitude toward rejection and acceptance. Decisions by jurors are not perfect, absolute truths. The imperfections of human-kind surface during the dispensation of esthetic justice. When rejection comes, the artist sees the awkwardness, the grossness and the injustice of the real world. This is the time to plunge into work, to recreate reality in accordance with personal values and desires.

I returned, and saw under the sun, that the race is not to the swift, nor the battle to the strong, neither yet bread to the wise, nor yet riches to men of understanding, nor yet favor to men of skill; but time and chance happeneth to them all.

...Ecclesiastes 9:11

Commercial galleries

A gallery affiliation usually includes a solo show every two years. In addition to such shows, galleries stock an amount of artist members' work for display and also for making presentations outside the gallery. Galleries may be somewhat cavalier toward new artists because there are always more artists than available gallery affiliations. Artists vary in their interest toward gallery affiliations according to the following criteria: the quality of other members' work, promptness of payment, faithful recordkeeping, honesty and enthusiasm for the artist's work. Professional galleries must meet expenses and present a dignified sales setting for buyers. Those most reputable charge from 40 to 50% commission, and request some degree of exclusivity within a geographical area. Each artist should ask, "What can this gallery do for me that I cannot do for myself?" Also ask for an appraisal from the other gallery members.

Solo shows

Commercial galleries do not have a monopoly on solo shows. Others are sponsored by art centers, artist co-op groups, museums, colleges and universities, clubs, libraries, civic buildings, banks, etc. Some of these charge little or no commission. When leaving artworks in another's care, provide a list of titled works with prices and get a receipt for consignment, stating terms. Keep a duplicate for your records. Also agree on other variables, such as who pays the state sales tax, when sold works will be made available to the buyer, will the published gallery hours be observed by the gallery, will insurance and security be provided, what is the length of the consignment?

Sales presentations

Mighty engines of institutionalized art are handled by nonpainters who maintain some control over sales and reputations. Since cubism was invented, middlemen have done most of the talking and writing. Artists do not necessarily have to play that cliché role of the eccentric Bohemian, who is an inarticulate, though inspired duffer, for whom others must speak and manipulate accounts payable and receivable.

Many collectors enjoy meeting and talking with the artist. Meet them with confidence and businesslike poise. If your work has merit, be proud of it without displaying arrogance. The prospective buyer may not have ability to recognize esthetic qualities of your work, but may have confidence in your reputation or interest in the subject matter. Do not overstate, shuffle or otherwise belittle your work. Do not expect the buyer to make an offer, but have prices labeled or listed in advance. State whether prices are inclusive or exclusive of framing.

You can make sales presentations to corporations and galleries with matted works or slides. Many of today's corporations are buyers or potential buyers of art. Make presentations to interior design firms who represent corporate clients. When the client proves indecisive, do not hesitate to leave a portfolio for consideration. You are really in business if you can provide a showcase for your work in your studio.

Commissions

Commissioned work is as varied as there are ways of interpreting instructions. Because of the intangibles involved, the provision of a rough or preliminary visual is a logical step. For clients who cannot visualize, a comprehensive layout is helpful. Approval of these provides a substantial basis for mutual agreement. The biggest bug-a-boo of commissioned work is the request for changes. Do not be implacable, but on the other hand, do not be a door mat. Chances for success are much greater if the client is familiar with your work. If a written agreement of the commission is not received, provide one of your own, and get a signature on it. Keep your promises.

Publicity

Free publicity enhances local, regional and national visibility. Notice of solo shows, honors received, such as awards or election to prestigious associations, might be of interest to the public. Copy for presentation to editors should be typewritten, double-spaced, and should answer the journalist's questions of who, what, when, why, where and how. Include your name, address and phone number. Photo prints, if practical, might encourage publication. Send your presentation copy to various editors of print and broadcast media. Editors use this low-priority news when there is available space. Paid space advertising and direct mail (in good taste) can announce a show or classes, and can project your exact desired visual and verbal image to targeted audiences.

Attracting an audience

Pleased collectors of your work are your best references. Appearances on TV and radio are helpful. Such appearances maintain and sustain your professional stature, converting you into a quasi-institution. Teaching full-time or part-time can be a springboard to extend your reputation. Consider the kind of image you wish to project: are you the town lout who mechanically puts on the paint, or are you a person of some sensitivity doing interesting work and willing to communicate with others?

A lack of appreciation by the public tends to lower morale. A lowered morale results in decreased vitality. Aim for a specific audience. The respect and interest of just a few selective persons can be worth more than a large, uninformed following.

Photography

Your basic camera should be a 35mm single lens reflex. It will produce the 35mm transparency (sometimes described in a prospectus as a 2-inch slide). This size is also convenient for gallery and sales presentations. Although it is not necessary to have built-in or automatic camera features, a light meter will prove useful. Many professional artists and some photographers prefer to photograph artwork in outdoor lighting. While this can give excellent results, it might prove inconsistent and impractical during inclement weather. The following is a summary of my procedure which, because it is strictly controlled, yields good copies, without need of bracketing exposures, i.e., or making additional exposures for the sake of insuring a good copy.

Support the painting on a flat black copyboard. Looking through the lens of the reflex camera on a tripod, adjust distance until the unmatted painting fills as much of the framed viewer as possible without cropping. Temporarily remove the painting and tape a small

mirror on the center of the copyboard. The copyboard, and ultimately the painting, is aligned parallel to the lens when the lens is reflected back through the camera viewer (as you look through the camera viewer and see the mirror image of the lens looking back at you). The painting is then replaced on the board.

As standard photocopy practice dictates, aim two light stands at 45 degrees to the painting. Avoid hot spots by placing lamps at a sufficient distance from the painting, and aim them downward from a higher level. Use lamps which are color-balanced with the film (measured in kelvins). Avoid the use of color or polarized filters.

Take a light meter reading of the darkest area of the painting and another of the lightest. Use an exposure about halfway between these two readings. A cable release added to the camera assures a steady exposure.

For general outdoor use, a 35mm camera with an accessory 135mm telephoto lens improves landscape documentation because it brings distant objects closer, reducing extreme perspective convergence.

Photocopy setup. To get the lamps into this shot, I moved them closer to the copyboard, creating a "hot-spot" on the right side. Avoid this by placing lamps further back, always at 45° to the copy. If the painting to be copied is under glass, I hang a dark cloth over the camera and tripod, allowing only the lens to show. I avoid light clothing and any light or white areas or objects behind the camera, since they reflect on the painting. Professional photocopiers sometimes paint the bright metal parts of their cameras with lampblack paint, or they and their lens peek out from a hole in a black drape. Here you must especially check the 45° angle and distance of the lamps to avoid hot spots left and right. My copyboard has penciled cross centerlines and perimeter guidelines for common half sheet and full sheet painting sizes. The small round mirror is fastened at the exact center. Any sized painting should be centered when applied to the board.

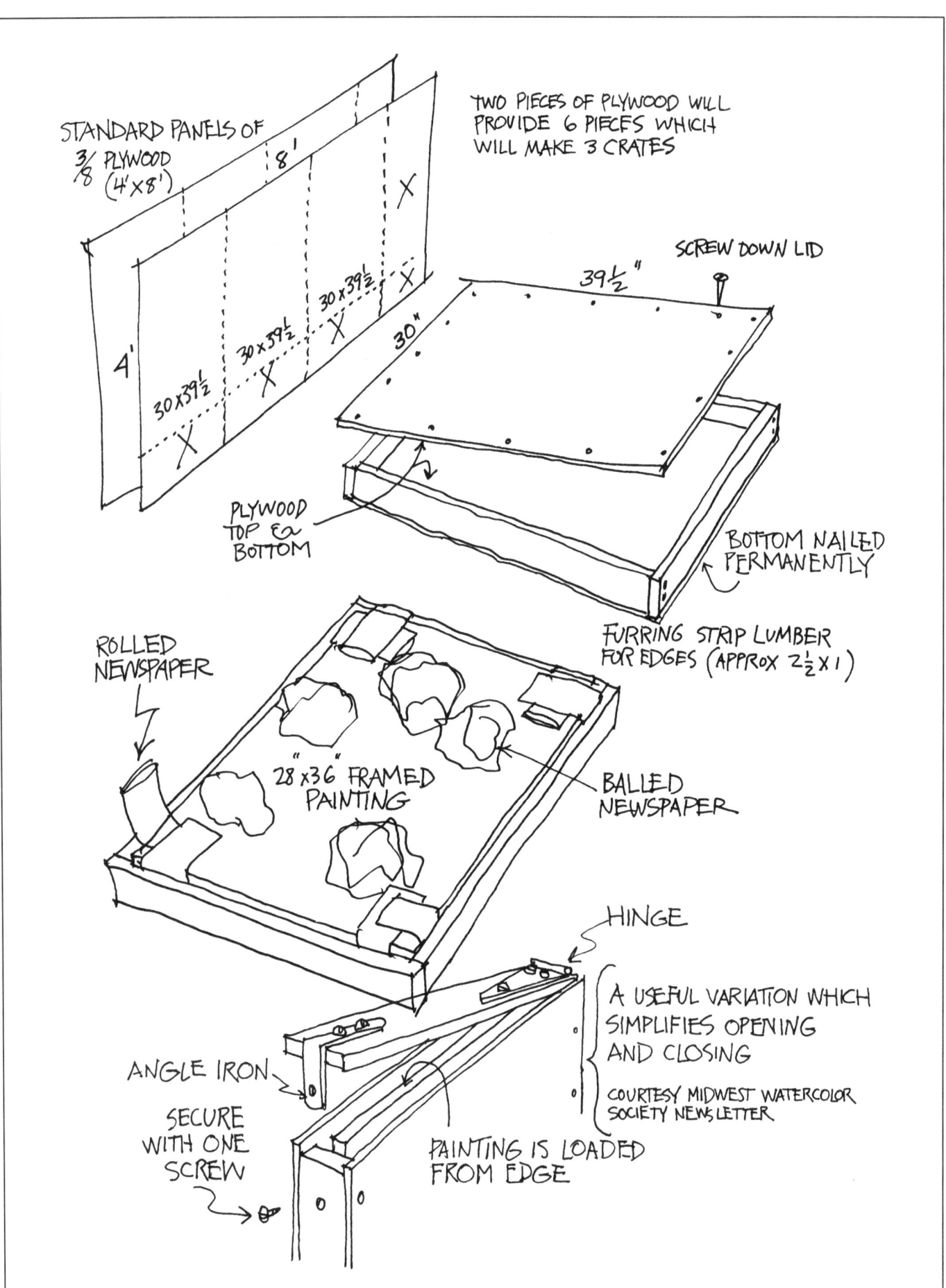

Standardized system of presentation and shipping

High shipping costs, size requirements and availability of materials advocates a uniform system of sizes. Lumber, crates, frames, mats, and acrylic sheets (glass) are bought to provide only two frame sizes. Full sheets are matted and framed to 28 x 36 inches, and half sheets 22 x 28 inches. Random sizes may be fine for occasional work, or for variety, but this system saves time and cost when handling large numbers of paintings.

Shipping crates

A major shipper limits size to 108 inches (girth plus length). The illustrated crate is just a couple inches below that limit. It uses furring strip edges and 1/4-inch plywood for the bottom and lid. Sufficient space is supplied for a full sheet framed painting, using a 28 x 36 inch metal section frame. The approximate mat width within this frame size is 3 1/4 inches.

The bottom of the crate is nailed permanently to the furring strips. The top is fastened with No. 6 pan-head or oval-head screws. The weight of one crate containing one full sheet framed painting is approximately 27 pounds. The thickness of the crate is sufficient for stacking two or three framed or several matted pictures in one crate.

Acrylic sheet glazing

This product is more expensive than glass, but is the only practical glazing suitable for shipping. It is more economical when bought in large sheets and cut to size. Cut the sheets by making multiple strokes with a special hooked knife which scores the surface. The knife is used in a pulling direction with the aid of a straight edge. After it is well scored, break it in the manner of glass. Handle the sheet carefully, for it scratches easily. The knife and a special cleaner-polish, can be found in a hardware store. In addition to cleaning, the polish also reduces static electricity. For rubbing out scratches, try a brand of toothpaste containing "whiteners." Though there is some demand in the market for nonglare glazing, professionals and jurors tend to reject its use. It is especially obnoxious when used on a low key painting, or any matted painting because the distance between the glass and the surface of the picture increases the cloudiness.

Framing

Standard metal section frames are practical because their narrow width allows the mat to serve as the principal separation between the art and the wall. Functionally, the thin frame acts to hold the glass against the matted work. Metal section frames make shipment easier, as they save a few inches of space within a crate. The silver color is the most versatile of the various finishes because it reflects and relates to the surroundings.

Mat cutting

The illustrated matting system is homemade. It uses a Dexter mat cutting knife. The baseboard is 1/2-inch plywood which has a strip mounted across the bottom edge and a short strip at the top. Into these strips, slots have been cut, into which a straight edge fits snugly at exactly 90 degrees to the bottom strip. The straight edge is an aluminum channel acquired from a hardware store. Make sure it is rigid and straight. The rig shown is inexpensive, easy to construct and efficient in use.

Conservation matting requires neutralized mat boards which have a controlled maintenance of alkaline pH over a time span. Archival framing dictates the use of museum quality rag board, which is expensive and sometimes unavailable from stock. Standard materials can be modified toward conservation quality framing in the following ways:

1. Use a barrier between the backing board and the painting such as rag paper, metal foil, mylar or discarded rag paper.
2. Use backing boards of foam-core. These strong boards are lightweight and not likely to warp.
3. Paint the cut edge of the mat, for this is where the concentration of acid will leak onto the painting. Or, paint the entire mat with latex or oil wall paint. This can also be done for esthetic reasons, to create a desired color.
4. Avoid all-over wet mounting or dry mounting of paintings to any surfaces, as this devalues a work of art.
5. Using hinges of linen cloth tape, attach a painting to the back of its mat from the top only. This allows the paper to swell and shrink within the frame. When ready-made cloth tape is unavailable, substitute with strips of rag paper using wheat paste.

Mat sizes

The common 32 x 40 inch size mat board subdivides into photographic print sizes. It does not translate into standard watercolor sizes. A more useful 28 x 44 inch size is available from some dealers. This allows for a full sheet size of 28 x 36 inches with only 8 inches of waste trimmed from one edge. For two half sheet mats, it is simply cut in half, each half measuring 22 x 28 inches. Widths of the mat and the frame should always be decidedly different. More mat—less frame or vice versa.

The center waste piece cut from the full sheet mat measures about 21 x 30 1/2 inches, which, though a little smaller than standard half sheet mat size, when trimmed to 28 inches, is suitable for a half sheet mat as an unframed painting for your portfolio.

Mat tones

Most discerning jurors and professionals recommend off-white tones. Garish colors and deep tones should be avoided. When acceptable tones are unavailable, one alternative is to paint the mats. A practical mat tone is one which is a little darker than the whites of the painting.

Buy in quantities

All items of presentation thus far, including mat board, acrylic sheet, metal frames, wood frames and crate lumber can be bought in lots, greatly reducing prices. Some of these items can be purchased through mail order. Send for catalogs from nationally advertised firms. Some dealers recognize artists as wholesalers and are willing to negotiate for something less than list price.

Free agents

Exchange paintings with artists in cities or areas which have juried shows. Paintings can be mailed in tubes. Instead of the standard cheap paper tube, seek to buy the new plastic mailing tubes at your art materials store, or make your own from a section of rigid plastic drain pipe. If end caps are unavailable, jar lids serve well. Each artist puts the received painting into a mat and frame, delivers it, picks it up and returns it. This greatly simplifies handling, resulting in lower costs.

Stationery

Since a painting career is a public life, there is a need for correspondence. Consider a simple letterhead design of type printed on rag stock. Calling cards and biographical sheets are also useful. A biography should list only the facts of your career. Omit philosophy and adjectives. Limit it to one side of a standard size page in one color—black. Avoid elaborate graphics and display type.

Your collection

Most painters like to own and be surrounded by good work. A collection of original art can be a source of inspiration. If you cannot afford to lay out hard cash, why not trade with other painters? A file or a box of reproductions is also useful to create enthusiasms. This is not for the purpose of copying others' work, but for legitimate appreciation. You might wish to trade color slides with other painters. Books, cassettes and the new video tapes will also enrich your repository of human creativity.

In earlier chapters your education and your work was discussed in terms of design. In this chapter you have been encouraged to design your professional life including an audience and a public life.

The whole difference between a construction and a creation is exactly this: that a thing constructed can be loved after it is constructed; but a thing created is loved before it exists.

. . . Chesterson

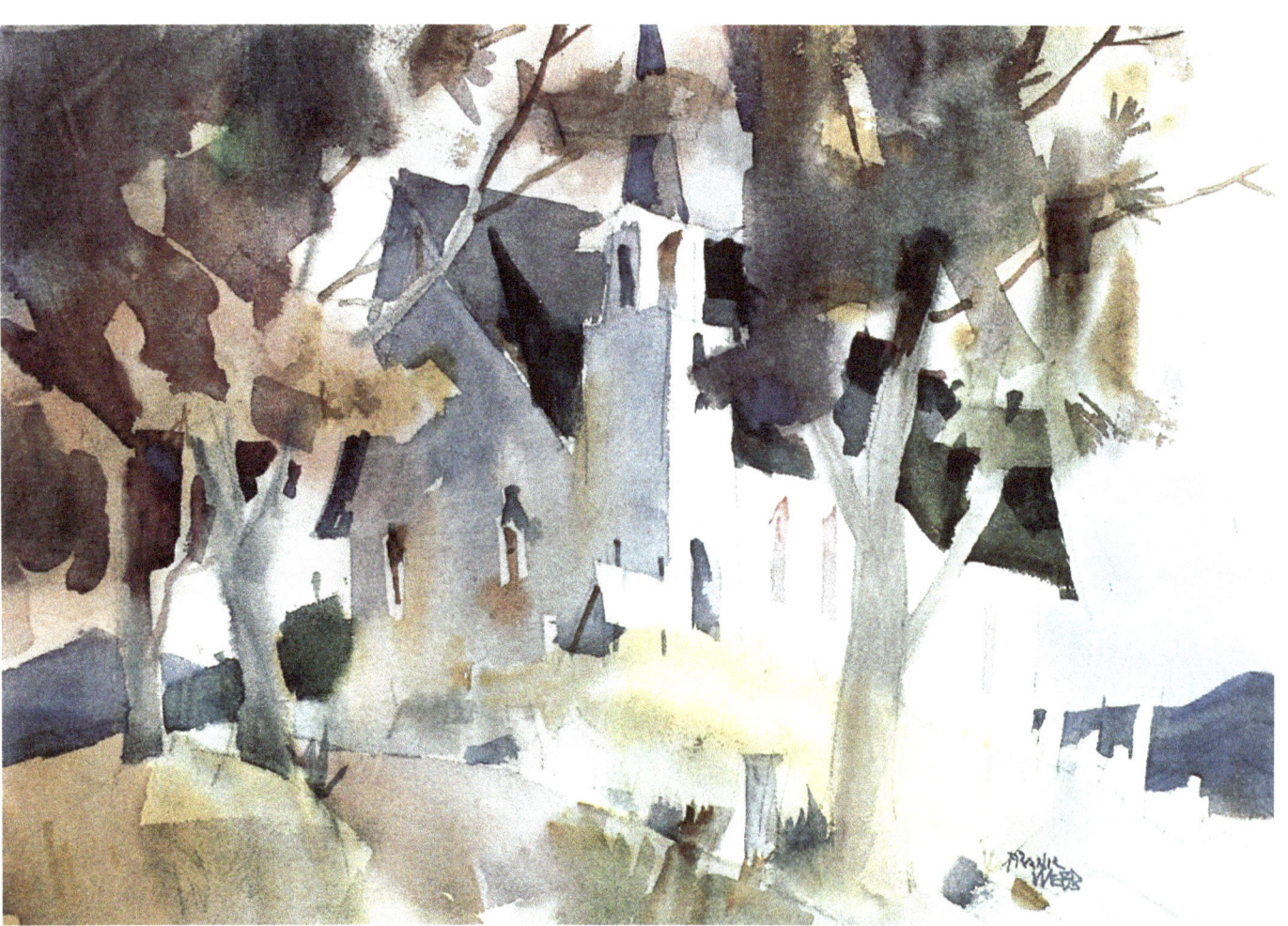

Bayfield Church *15 x 22 inches.*

Conclusion

After a painting is finished it becomes separated from the process by time and space. It is the function of art to give moments of felicity to our lives; to furnish us with insights into possibilities beyond facts. It should jolt us not only into knowledge, but into union with reality.

We have considered some of the most important facets of our art and craft. It has been a privilege for me to sift esthetic opinion with you. You will not agree with everything I have said, but the findings of any dedicated painter are worth consideration. Historical records show that emphasis has shifted from the distant to the near. Let us trace this shifting of attention:

1. The Old Masters concentrated on the model or the scenery; out there.
2. Then came the impressionists who fixed their gaze on the palette as much as, or more than, the scene.
3. Following this period, early twentieth century artists looked more and more at the surface of their painting, and less frequently at palette and model.
4. More recently, the vision of the artist turned inward, ever closer, to become a scrutiny of self.

These various areas of the painter's curriculum are worth our meditation. We need to study nature, the palette, the paper and ourselves. The areas are so vast that we can only glimpse the possibilities. As each area receives the illuminating rays of new understanding, new challenges arise. My goal is to eliminate my ignorance. As an instructor I share my findings with my students. I try to choose and act upon my goal-related values and convictions. The sweetest reward of a career is to achieve some of those goals.

Blessed is he who has found his work; let him ask no other blessedness.
 . . . Carlyle

Soli Deo Gloria!

Glossary

Abstract... Away from nature

Aerial perspective... The diminishing of tone, hue and chroma contrasts when seen at a distance

Affinity... A similarity between two things

Archetype... The prime form

Archival... Preservation, usually of papers

Beauty... That quality which comes from the bond among parts

Calligraphy... Beautiful graphic marks

Chiaroscuro... Light–Dark (Italian)

Chroma... The intensity of a hue

Classicism... Subscription to concrete principles

Cognitive... Knowledge of facts

Concept... An idea—a mental integration of units to project a similar theme

Content... Awareness of the external world, subject matter transformed

Decoration... Ornamentation which makes a surface more visible

Design... Order out of chaos

Dye... A liquid substance which penetrates a surface and imparts tone or hue

Epistemology... How we know what there is

Esthetic... Sense of the beautiful, the criticism of taste

Experience... Something which happened in me

Form... How work is dished up, the substance and design of a thing

Genius... A unique and powerful form of conception

Glaze... A transparent paint layer, usually a term describing superimposition

Gouache... Opaque watercolor, usually mixed with white

Gradation... A series of gradual successive changes

Hue... The perceived quality of a color interval from red through yellow, blue and back to red

Imprimatura... A stain added to a paper or ground before painting

Intention... An aim that guides action

Intervals... Rests, interstices

Intuition... Immediate seizing the greatest form and the primary import without conscious reasoning, induction

Metaphysics... Theory of reality

Mnemonic... An aid to memory

Motif... A motive which is used in the development of artistic work

Naturalism... Pertaining to nature, not man made

Nexus... Organizations of entities

Normative... Evaluation of facts

Notan... Japanese art, light dark pattern without reference to light and shade

Objectivism... Reality is external to the mind.

Oblique... Slanted, not vertical or horizontal

Opaque... Impenetrable to light

Paint... A liquid mixture, usually pigment in a vehicle

Painting... A surface with applied patches of paint

Pattern... An ideal to be followed, the distribution or arrangements of picture elements

Percept... Group of sensations giving a grasp of reality

Perception... Something perceived by the senses, the basic component in forming concepts

Perspicacity... Acuteness of perception

Phenomenology... The study of appearances

Qualities... The essential character of something

Realism... Inclined to literal truth

Reality... Actuality

Relationships... Resemblances

Resonate... Frequency excitation

Respond... To cooperate, to react to stimulus

Reverberate... To re-echo, things repeatedly reflected

Romanticism... The ideal that a person has volition; contrast with classicism, realism

Saturate... Filled to capacity

Shade... Areas receiving less light as they turn away

Shadow... Areas which have light obstructed by other objects

Solipsism... The self is the only reality.

Solubility... Capable of being dissolved

Spatial tensions... A living quality which comes from forces in pictorial space

Subjective... Concentration on the self

Subsume... To place in a more comprehensive category

Symbol... Vehicle for the conception of objects, such as a painting

Talent... The ability to express concepts

Tension... The measure of vitality in intervals

Tint... The addition of white or the dilution of a color toward lightness

Tertiary color... Olive, russet and citron—any intermediate hue that contains some part of each of the three primary colors

Tone... The intervals between light and dark, exclusive of color

Virtual... Existence in effect rather than in fact

Viscosity... High resistance to flow

Volition... Willing, choosing, deciding

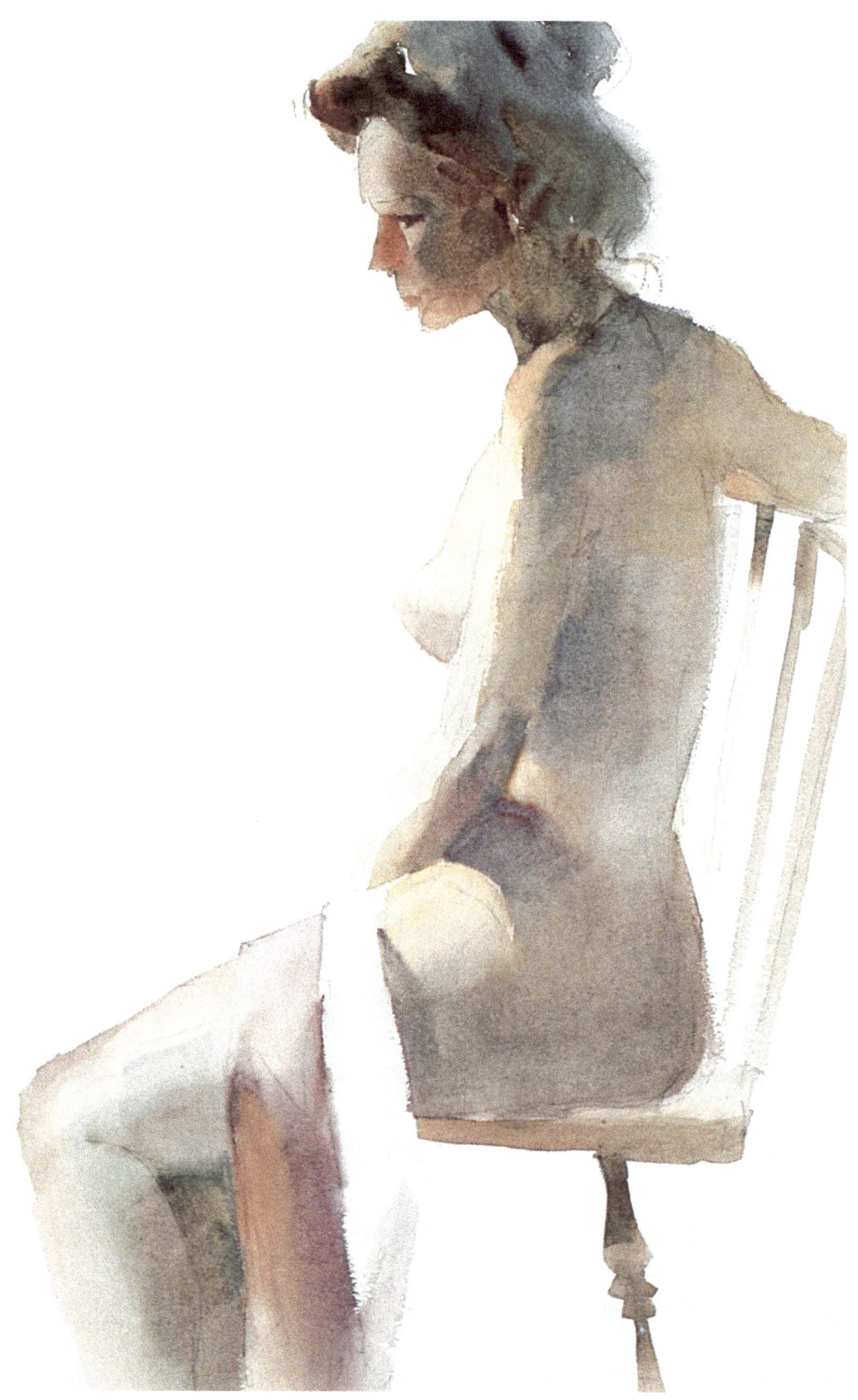

The heightened color contrast of bluish shadows vs. warm lights dramatizes this painting. The most challenging color problem confronting the figure painter is introducing cool hues into usually warm flesh tones. Manet advised, "Train your memory; for nature will never give you more than indications."

Bibliography

Barzun, Jacques
Use and Abuse of Art, The.
Princeton: Princeton University Press, 1975

Bell, Clive
Art.
New York: Capricorn Books, 1958

Berenson, Bernard
Seeing and Knowing.
Greenwich, Connecticut: New York Graphic Society, Ltd., 1953

Betts, Edward
Master Class in Watercolor.
New York: Watson-Guptill Publications, 1975

Betts, Edward
Creative Seascape Painting.
New York: Watson-Guptill Publications, 1981

Brandt, Rex
Winning Ways of Watercolor, The.
New York: Van Nostrand Reinhold Company, 1973

Carlson, John F.
Carlson's Guide to Landscape Painting.
New York: Dover Publications, Inc., 1973

Clark, Kenneth
Landscape into Art.
Boston: Beacon Press, 1963

Cheney, Sheldon
Expressionism in Art.
New York: Liveright, 1962

Collingwood, R. G.
Principles of Art.
New York: Oxford University Press, 1972

Duren, Lista
Frame it.
Boston: Houghton Mifflin Company, 1978

Fiebleman, James K.
Aesthetics.
New York: Humanities Press, 1968

Fiebleman, James K.
Quiet Rebellion, The.
New York: Horizon Press, 1972

Graves, Maitland
Art of Color and Design, The.
New York: McGraw-Hill Book Company, Inc., 1951

Gray, Clive (Ed.)
John Marin by John Marin.
New York: Holt Rinehart and Winston

Guerard, Albert L.
Art for Art's Sake.
New York: Schocken Books, 1963

Hawthorne, Mrs. Charles W.
(Collected by) *Hawthorne on Painting.*
New York: Dover Publications, 1960

Henri, Robert
Art Spirit, The.
New York: Lippincot Company, 1939

Hunt, William Morris
On Painting and Drawing.
New York: Dover Publications, Inc., 1976

Huxley, Aldous
Doors of Perception, The.
New York: Harper & Row, Publishers, 1954

Kepes, Gyorgy
Language of Vision.
Chicago: Paul Theobald, 1944

Langer, Susanne K.
Feeling and Form.
New York: Scribner's Sons, 1953

Leepa, Allen
Challenge of Modern Art, The.
New York: A. S. Barnes and Company, Inc., 1961

Loran, Erle
Cézanne's Composition.
Berkeley and Los Angeles: University of California Press, 1970

Maritain, Jacques
Creative Intuition in Art and Poetry.
New York: Noonday Press, 1955

McLuhan, Marshall
Gutenberg Galaxy, The.
Toronto: University of Toronto Press, 1962

Meyer, Leonard B.
Music, The Arts, and Ideas.
Chicago and London:
The University of Chicago Press, 1967

Nechis, Barbara
Watercolor, The Creative Experience.
Westport, Connecticut: North Light Publishers, 1979

Ortega y Gasset, Jose
Dehumanization of Art, The.
Princeton: Princeton University Press, 1968

Prall, D. W.
Aesthetic Judgement.
New York: Thomas Y. Crowell Company, 1967

Philipson, Morris
Aesthetics Today.
New York: The World Publishing Co., 1968

Protter, Eric
Painters on Painting.
New York: Grosset & Dunlap, 1971

Rand, Ayn
Romantic Manifesto, The
New York: The New American Library, Inc., 1975

Read, Herbert
Art and Society.
New York: Schocken Books, 1966

Read, Herbert
To Hell With Culture.
New York: Schocken Books, 1964

Reep, Edward
Content of Watercolor, The.
New York: Van Nostrand Reinhold Company, 1969

Reid, Louis Arnaud
Meaning in the Arts.
New York: Humanities Press, 1969

Rookmaker, H. R.
Modern Art and The Death of a Culture.
London: Inter-Varsity Press, 1971

Sargent, Walter
The Enjoyment and Use of Color.
New York: Dover Publications, Inc., 1964

Shahn, Ben
(edited by John D. Morse) *Ben Shahn.*
New York: Praeger Publishers, 1974

Sloan, John
Gist of Art.
New York: Dover Publications, 1977

Stein, Leo
Appreciation: Painting Poetry and Prose.
New York: Random House, 1947

Whitney, Edgar A.
Complete Guide to Watercolor Painting, The.
New York: Watson-Guptill Publications, 1974

Wolfe, Tom
Painted Word, The.
New York: Bantam Books, 1975

Wood, Robert E.
Watercolor Workshop.
New York: Watson-Guptill Publications, 1974

Other Frank Webb Titles from
Echo Point Books
You May Enjoy

Strengthen Your Paintings with Dynamic Composition

Here it is—the book sought by students and myself. Composition deals more with forces than with objects. It should not only precede execution but also spring life-like out of countless decisions made during painting. It requires little courage to paint what you see. To paint what you think and feel takes guts. Break through the composition barrier. 24 painters show you how.

PAPERBACK ISBN 978-1-62654-040-8
HARDCOVER ISBN 978-1-62654-066-8

Webb on Watercolor

Great watercolors require a mastery of technique. This book introduces the painter to not only numerous techniques relating to watercolor, but by the way of design principles. Each of us wants to be more creative, to grow independently from others, to find our own style and most of all, to develop a sense of criticism toward our own work. Learn to fan the flames of your enthusiasm.

HARDCOVER ISBN 978-1-62654-081-1

FRANK WEBB, a professional artist since 1947, is a Dolphin Fellow of the American Watercolor Society, which he has represented in international exhibitions in Canada, New York, England, Scotland, and Mexico City. A guest instructor in all 50 states, juror, and lecturer, Webb has received over 110 major medals and awards from national competitions, including six from the American Watercolor Society. Collectors of Webb's paintings include National Taiwan Arts Education Center, Baylor University, Palmer Museum of Art at Penn State University, Portland Museum of Art, and South Arkansas Arts Center, to name a few. Webb is featured in *Who's Who in American Art* and *Who's Who in the East,* and he is also a member of the Allied Artists of America, Audubon Artists, the Rocky Mountain National Watermedia Association, and many other art associations.

Our books may be ordered online from Amazon or directly from our Web site, www.echopointbooks.com. Or visit our retail store located in Brattleboro, Vermont.